LONDON
UNDERGROUND
MAPS

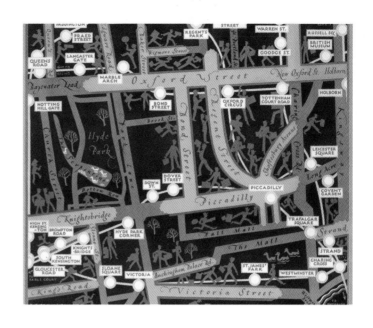

LONDON UNDERGROUND MAPS

ART, DESIGN AND CARTOGRAPHY

CLAIRE DOBBIN

LUND HUMPHRIES
IN ASSOCIATION WITH
LONDON TRANSPORT MUSEUM

First published in 2012 by Lund Humphries,
in association with the London Transport Museum

Lund Humphries
Wey Court East
Union Road
Farnham
Surrey GU9 7PT

Lund Humphries
Suite 420
101 Cherry Street
Burlington
VT 05401–4405
USA

www.lundhumphries.com

Lund Humphries is part of Ashgate Publishing

British Library Cataloguing in Publication Data
Dobbin, Claire.
 London Underground maps: art, design and cartography.
 1. Subways—England—London—Maps—History—20th
 century. 2. Gill, MacDonald, 1884–1947–3. Beck, H. C.
 (Henry C.)
 I. Title
 388.4'2'09421-dc23

ISBN: 978–1–84822–104–8

Library of Congress Control Number: 2011942848

Edited by Belinda Wilkinson
Designed by Nigel Soper

Set in Kievit
Printed in Singapore

Frontispiece
Visit the Empire
Ernest Michael Dinkel, 1933
Double royal, 1016 x 635 mm
(40 x 25 in)
Published by the UERL
Printed by Waterlow & Sons Ltd

Title page
Your Guide to Winter Sales (detail)
Reginald Percy Gossop, 1928
Double royal, 1016 x 635 mm
(40 x 25 in)
Published by the UERL
Printed by Dangerfield Printing Co Ltd

CONTENTS

FOREWORD

LONDON IS A WORLD LEADER in public transport mapping, which reached its apogee in Harry Beck's iconic diagram of the London Underground (chapter 2, pl.1). In *London Underground Maps*, Claire Dobbin shows how this ascendancy was achieved. She traces in detail the evolution of Beck's plan from its creation in 1931, and describes how it has been transformed into a cultural icon, a commercial amenity and an artistic source. But readers might be most surprised and delighted by her opening chapter on the early decorative maps created for London's travelling public. Particularly associated with Macdonald Gill, for the first time these engaging maps receive the critical attention that they merit.

Claire Dobbin is fortunate to have at her disposal the abundant collection and archives of the London Transport Museum. They contain innumerable maps and images, which 'serious' map libraries initially scorned as being mere ephemera. The British Library has had to work hard recently to fill just some of these gaps in its collection as public appreciation of maps as cultural, and not simply geographical, artefacts has grown.

Transport maps did not suddenly appear in the twentieth century. They have been enticing viewers to travel, as well as simply to tell them where to travel, since early times. A St Albans monk, Matthew Paris, drew diagrammatic itineraries of the route from London to Jerusalem in about 1250, and even included interesting diversions from the main routes (pl.1). His itineraries were probably intended to encourage his fellow monks to undertake spiritual pilgrimage without leaving the walls of their monasteries. In about 1500, however, Erhard Etzlaub published a map that was most certainly intended to encourage actual travel. To coincide with the Papal Jubilee of that year, he designed a pilgrim map called 'This is the way to Rome', with the route picked out in a series of dotted lines.

Decorative maps with the same intent can also be found from the mid thirteenth century in the large *mappaemundi* (world maps), of which the sole

1. Diagrammatic route map
Matthew Paris, *c.*1250
360 x 245 mm (14 x 9.6 in)

The St Albans monk, Matthew Paris, produced visual itineraries of the pilgrim route from London to Jerusalem. The strip here shows the first lap of the journey in southern England, with the walled city of London illustrated at lower left.

2. The Hereford *mappamundi*
Artist unknown, *c.*1290–1300
1580 x 1330 mm (62 x 52 in)

Medieval maps, such as the Hereford *mappamundi* (world map) here, often went beyond the purely geographic to illustrate scenes from history, legend and religion, such as the Garden of Eden shown at top in a circle at the edge of the known world.

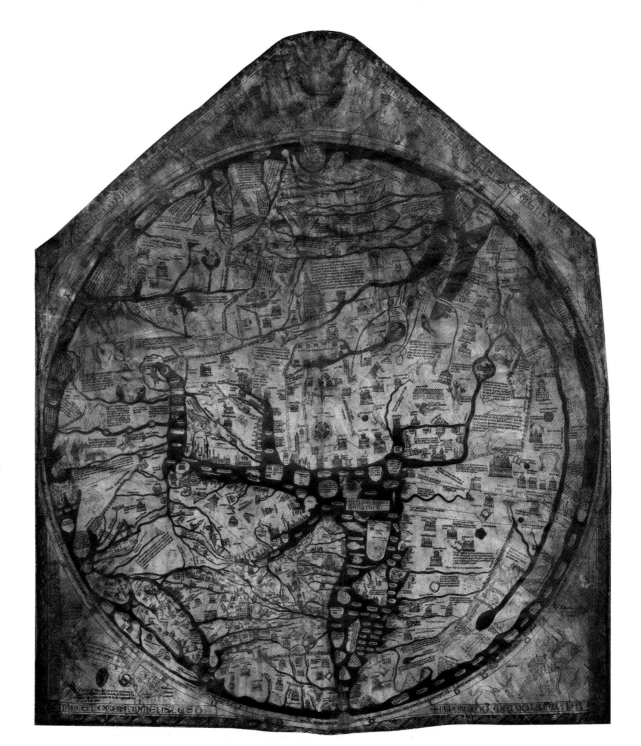

complete example is the famous map in Hereford Cathedral (pl. 2), Herefordshire, in midwest England. Their content – like Macdonald Gill's – went far beyond the geographic to depict legends, historical episodes and famous sights. Between about 1550 and 1620 these elements were pushed to the edges of printed maps, where they were joined by the heraldry. Gill copied these early decorative maps, but added a disrespectful humour and warmth and, above all, a deep knowledge and love of London, which make his maps unique and which readers of this most informative, well-researched and timely book will be able to share.

PETER BARBER
The British Library, London, December 2011

TIMELINE

PRE-1900

1863 The Metropolitan Railway opens in London, linking Paddington and Farringdon. The world's first urban underground railway, it operated with steam trains.

1868 The District Railway is set up, running between Westminister Bridge and South Kensington, and is soon extended to Blackfriars (1870). By 1884, services had reached New Cross via the Thames Tunnel.

1884 The Circle line is completed, linking the Metropolitan and District Railways in central London. Both the District and Metropolitan Railways are extended with overgorund lines through outer London and into the surrounding countryside, encouraging suburban development.

1890 The City & South London Railway, the world's first deep-level, electric underground line, opens, connecting Stockwell and the City. Today, it forms part of the Northern line.

1898 The Waterloo & City Railway opens in central London.

1900s

1900 The Central London Railway, known as the 'Twopenny Tube', opens in central London.

1902 Establishment of the Underground Electric Railways of London (UERL).

1905 The Metropolitan and District lines are electrified. The District line now forms part of the UERL, but the Metropolitan remains independent.

1906–7 The UERL opens the new Bakerloo, Piccadilly and Hampstead Tube lines.

1908 Frank Pick (1878–1941) heads up UERL publicity, and commissions his first Underground poster, *No need to ask a P'liceman!*, depicting passengers using a new Underground map. The period marks the start of co-ordinated marketing across the UERL's railways, through its distinctive lettering and signage, including a nascent form of the roundel symbol.

1908 The UERL produces its first map showing the Underground as one coordinated system.

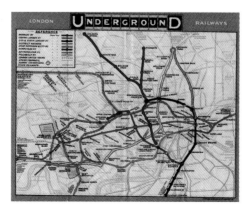

1910s

1912 The capital's main bus operator, London General Omnibus Company (LGOC), is taken over by the UERL. Pick heads up traffic development in the new, enlarged UERL Combine, promoting and co-ordinating the company's bus, tram and Underground services.

1913 The artist MacDonald Gill (1884–1947) is commissioned to produce his first decorative poster map for the UERL.

1914–18 World War I

1915 The Design & Industries Association (DIA) is established, with Pick as a founding member.

1916 The typographer Edward Johnston (1872–1944) completes a new Underground letter face for Frank Pick.

1919 Fred H. Stingemore (1890–1954) joins the UERL's publicity office. He is later appointed as personal draftsman to Frank Pick.

1920s

1920 MacDonald Gill's signature is the first to appear on an Underground map, which is now stripped of all topographical detail.

1924 Harry Beck (1903–74) joins the Underground as a draughtsman.

1924–6 Underground extensions north to Edgware and south to Morden are completed.

1925 Fred H. Stingemore produces his first pocket Underground map. In 1926 he adds the river Thames to aid orientation.

1928 Piccadilly Circus station is redesigned by Charles Holden with an innovative sub-surface booking hall. The new showpiece – the 'hub of the Underground' – displays Stephen Bone's mural map *Piccadilly Circus – Hub of the Empire*.

1928 Pick is now managing director of the UERL.

1929 The UERL's new headquarters open at 55 Broadway over St James's Park station.

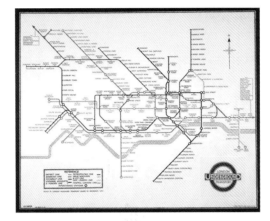

1930s

1931 Harry Beck produces his first design for a diagrammatic Underground map. He presents it to the UERL, but it is rejected.

1932–3 The Piccadilly line's western and northern extensions are completed, with stations built in Charles Holden's distinctive architectural style.

1933 The UERL publishes Harry Beck's diagrammatic Tube map for the first time.

1933 The London Passenger Transport Board (LPTB), soon to be known as London Transport (LT), is created as a single public corporation to run all bus, tram and Underground railway services in London.

1935 Christian Barman (1898–1980) is appointed publicity officer under Pick. He serves in the role until 1941.

1940s

1939–45 World War II

1940 Pick leaves London Transport.

1941 H. T. Carr becomes LT's acting publicity officer, serving in the role until 1947.

1947 Harold F. Hutchison becomes LT's publicity officer until 1966.

1947 The first Sperry route indicator machine is installed at Leicester Square station.

1948 LT is nationalised, along with Britain's four mainline railway companies.

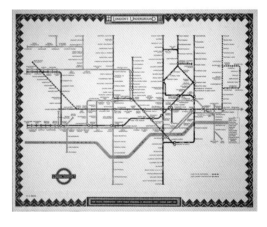

1950s

1950 The First Braille Underground map is produced.

1951 *The Festival of Britain* celebrates national contributions to art, science and technology.

1955 Grid coordinates appear on the Tube map.

1959 Beck produces his last Tube map for LT.

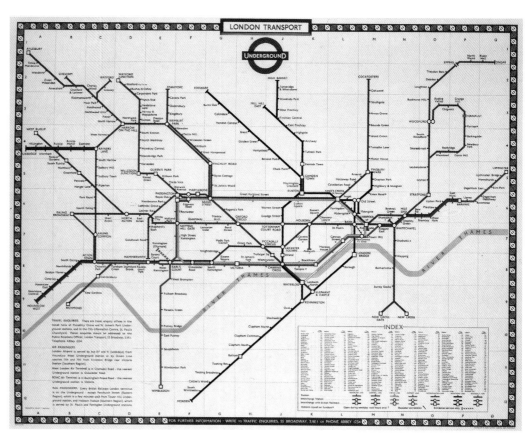

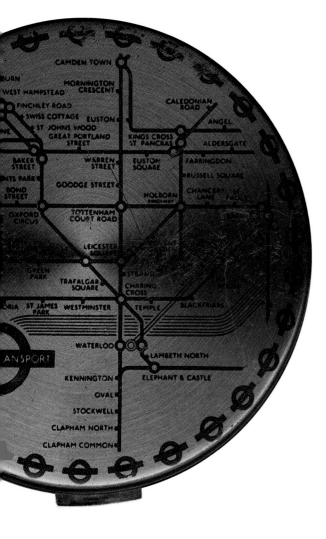

1960s

1960 Harold Hutchison redesigns the Tube map creating a more angular, less popular design.

1964 Paul Garbutt restores the Tube map along Beck's design principles.

1966 Bryce Beaumont becomes LT's publicity officer, serving in the role until 1975.

1968–9 The Victoria line is launched. It is the world's first computer-controlled underground railway, with automatic trains and ticket gates.

1970s

1973 Tim Demuth designs the first combined Tube and mainline railway map for LT.

1975 Michael Levey becomes LT's publicity officer, until 1979.

1977 The Piccadilly line is extended west to Heathrow Airport, and later to the airport's Terminal 4 (1986) and Terminal 5 (2008).

1979 The Jubilee line opens in central London.

1980s

1980 Nick Lewis becomes LT's advertising and publicity officer.

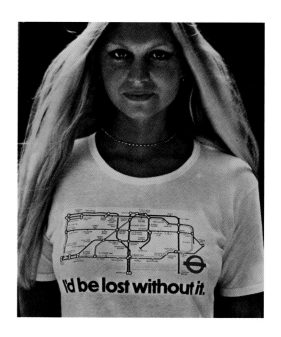

1986 Dr Henry Fitzhugh becomes LT's marketing and development director, serving until 1992. He introduces *Art on the Underground*, a poster-commissioning initiative. The famous poster, *The Tate Gallery by Tube*, is one such commission, designed in 1987 by David Booth of Fine White Line.

1987 The Docklands Light Railway (DLR) opens. It has since more than doubled in length, with a series of extensions.

1990s

1992 The artist Simon Patterson creates *The Great Bear*.

1994 Ken Garland's book, *Mr Beck's Underground Map,* celebrates Harry Beck as the designer of the diagrammatic Tube map.

1999 The Jubilee line extension (JLE) opens between Westminster and Stratford, with dramatic new station architecture and design.

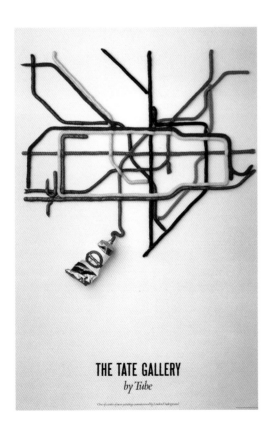

THE TATE GALLERY
by Tube

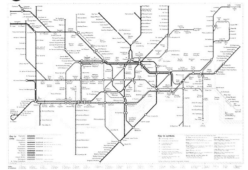

The Great Bear

2000s

2000 Transport for London (TfL) is created. TfL is responsible to the Mayor of London and has a much wider remit than LT had. As well as bus and Tube services, TfL manages the DLR, Tramlink, taxis and private hire (through the Public Carriage Office), river services, cycling, main roads, traffic control and Victoria coach station.

2000 *Platform for Art* is set up as London Underground's official art programme.

2001 TfL adds a credit to Beck on the Tube map which remains in place today: 'This diagram is an evolution of the original design conceived in 1931 by Harry Beck.'

2004 Platform for Art (re-named *Art on the Underground* in 2008) launches a new initiative, commissioning artists to produce work for the covers of pocket Tube maps. The first, by Emma Kay, is entitled *You Are in London*.

2006 Harry Beck's Tube map is voted the second-favourite British design of the twentieth-century in the 'Great British Design Quest', a public poll on the best-loved British design. The winner was Concorde.

2007 London Overground is created as part of TfL to run some suburban railway services.

2009 Royal Mail produces a stamp featuring Beck's map in its British Design Classics series.

2009 The river Thames is removed from the Tube map, but reinstated after a public outcry.

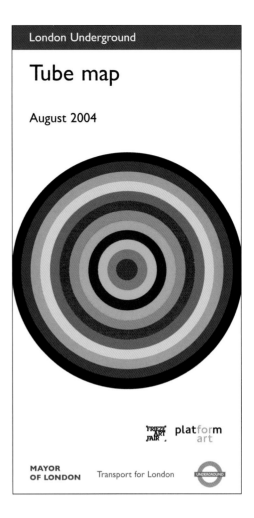

London Underground

Tube map

August 2004

MAYOR OF LONDON Transport for London

2010s

2011 A retrospective of MacDonald Gill's work is held at Brighton University.

2012 The exhibition *Mind the Map* opens at the London Transport Museum.

Underground Film Map

INTRODUCTION

ODAY, THE LONDON UNDERGROUND is such a
fundamental part of daily life in the capital
that it is hard to imagine London without it.
It is also hard to imagine the Underground without
the Underground map. As well as guiding thousands
of passengers every day, its distinctive
diagrammatic design, devised in 1931 by Harry Beck,
has become part of the city's graphic identity.

The world's first underground railway opened in
London on 10 January 1863 (pl. 1). The Metropolitan
Railway, as it was then known, was designed to
transport passengers from London's mainline
stations, Paddington, Euston and King's Cross, to
the capital's business district in the city centre. The
first stretch of the Metropolitan line ran between
Paddington and Farringdon. A second underground
line, the District, opened five years later and was
eventually linked with the Metropolitan to create
the Circle line in 1884.

The early underground was a huge engineering
achievement and an instant success, which
revolutionised public transport in London. Like
traditional overland railways, early underground
services were steam-operated. By contrast, however,
they ran just below ground-level, following the
course of the main streets above. After a shallow
cutting, or trench, had been excavated along the
street, it was covered with a sequence of cast-iron
rings and then lined in brick to create a tunnel, over
which the road surface was relaid. This early 'cut-
and-cover' method minimised property demolition
along the route, but caused chaos on the streets
during construction, and was also very expensive.
A new approach, pioneered by the City & South
London Railway in 1890, involved tunneling deeper,
electric lines some 18 m (60 ft) underground, in
isolation from the course of the street plan above.
The electric-powered trains running through the
new tunnels were quieter, cleaner and more efficient
than the earlier steam locomotives of the first
'cut-and-cover' lines.

The City & South London line marked the start
of the deep-level, electric Tube network that would
provide the key to London's future transport system.
By 1900, two more lines had opened: the Waterloo
& City Railway in 1898, followed two years later by
the Central London Railway, running between
Shepherd's Bush and Bank. The Central London
Railway became popularly known as the 'Twopenny
Tube', alluding to its flat-rate fare and tubular
tunnels. The nickname, first used by the press, was
quickly adopted by the railway itself in its publicity
publications, and soon spread to songs, games, toys
and plays. The term 'Tube' is still widely used for the
network as a whole (pl. 2).

More than a century after its first line opened,
the London Underground has now extended across
the city, reaching its outer limits, from Heathrow in
the southwest to Epping in the northeast, with 11
lines serving 270 stations stretched out along more
than 400 km (s48.5 miles) of track.

Inspiring lines

In the course of its evolution, the London
Underground has generated two separate but
complementary strands in popular mapmaking. It
has inspired the development of navigational maps
as clear, user-friendly guides for travellers, as well as
a new form of map-based publicity. This book draws
on London Transport Museum's rich collection of
more than 4,000 maps to explore the creative and
influential ways in which the early Underground and

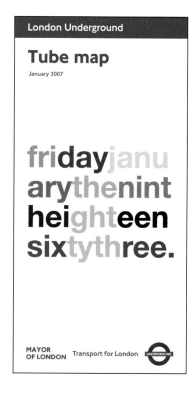

1. *The Day Before (You know what they'll
call it? They'll call it the Tube.)*
Liam Gillick, 2007
150 x 75 mm (9.1 x 5.9 in)
Published by TfL
Commissioned by *Art on the Underground*

On the cover of the January 2007 pocket
Tube map, an eye-catching artwork in the
Underground's distinctive line colours
commemorates the day before the
world's first underground railway
opened in 1863.

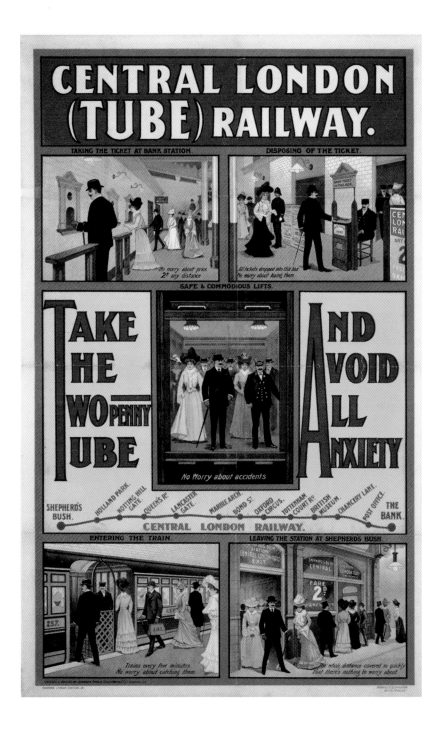

its successors, London Transport (LT) and Transport
for London (TfL), have employed maps both to
publicise and to guide passengers across its new
and expanding network. In both capacities, London's
Underground maps have inspired art, design and
cartography worldwide.

In the late nineteenth century maps were
expensive to produce. The first to include the
capital's new Underground lines were published by,
or on behalf of, the Metropolitan and District
Railways from the mid 1860s (pls 3 and 4). As each
new line opened, it was added to a topographical
base map. The early 'cut-and-cover' method of laying
underground lines beneath existing roads, however,
made it virtually impossible to represent their true
course – hidden beneath the street – on a ground-
level map. The result was invariably an unwieldy
document presenting a mass of street-level detail,
far beyond the specific requirements of an
Underground passenger.

In the 1880s and 1890s, the maps produced for
the Metropolitan Railway were usually printed in
three or fewer colours, and issued as fold-out
supplements to railway publications, such as
timetables. The District Railway line featured on a
more extensive range of maps that accommodated
with each new edition a baffling level of topographic
detail as well as the latest expansion of the network.
Available in either book form or as sheet copies,
the early line maps could be purchased not only as
fold-out maps, but also on rollers, mounted on linen
or varnished. The varying methods of presentation
catered for display in libraries, hotels and offices as
well as for use by engineers, but little about the
maps' production or design suggested any tailoring
to the needs of London's travelling public.

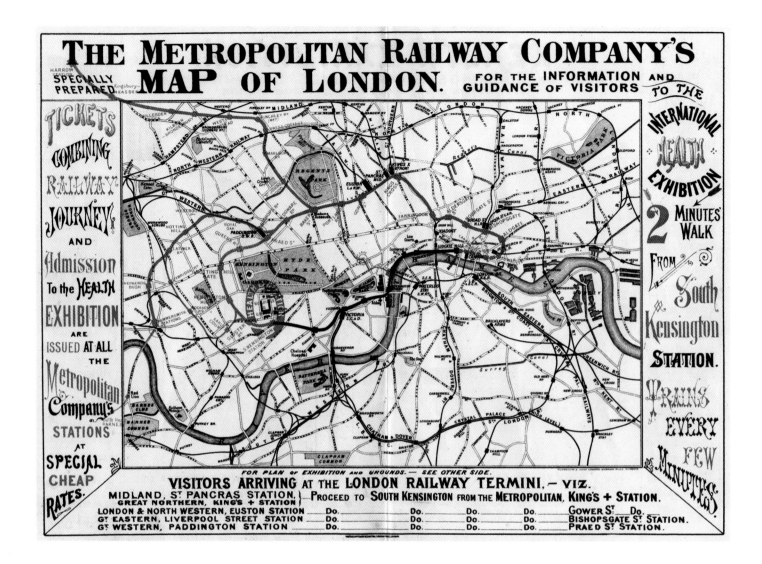

The fold-out maps were, indeed, sold for the modest sum of around a shilling (5p), but still not really with the passenger in mind. Apart from anything else, these early Underground maps were loaded with far too much information to be quickly interpreted or conveniently carried around.

It was not until the beginning of the twentieth century, after the opening of London's first deep-level, electric Tube lines from 1890, that maps became more passenger-focused.

Coordination, navigation and promotion

Most of the lines of the time were operated by the recently formed Underground Electric Railways of London (UERL), which from 1908 took the lead in coordinating the publicity of all the city's underground railways. The new coordinated approach to the UERL's publicity was headed up by Frank Pick from 1908. Pick, who had joined the UERL in 1905 from the Great Eastern Railway, rose to become managing director of the Underground and was later the first chief executive of London Transport, when it formed in 1933. An early and active member of the Design and Industry Association (DIA), Pick believed that good design was good for business. He recognised that transport provided London with more than a means of getting from A to B. Conceptually as well as physically, it transformed the urban landscape, and a new landscape called for a new map.

In 1908 the UERL published the first map to present London's Underground railways as

3. *The Metropolitan Railway Company's Specially Prepared Map of London*
Unknown artist, 1884
294 x 395 mm (11.6 x 15.5 in)
Published by the Metropolitan Railway
Printed by Waterlow & Sons Ltd

A map showing the Metropolitan Railway services available in 1884, it also provides information in the border on fares and tickets, as well as train times for an International Health Exhibition at South Kensington.

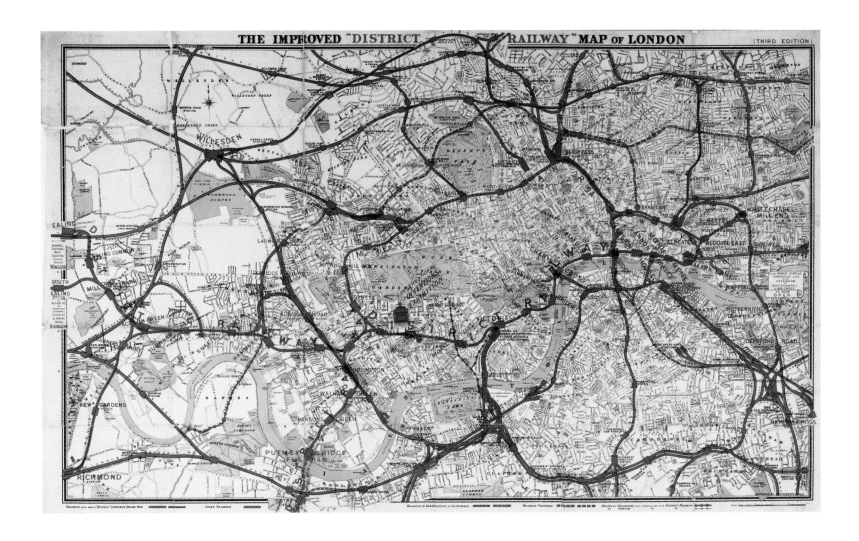

THE IMPROVED "DISTRICT RAILWAY" MAP OF LONDON (THIRD EDITION)

4. *The Improved 'District Railway' Map of London*
Unknown artist, 1884
665 x 1090 mm (26 x 43 in)
Published by W. J. Adams & Sons
Printed by Waterlow & Sons Ltd

The District Railway's 'improved' pocket map highlights the recently completed Circle Line (in red), as well as the extensions east to Whitechapel and south to New Cross.

one coordinated system, with the distinctive 'UNDERGROUND' lettering operating as its trademark (pl. 5). Pick realised that Underground maps should be more about concisely presented routes and services, than accurately documented lines. The first Underground pocket map of 1908 was small and compact, opening rather than unfolding, to make it more readily accessible. It was printed in large numbers and issued free of charge. Like today, the map provided a means of journey-planning outside the station, as well as a handy, reassuring reference en route. The new map design, a variation of which was also printed as a station poster, worked alongside recognisable and increasingly standardised signs and symbols to 'make every way Of the mighty Metropolis plain as the day' (pl. 6).

For a public transport system, however technically advanced, is of no use to passengers if they cannot navigate the network.

As well as making it easier for the public to negotiate the Underground and find their way around London, Pick's revolutionary approach to visual communication involved the innovative use of poster publicity. His campaign of modern graphic posters painted a positive picture of the Underground. The inspired combination of user-friendly network maps and appealing publicity posters created an impression of the Underground as something safe and reliable, whilst also being modern and progressive. The Underground's new image made passengers feel comfortable about engaging with an unfamiliar and alien transport

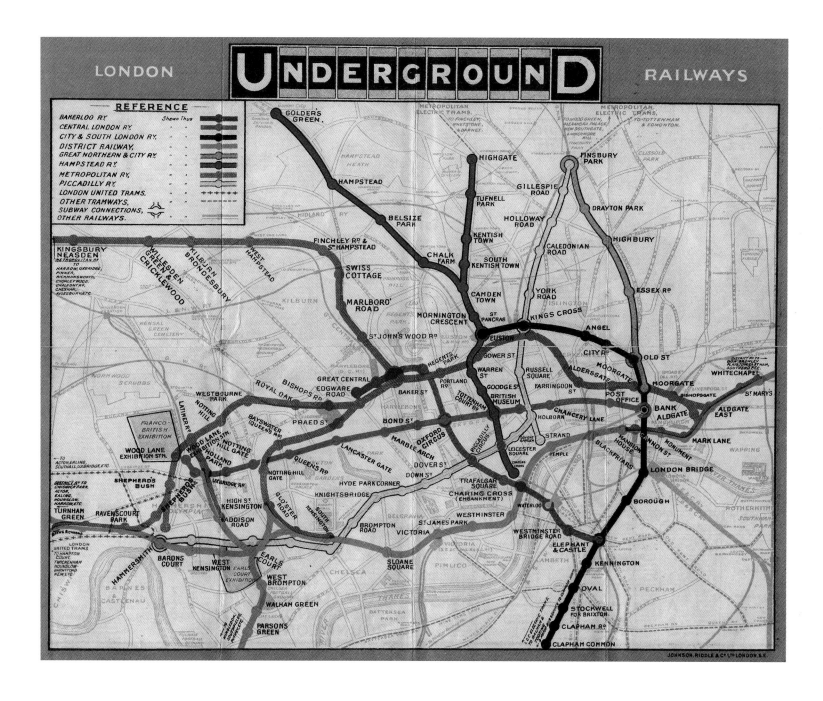

5. *London Underground Railways*
Unknown artist, 1908
203 x 272 mm (8 x 11 in),
Published by the UERL
Printed by Johnson, Riddle & Co Ltd

The UERL's first free pocket Tube map presented London's various Underground railways as one coherent network, branded with the distinctive new 'UNDERGROUND' logotype.

system that might otherwise have seemed complex and threatening.

Chapter One celebrates a pioneering yet lesser-known strand of cartographic history – the Underground's creative use of decorative maps as a form of modern publicity. The prototype, MacDonald Gill's poster, *By Paying Us Your Pennies*, introduced in 1914, publicised the merits and wonder of the Underground. As well as establishing a powerful and popular new poster genre, maps of this kind inspired goodwill by entertaining London's travelling public. They actually worked a little too well, as some Underground passengers apparently became so enthralled by the posters that they missed their trains!

Chapter Two traces the evolution of what is now London Underground's standard navigational network map. The classic diagrammatic design was devised by a young engineering draughtsman,

Henry C. Beck, in his spare time. He took it speculatively to the UERL's publicity department in 1931, but it initially met with little enthusiasm. When it was finally printed in 1933, however, it was an instant success with the travelling public. Beck's design is now rightly seen as a radical breakthrough in communication graphics, or what we today would call 'information design'. As well as celebrating Beck's innovative approach, Chapter Two follows the history of the map's design pre- and post-1933, examining how London Underground's complex and ever-expanding network of lines has been successfully transposed on to a convenient and coherent pocket-sized map.

Chapter Three explores the now iconic status and enduring inspiration of Beck's design. In addition to serving as a model for transport mapping worldwide, London's Tube map has been a popular reference point for artists, designers and advertising agencies. It has also captured the public imagination and even inspired academic theory. From T-shirts and tourist trinkets to award-winning posters and contemporary art, the broad range of material culture to have borrowed Beck's design reflects the place that London's Underground map has earned, not just in design history, but in popular visual culture and in the hearts and minds of passengers.

6. *An Alphabet of T.O.T* (detail)
Charles Pears, 1915
Published by the UERL
Printed by Johnson, Riddle & Co Ltd

The letter 'M' from an illustrated alphabet, sold as a poster and book. Proceeds went to T.O.T. (Train, Omnibus, Tram), a charity for the families of transport workers serving in World War I (1914–18).

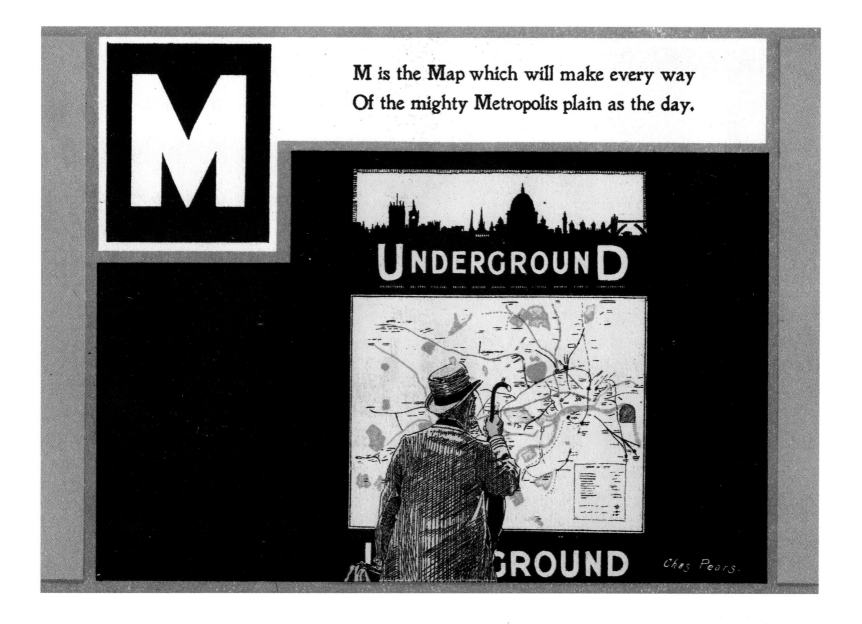

M is the Map which will make every way
Of the mighty Metropolis plain as the day.

UNDERGROUND

GROUND

Chas Pears.

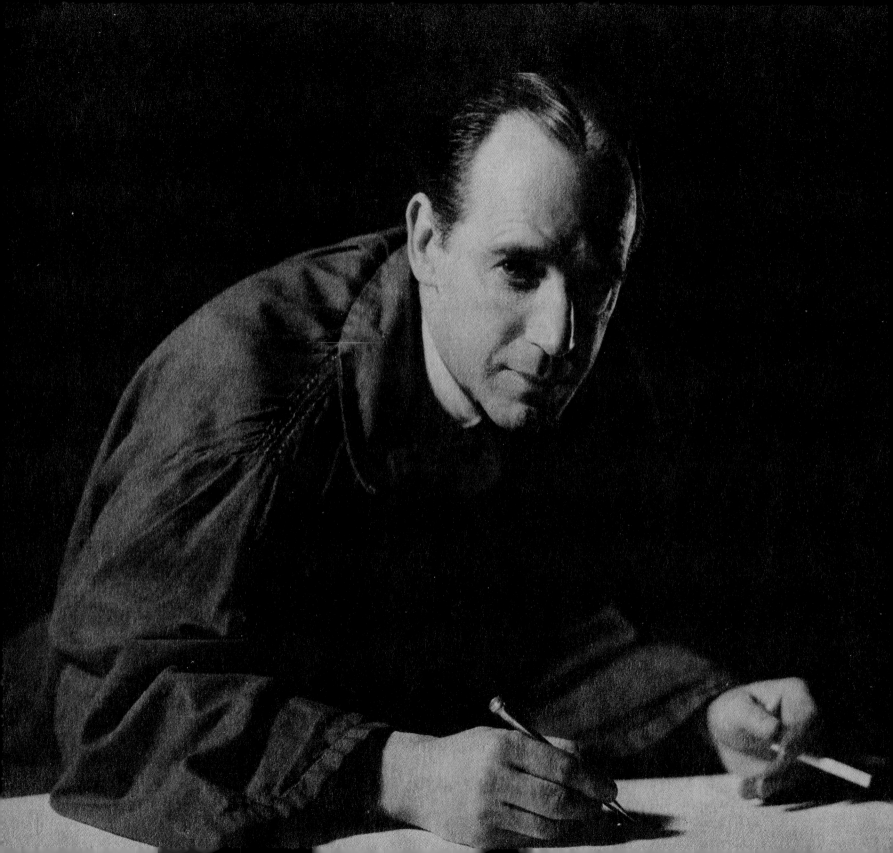

THE 'WONDERGROUND'

MAX GILL AND THE DECORATIVE MAP

*... the easiest way for the Board to build up goodwill
and to impress itself upon the public is
to resort to a series of maps.*[1]
(Frank Pick, 1933)

MAPS ARE ONE OF THE OLDEST FORMS of visual communication. With their distinctive bird's eye viewpoint, they can reveal much about a place, its geography, history and identity, in a simple and immediate way. Although no one knows the exact moment when the first map appeared, maps of one kind or another have evolved around the world for more than 3,000 years. From the city plans of ancient Mesopotamia to the coastal charts of early sailors, from the decorative maps of the Middle Ages to the scientific surveys of the modern world, maps have developed at different times for different needs. Some, like street plans and sea charts, serve essentially navigational roles, guiding people around a busy city or rocky coast. Others, like the richly illustrated Medieval *mappaemundi* (world maps) and Renaissance maps of the New World, often include symbolic, historical or mythical elements, from fantastical creatures to the idyllic Garden of Eden.

A 'cartographic masterpiece'

In the early twentieth century, the Underground Electric Railways of London (UERL) was quick to recognise the potential of mapmaking beyond its basic role of navigation. Decorative maps would play a prominent part in a new type of publicity poster, the first of which made its debut on Underground platforms in 1914. Designed by MacDonald Gill, *By Paying Us Your Pennies* was a 'cartographic masterpiece', laying stylistic foundations for a distinctive new genre of poster, and opening the eyes of advertisers to the power of maps in promotion and publicity (pls 2–3).

1. MacDonald (Max) Gill in his studio
Photographed by Howard Coster, 1930

Max at his drawing board at the peak of his creative career.

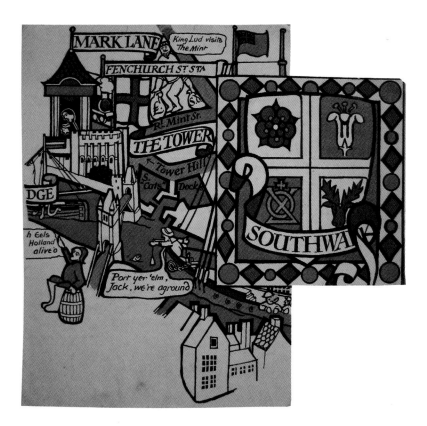

2. Artwork for *By Paying Us Your Pennies*
MacDonald Gill, 1914
190 x 190 mm (7.5 x 7.5 in)

A preliminary colour proof showing a section of Gill's proposed decorative poster map of London (pl.3).

MacDonald Gill – Max to all who knew him – was one of the most versatile and prolific artists of his time (pl.1). The simple brass plaque on his studio door, inscribed 'MacDonald Gill, Architect', revealed little more than the modesty of the man on the other side. He was also a painter, type designer, poster artist and cartographer. Despite Gill's versatility and output, few references to his work appear in the written histories of art and design, although examples can be found in public buildings and museum collections throughout the country, such as his ceiling frieze of 1934 at the Polar Museum in Cambridge, or his magnificent North Atlantic map mural of 1936, painted for the decorative scheme of the transatlantic ocean liner RMS *Queen Mary*.

Gill's work was commissioned almost exclusively commercially, which may in part account for his relative obscurity, although his creations were no less original or influential because of it. Practical, creative and hardworking, Gill applied himself to his art with what he called 'sincerity of purpose'. His many masterpieces may have served the specific requirements of businessmen, the Church,

government agencies and private individuals, but their art was his own.

In 1914, the poster *By Paying Us Your Pennies* presented to London's travelling public Gill's eclectic knowledge, passion for maps, engaging humour and phenomenal skill as a designer (pls 2–3). The poster was primarily intended to promote Underground travel for pleasure. It was part of Frank Pick's 'soft-sell' approach to building up passenger numbers on under-used, off-peak services. Designers usually featured one London leisure attraction per poster, but in *By Paying Us Your Pennies* Gill portrays the excitement and wonder of an entire city made gloriously accessible to all by the Underground.

Far from conforming to the typically idealised imagery of contemporary travel posters, Gill's map confronts viewers with some startling sights. At Hyde Park, for instance, a life-like, anthropomorphised river Serpentine snakes its way towards a public hanging from the Tyburn Tree by Marble Arch. At London Zoo in Regent's Park, an oversized griffin-type creature gobbles up a child who politely protests, 'I promised mother I would be

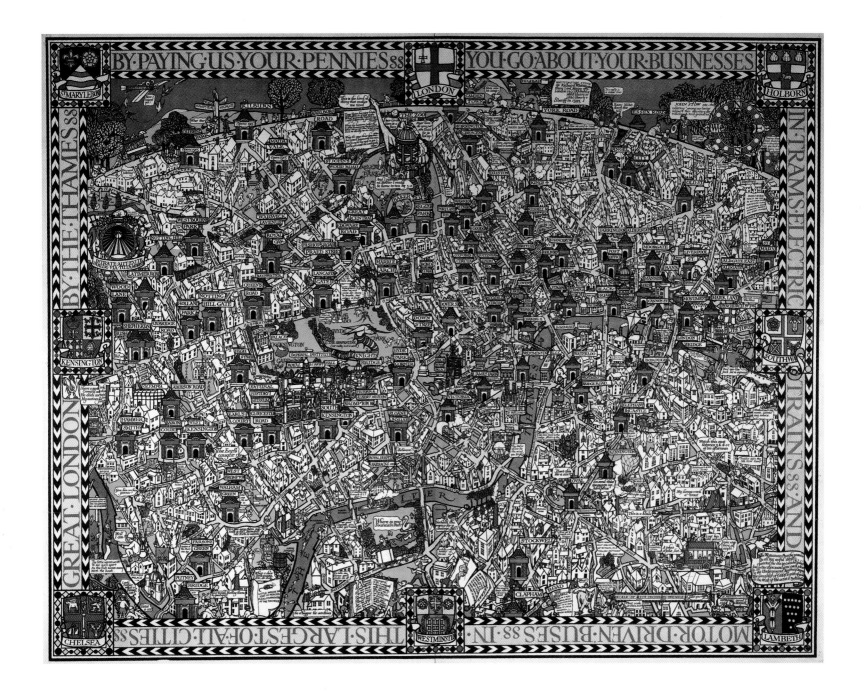

ABOVE AND OVERLEAF:

3. By Paying Us Your Pennies
MacDonald Gill, 1914
Quad royal, 1016 x 1270 mm (40 x 50 in)
Published by the UERL
Printed by the Westminster Press

The first of its kind, Gill's decorative
poster map, promoting the wonder of
travel on the Underground, soon became
popularly known as *The Wonderground
Map of London Town*.

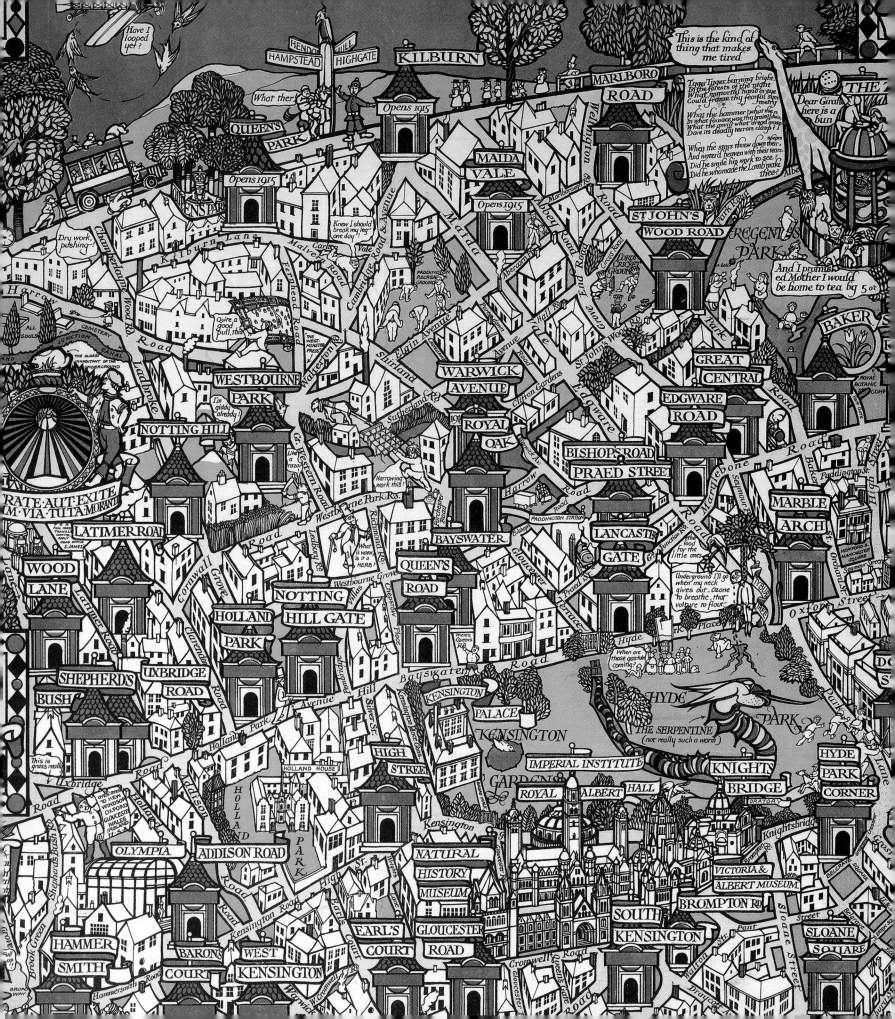

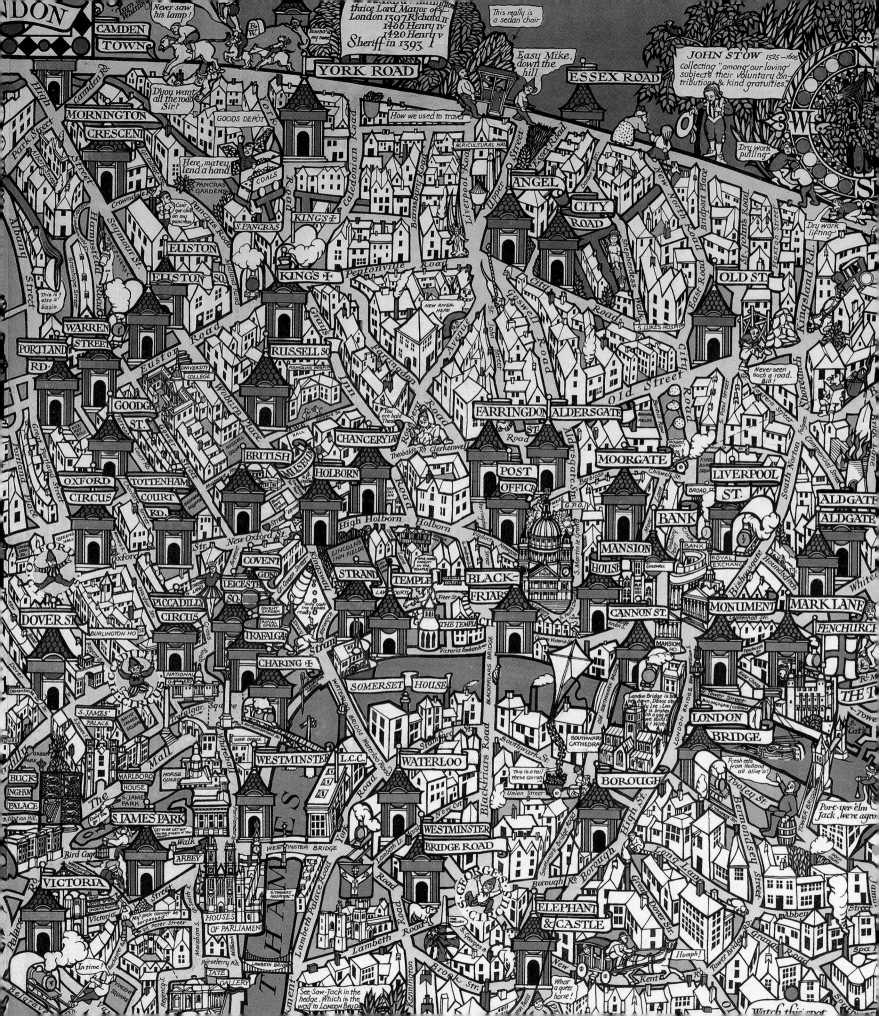

home for tea.' A rather smug-looking tiger appears to have escaped to some tall grass behind St John's Wood station, where he is seen to be reciting 'The Tyger' by the nineteenth-century poet William Blake.

In an article for *The Studio* art magazine in 1944, Gill spoke of the freedom he was permitted by the UERL for this kind of creativity: 'The series of posters I designed for the Underground Railway Company showed the facilities offered for travel by their service. Naturally historical references were many, and full licence was allowed for humour and play upon etymology and topical illusions.'[2]

Packed with historical facts, literary references and whimsical quips, Gill's maps provided an endless source of entertainment. Once the striking size and colour of the poster had turned heads on the platform, there was something in the detail for everyone.

The 'latest thing in maps'

Original, skilful and 'fit for purpose', Gill's design instantly met with Pick's approval. The two young men shared a complementary work ethic and design philosophy and the same brimming ambition for the careers before them (pls 4–5). Gill had been greatly influenced by the Arts and Crafts movement, at its height during his training as an architect; and he was keen to bring some of their ideals, such as traditional craftsmanship, into the twentieth century. Like Pick, he believed in the social importance of integrating high quality art and design with everyday modern life. For Pick, whose quest for moral and civic harmony was that of a businessman and commissioner, this meant promoting the integration of art with industry, commerce and education. For Gill it was more about the practical and appropriate application of traditional mapmaking techniques and materials to his work in a way that conformed to the modern requirements of contemporary design.[3] 'Medieval Modernism' is a recent term that has been used to describe Pick's design values. It also provides an apt description of Gill's new breed of poster map, with its innovative balance of old and new mapmaking styles.[4] Strictly-speaking, the poster's inscribed border, heraldic imagery and coats of arms, its encyclopaedic detail and allegorical interpretation

4. **Macdonald (Max) Gill**
Photographer unknown, *c.*1914

Max Gill in his early thirties at the outset of his creative collaboration with Frank Pick at the London Underground (pl.5).

5. **Frank Pick**
Unknown photographer, *c.*1913

Pick, the creative force behind the Underground's modern publicity campaign, had just been appointed Commercial Manager in 1913.

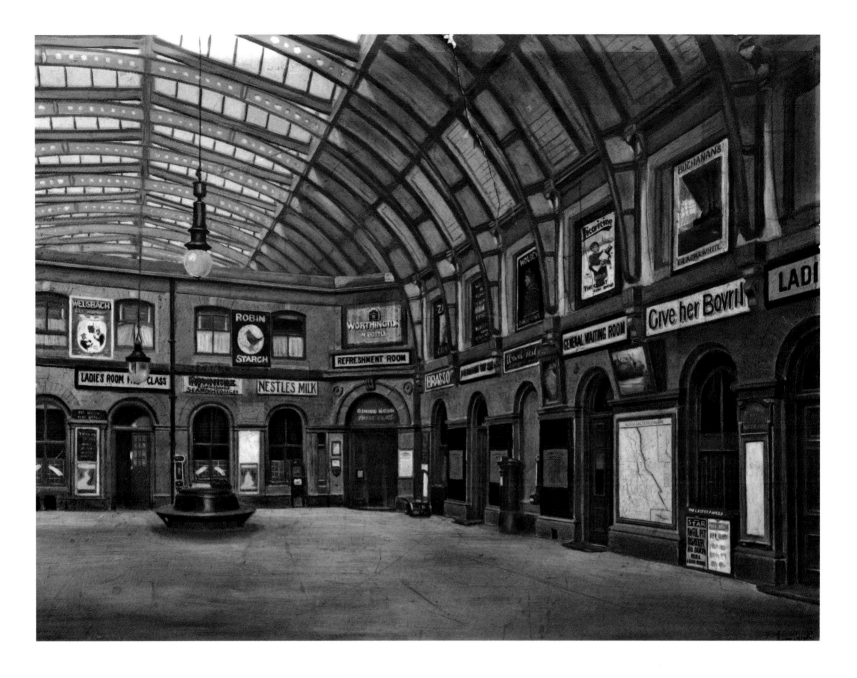

6. *York Station*
Bertram Curry, 1913

A view of the concourse at York station. Displayed on the right-hand wall is one of the new large-format, tiled maps commissioned by the North Eastern Railway as both a guide for passengers and promotion for the network.

are all features of Early Modern, or Renaissance, rather than Medieval, mapmaking, although the sentiment of the concept applies.

A contemporary cartographic development, of which Gill, Pick and London's travelling public would have been aware, was a series of 23 large tiled maps, commissioned by the North Eastern Railway and installed at stations across the network including London (pl. 6). The first, displayed at King's Cross station, was authorised in 1900 and the remaining maps were in place by 1910. The impressive large-

scale maps, manufactured by Craven, Dunnill & Co Ltd, were not decorative in the sense of Gill's modern poster designs, but they were certainly intended as decoration, and to serve as much for promotion as for navigation.

In *By Paying Us Your Pennies*, Gill drew on both past and contemporary cartographic imagery to form the template for his novel form of publicity. A *Daily Sketch* article, printed the week before Gill's map was posted in 1914, drew immediate attention to its modernity, describing it as 'the latest thing in

maps' and praising its combination of 'the quaint humour of the nursery-rhyme books with the queer cubes and colours of Futurist art'.[5]

The use of speech bubbles was also a notably modern phenomenon at the time. Cartoon strips had only become a regular feature in newspapers within the previous 20 years and the comic book had become part of mass popular culture even more recently, during the past decade.[6] The dialogue between characters allowed Gill to comment on and engage with contemporary society in a fittingly modern and immediate way. The map's factual and fictitious snippets ranged dramatically from the biographical and the literary, to the comical and absurd, as we shall see.

By Paying Us Your Pennies was actually jointly commissioned by Pick and Gerard Meynell, head of the Westminster Press, who printed the map. Gill pays tribute to both men in his design. The reference to Pick, a markedly modest man, is relatively inconspicuous; it comes in the form of a humble workman digging the road outside the Underground's headquarters. With his back turned, he mutters, 'My pick cannot be surpassed'. Meynell's presence is far more overt. Perched on top of the Westminster Press building, next to Westbourne Park station, he proudly examines the finished map while commenting, 'Quite a good pull, this'.

The wording around the outside gives the map its overarching context: 'By paying us your pennies, you go about your businesses, in trams, electric trains and motor driven buses, in this largest of all cities, Great London by the Thames.' It also provided the work's original title, *By Paying Us Your Pennies*, although the poster soon more fittingly became known as *The Wonderground Map of London Town*. Although Pick's presence is barely distinguishable, references to public transport are plentiful, contemporary and notably accurate. The red-and-blue, roundel-bearing Underground stations, although decidedly Medieval-looking in structure, are distinctly more grand than their mainline counterparts. In 1914 mainline trains were still steam-operated and even the electrification of the Underground railways, completed by 1905, remained relatively recent (see p. 12). When Gill arrived in

London in 1903, he would have experienced the Underground's former steam operation. It was described disparagingly in a contemporary editorial in *The Times* of 1884, complaining that 'a journey from King's Cross to Baker Street is a form of mild torture which no person would undergo if he could conveniently help it'. By representing mainline stations with their steam trains emerging from smoky tunnels in colours that pale by comparison to their Underground counterparts, Gill draws attention to the contrasting excitement and modernity of travelling by Underground.

In 1913 the Underground expanded, taking over London General Omnibus Company (LGOC), which afforded new opportunities for promoting more services. The extended routes out to the country also offered poster artists an appealing new raft of leisure activities to motivate weekend day-trippers. Again, on his *Wonderground* map, Gill did not conform to the common, idealised view of bus travel. In the top left corner is an accurate depiction of a contemporary B-type motorbus. Detracting from its modernity somewhat are the facts that it is being

7. Cover of *The Wonderground Map of London Town*
MacDonald Gill, 1914
753 x 943 mm (open) (29.5 x 37 in)
Published and printed by the Westminster Press

Produced especially for sale, this small, foldout version of Gill's original poster, *By Paying Us Your Pennies*, became a popular decoration in private homes, schools and nurseries.

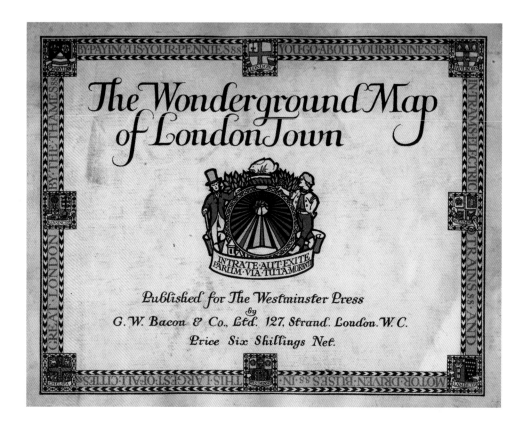

pushed, and also appears to have knocked someone down. The steep incline, up which the bus needs a helping hand, is created by Gill's use of a curved horizon, mimicking a Medieval depiction of an enclosed globe or walled city on a map. The horizon cuts London off at Queen's Park and Kilburn stations in northwest London. Both were scheduled to open the following year, which not insignificantly implies some correlation between the expansion of London and its Underground railways. On both sides of the map, town criers allude to areas beyond the border, including 'Kew, Windsor, Oxford, Gloucester, Wales, Ireland and the USA' to the west, and 'Victoria Park, Wanstead Flats, N. Ockendon, Chelmsford, Harwich, Russia … and other villages' to the east.

A Londoner's London

Gill's *Wonderground* map is full of topical references, allegorical tales and local pride. Like the recent map-based work of the artist Stephen Walter (chapter 3, pl. 28), Gill's *Wonderground* has also been fittingly described as 'an insider tourist map'. It is the map of a Londoner's London, reflecting the creator's personal engagement, in-depth knowledge and first-hand experience of the city.

Although he was born in Brighton, Sussex, in southeast England, and spent most of his childhood in nearby Chichester, Gill started his professional life in London. If it was not always his home, it was always at the heart of his work. Even after returning to Chichester in the 1920s, Gill kept his studio in central London. The address, 1 Hare Court, the Temple, was the subject of many verbal and pictorial witticisms within his maps. A hare in the top left-hand corner of *Wonderground* claims to be 'the oldest inhabitant of the underground', whilst a man clutching a hare on top of Gill's studio (just right of the centre) remarks, 'One hare caught in the Temple'.

The characters in Gill's map to which the contemporary public would have warmed most readily are those of the working and middle classes. It was this section of society for whom public transport was provided and duly advertised. Contemporary publicity presented the Underground as classless, which, in terms of its carriage

categorisation and flat-rate fares, it certainly was. Slogans, such as 'The way for all', were common on Underground posters of the time. The upper classes in Gill's map are presented as foolish, antiquated buffoons. One such top-hatted fellow (northwest of Hyde Park) idly wonders, 'What's work, is it a vegetable?', as he watches a man pushing a harrow up Harrow Road, muttering, 'Harrowing work this'.

The *Wonderground* map is littered with literary references, which provided a readymade means of engagement with London's travelling public. Nursery rhymes, many already intrinsically loaded with historical significance and suppressed social concerns, operate on multiple levels in Gill's maps.

A more contemporary literary reference is the quotation from Algeron Blackwood's *A Prisoner in Fairyland*, a popular children's book published in 1913, which appears at the bottom of the map to the left of the river Thames: 'Little mouse that lost in wonder flicks its whiskers at the thunder.' Another directly contemporary reference, although this time not from literature, can be seen in the top left-hand corner. It is an upside-down aeroplane, whose pilot asks some passing birds, 'Have I looped yet?' The question alluded to the world's first upside-down flight, or 'loop the loop', which took place on 25 September 1913 at Brooklands Airfield in Surrey. Fifty thousand spectators gathered to watch the latest daring test of the modern flying machine. The pilot was Frenchman M. Pegoud, a skilled aviator testing the capabilities of the early aeroplane. The first Englishman to perform the stunt soon after, on November 24 1913, was 21-year-old George Lee Temple who died tragically in a flying accident two months later.[7] The plane did not appear in Gill's original sketches, suggesting that he added it later in response to public interest in the event.

It took Gill seven months to complete his *Wonderground* map. In his diary of Monday 9 March 1914, he wrote: 'Worked on last section of the London map all day – doing colouring till 3am Tuesday – until I completed it. (Began August 1913).' Three weeks later, his design had been printed and posted at Underground stations throughout London. It was clearly an instant success with the public, which was reflected in contemporary newspaper

previews. A piece in the *Evening Standard* described the poster as 'one of the most striking efforts in the way of pictorial burlesque ever attempted'.[8] Even though an article in *The Times* suggested that some might find Gill's wit 'somewhat primitive', it went on to concede that 'the total effect of the poster is quite striking'. The *Daily Sketch* followed up on their preview of Gill's map by printing a detail of the top right-hand corner with a caption claiming: 'People spend, sometimes, twenty minutes examining it, so entertainingly does it parody the names and characteristics of the different districts of the metropolis ... People watch so long they lose their trains – and yet go on smiling.'[9]

So many requests were made for copies of Gill's map that a smaller version was printed in 1914, especially for sale. It was this version that first included the title *The Wonderground Map of London Town* on the front cover (pl. 7). The wording that had originally run around the border was changed to: 'The heart of Britain's Empire, here is spread out for your view. It shows you many stations & 'bus routes not a few. You have not the time to admire it all? Why not take a map home to pin on your wall!'

Theatre-land by night

Less than a year later, in 1915, Gill was commissioned to produce a new poster map for the Underground. His diary entry for 27 January read, 'Called on Pick (of Underground Co) ... at 5:30: wanted to draw another map – this time of theatre-land ! Jolly job.'

Gill's new map, *Theatre-land*, depicted the West End at night, picked out by rows of black buildings with light shining from their windows (pl. 8). London's theatres are shown with their names in banners, while the nearest Underground station is displayed in roundel symbols around the border. In the bottom right-hand corner, the scene lifts like a stage curtain to reveal Gerard Meynell attempting to conduct an unruly orchestra.

Again Gill populates the map with factual and fictitious characters from both past and present. Autobiographical details include an image in the top right-hand corner of Max and his wife, Muriel, who were married that year. He pays another punning reference to his 'Hare Court' studio, as well as presenting many more pictorial witticisms of the same ilk, such as hay being sold at Haymarket near Piccadilly station in central London.

Topical references include someone tied to the railway tracks and about to be hit by a train at Charing Cross (just right of Nelson's column). The first damsel to suffer this distress onscreen was Pauline Marvin, who popularised the now hackneyed cliff-hanger in *The Perils of Pauline*, a movie serial of the previous year. Similar scenarios had been played out on the stage as early as 1887 in Augustin Daly's melodrama, *Under the Gaslight*, and in Dion Boucicault's *After Dark: A Drama of London Life* of the following year. Unlike the hapless heroine of *The Perils of Pauline*, however, Gill's character rather gallantly says, 'I hope they don't feel the jolt!'

The new masterpiece took nine months to complete. When it was printed and displayed in the winter of 1915, World War I (1914–18) was underway. Although barely detectable in Gill's *Theatre-land*, an allusion to wartime London is made by the soldiers standing in ranks outside St George's Barracks, behind the National Gallery (just left of Nelson's column), where a new recruit is also being measured up for a uniform. A small but more overt reference to the war, and the rather laissez-faire attitude at the

BELOW AND OVERLEAF:

8. *Theatre-land*
MacDonald Gill, 1915
Quad royal, 1016 x 1270 mm (40 x 50 in)
Published by the UERL
Printed by the Westminster Press

With a sparkling panorama of lamp-lit streets and
historic theatres (shown as green-domed arcades),
Gill's second decorative map for the Underground
encouraged travel to London's West End.

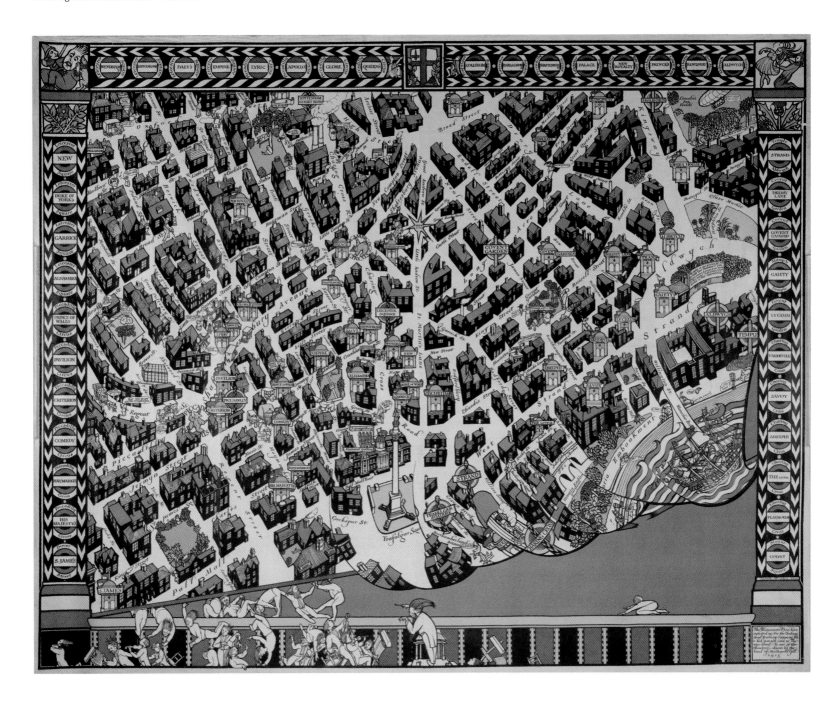

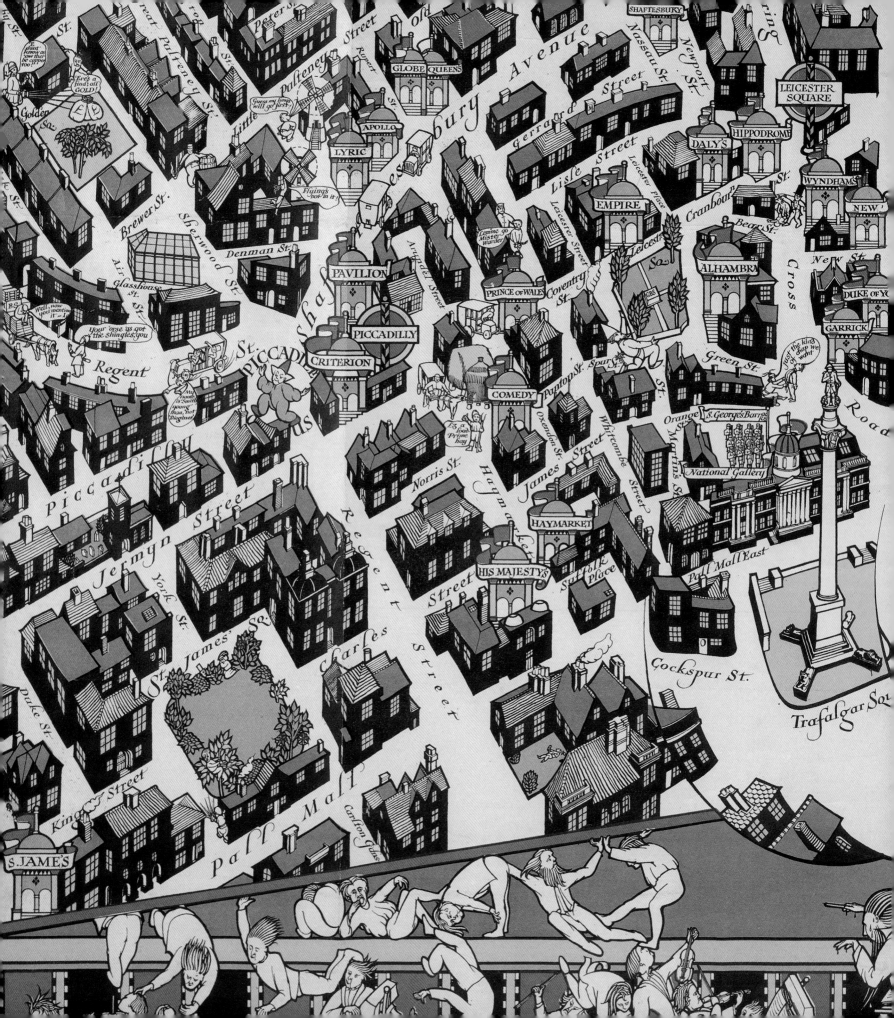

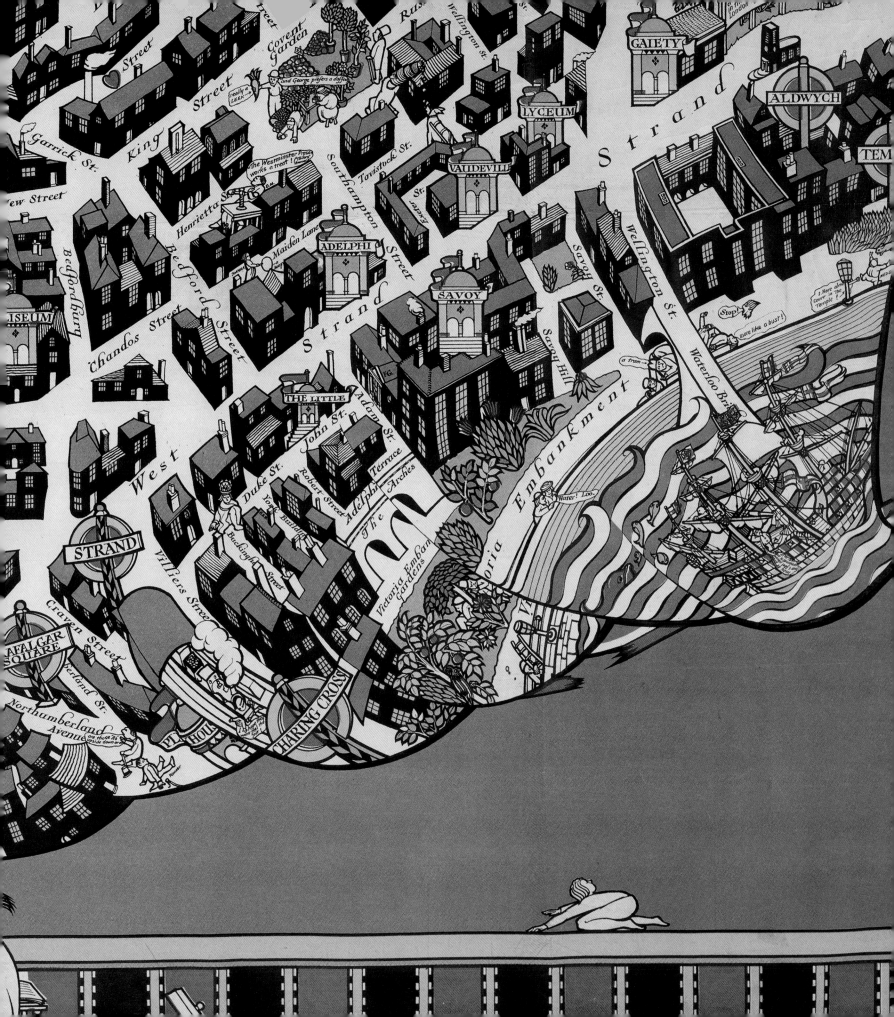

9. *You've only got to choose your bus …*

MacDonald Gill, 1920

Quad royal, 1016 x 1270 mm (40 x 50 in)

Published by the UERL

Printed by Waterlow & Sons Ltd

A decorative poster map promoting London's bus services paints an idyllic picture of England's countryside, with quaint village houses clustering around parish spires, children at play on green heaths and picnickers enjoying the fresh air.

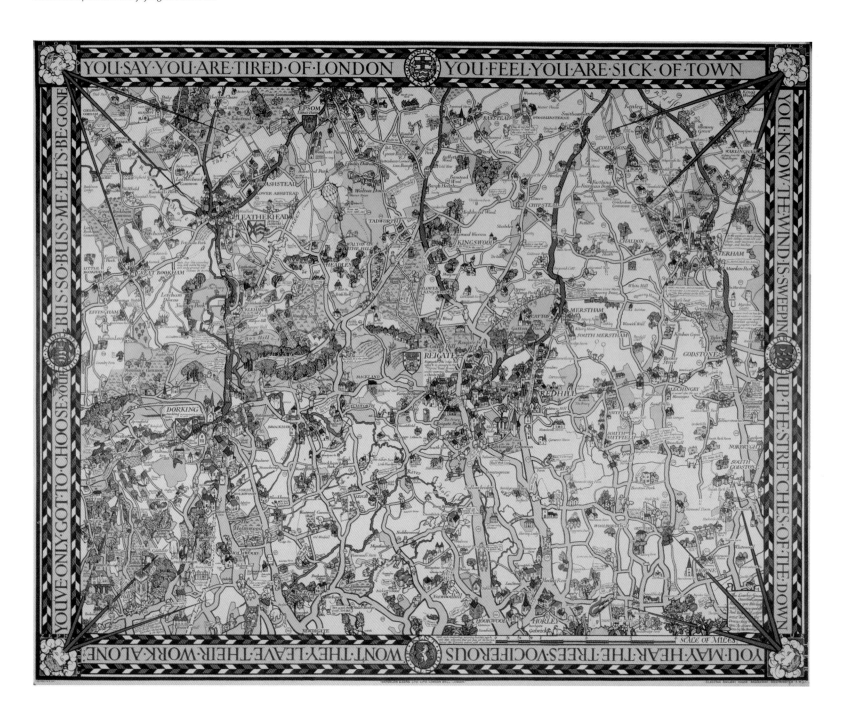

time to its consequence, is the Zeppelin airship flying into Lincoln's Inn Fields in the City of London (in the top right-hand corner). Zeppelin bombing missions had captured the public's imagination, especially those targeting London. As such, Gill approached the subject with the same light-hearted sense of fun in which he had illustrated the 'loop the loop' in his *Wonderground* map.

An addition to the final poster, which was not in Gill's original artwork, is the speech bubble from the airship pilot who asks, 'What about the censor?' The pilot's question might have been added in response to an increased sense of threat brought about by the very 'real bombs' that had dropped on 'Theatre-land' just days before Gill completed his design, one hitting the Lyceum Theatre in Wellington Street and killing 17 people. With hindsight, the inclusion of a Zeppelin bomber might seem inappropriate, as indeed might posters promoting travel for pleasure generally, but Gill's design quite poignantly reflects contemporary attitudes. Remarkably, leisure travel in the capital was only actively discouraged from 1917. From this point onwards, the Underground's publicity office used posters to tackle the day-to-day realities of wartime London.

Gill stopped work on a number of Underground commissions in 1917 and, like many artists, turned his creative attention to the war effort. He was selected to design an inscriptional font and some regimental badge patterns for the Imperial War Graves Commission. The lettering was used to record the names of the British and Empire dead and missing from World War I (1914–18) and World War II (1939–45). It is still carved today on the head-stones of fallen servicemen, and commemorates the names of over 1.7 million soldiers in 150 countries worldwide.[10]

In stark contrast to the comic style of his poster maps, his design for the commission was testament to his skill and versatility as an artist.

'You've only got to choose your bus ...'

In 1920, while working on his first pocket map of the Underground network (see chapter 2), Gill also produced a new decorative poster map for the UERL, this time promoting bus travel, *You've only got to choose your bus ...* (pl. 9). Newspapers were full of articles celebrating the welcome return of Gill's distinctive brand of entertainment to the Underground's hoardings, sparking a resurgence of interest in his work. Under the headline, 'Romance from a Bus-Top', the *Daily News* asked, 'What Londoner could resist the call to these tracts of fairyland and little Towns of nursery rhyme?'[11]

A cartoon published in *Punch* that year depicts a man doing a cartwheel in order to read the text that runs around the map, like that of Gill's bus poster (pl. 10): 'You say you are tired of London, you feel you are sick of town, you know the wind is sweeping up the stretches of the down, you may hear the trees vociferous, won't they leave their work alone, you've only got to choose your bus so buss me let's be gone.' The caption at the bottom of the cartoon reads, 'When people do posters I wish they wouldn't make the wording go all round like this.' Gill appears to have obliged – on the rest of his maps for the Underground, the text only runs along the top and bottom and is shown the right way up. This move would have been intended as a witty retort, rather than as bowing to criticism, since the cartoon would undoubtedly have been seen as a good-humoured jibe by both Gill and a *Punch*-reading public. In fact, the cartoon actually corroborates the distinct

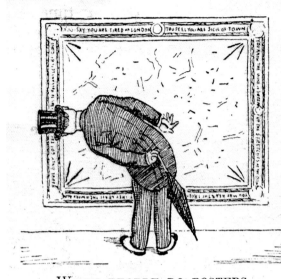

WHEN PEOPLE DO POSTERS—

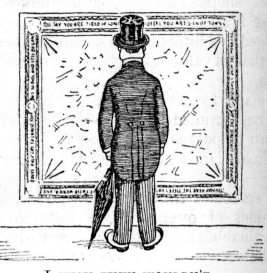

I WISH THEY WOULDN'T—

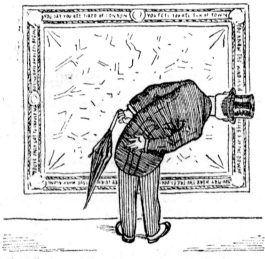

MAKE THE WORDING—

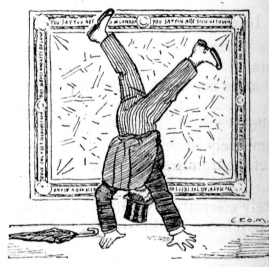

GO ALL ROUND LIKE THIS.

10. Untitled cartoon
Artist unknown, 1920
Published in *Punch*, 1920

In a topical cartoon of 26 May 1920, a reader tries a cartwheel to catch every last word of the text running around Gill's new poster, *You've only got to choose your bus ...* (pl. 9).

stylistic character of his maps, which would have had to have been easily recognisable to a wide public for the joke to have resonance.

The Wonderground trail

The *Wonderground* map had become so popular by the early 1920s that several smaller editions were printed with updated content. In one later edition, for instance, a greyhound has been added to the top left-hand corner, with an arrow beside the words, 'On to Wembley'. The Stadium at Wembley in northwest London did not open until 1923, and greyhound racing was not introduced until 1927, suggesting that variations were still being made to the *Wonderground* map more than ten years after the original had been produced. In 1922, the UERL also commissioned Gill to produce another full-size poster, *In the Heat of the Summer*, which reproduced the central area of London in the same style as his *Wonderground* map, but with a new border (pl. 11).

Gill's maps appealed to a broad audience. His *Peter-Pan Map of Kensington Gardens* of 1923, inspired by Sir George Frampton's bronze sculpture *Peter Pan* (1912), was aimed more specifically at children (pl. 12).

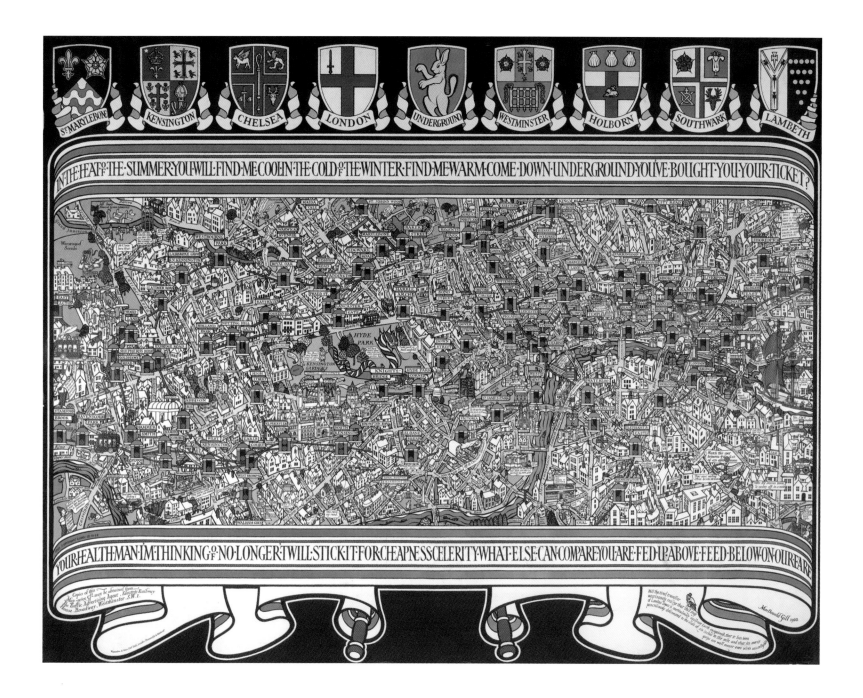

11. *In the Heat of the Summer*
MacDonald Gill, 1922
Quad royal, 1016 x 1270mm (40 x 50 in)
Published by the UERL
Printed by Waterlow & Sons Ltd

Gill's lively poster of central London
highlights the delights of the capital in
the 'heat of the summer', with trees in
leaf, kites in flight and bright-sailed boats
drifting lazily down the river Thames.

A newspaper article reviewing the map after it was posted in 1923 states that it 'will doubtless, as in the case of the preceding map, be greatly sought after by schools and children's nurseries.' [12]

Within its annual poster programme, the UERL intentionally commissioned designs that would appeal to children, or more specifically, to their parents. It was part of Pick's quest to establish goodwill. One such poster, *The Panorama of London*, was designed by a group of artists in 1925 working under the direction of the design agency R. P. Gossop Ltd, which had been set up in 1923 by Reginald Percy Gossop, a direct contemporary of Gill (pl.13).

The large quad royal format poster, measuring 1016 mm x 1270 mm (40 x 50 in), was designed to be cut up and made into a panorama. It comprised 16 backdrops with some elements left blank for colouring in. The backdrops were all scenes associated with typical London leisure activities, taken from past Underground posters, including a reproduction of Gill's *Wonderground* map as the final backdrop. It is accompanied by a cast of characters rather bizarrely related to the theme of Father Time.

Gossop's first Underground commission came comparatively late in his career, although it did prove to be the first of many. At the start of his career, Gossop had been appointed the first art editor for the British edition of *Vogue* in 1913. In the 1920s and 1930s, he produced design work for varied businesses and organisations (including the department store Heal's, the stationer W. H. Smith, the confectioner Cadbury and the Empire Marketing Board). From 1916, Gossop worked for the Ministry of Information until the end of World War I, when he became a joint manager at Carlton Studio. In his book, *Advertisement Design*, published in 1927,

Gossop observed: 'Recent years have seen a development in the decorative map, which has been so much appreciated that we find it used for home decoration. The maps of MacDonald Gill for the Underground are perhaps the best known and most widely circulated.' [13]

The first Gill-style map to be produced by another hand was a poster designed by Edward Bawden and Thomas Derrick for the British Empire Exhibition in 1924 (pl.14). Pick entrusted the main map design to the more experienced Derrick, leaving only the illustration to the untried Bawden, who was still a student at the Royal College of Art in London and for whom this was his first paid commission. Bawden went on to become one of Britain's most celebrated illustrators and, between 1924 and 1952, designed 14 posters for the UERL and its successor, London Transport (LT).

By the mid 1920s the contemporary press was beginning to focus on the collectable nature of Gill's former work, as much as on the genius of his latest creations. In papers ranging from the *Financial Times* to *The Referee* (which primarily dealt with sports news), speculation was even made as to their value. In 1923 it was claimed that an original print run copy of the *Wonderground* map had sold for ten guineas, the equivalent of well over £1000 today. [14] The figure had risen to 15 in 1928, a year in which the map's iconic status was further amplified by its inclusion in at least two exhibitions. [15] One, organised by the UERL to celebrate 20 years of poster design, was held at Burlington House in London. Another exhibition, show-casing work by the Society of Poster Designers, of which Gill had been a founder member since 1926, was staged at the Municipal Art Gallery in Bootle near Liverpool. A review of the

12. *Peter-Pan Map of Kensington Gardens*
MacDonald Gill, 1923
Quad royal, 1016 x 1270 mm (40 x 50 in)
Published by the UERL
Printed by Dobson, Molle & Co

A popular decorative poster map themed around the
adventures of the mercurial Peter Pan, a character
developed by the playwright and novelist J.M. Barrie
in his celebrated classic, *Peter Pan* (1904).

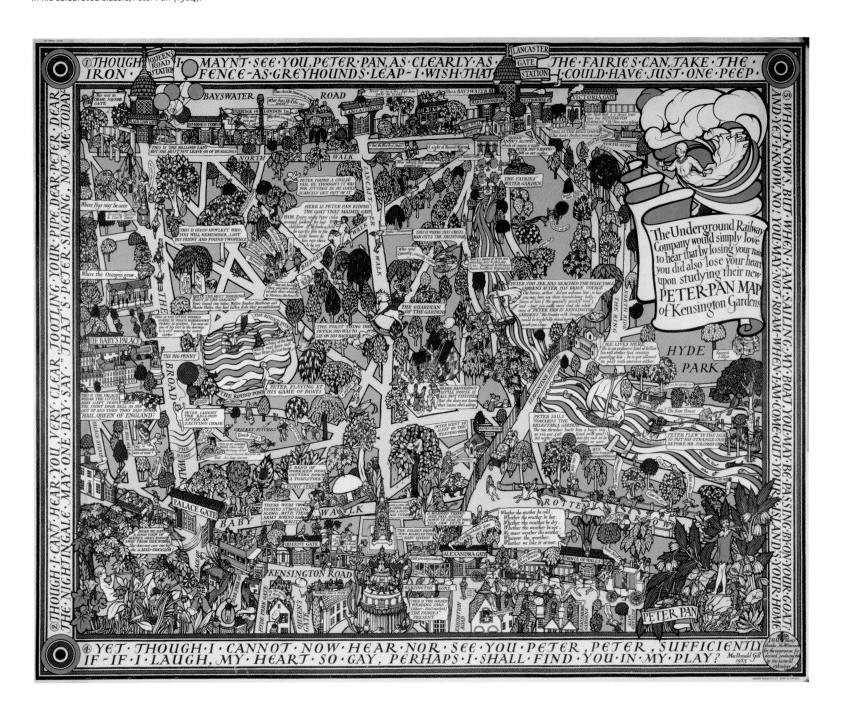

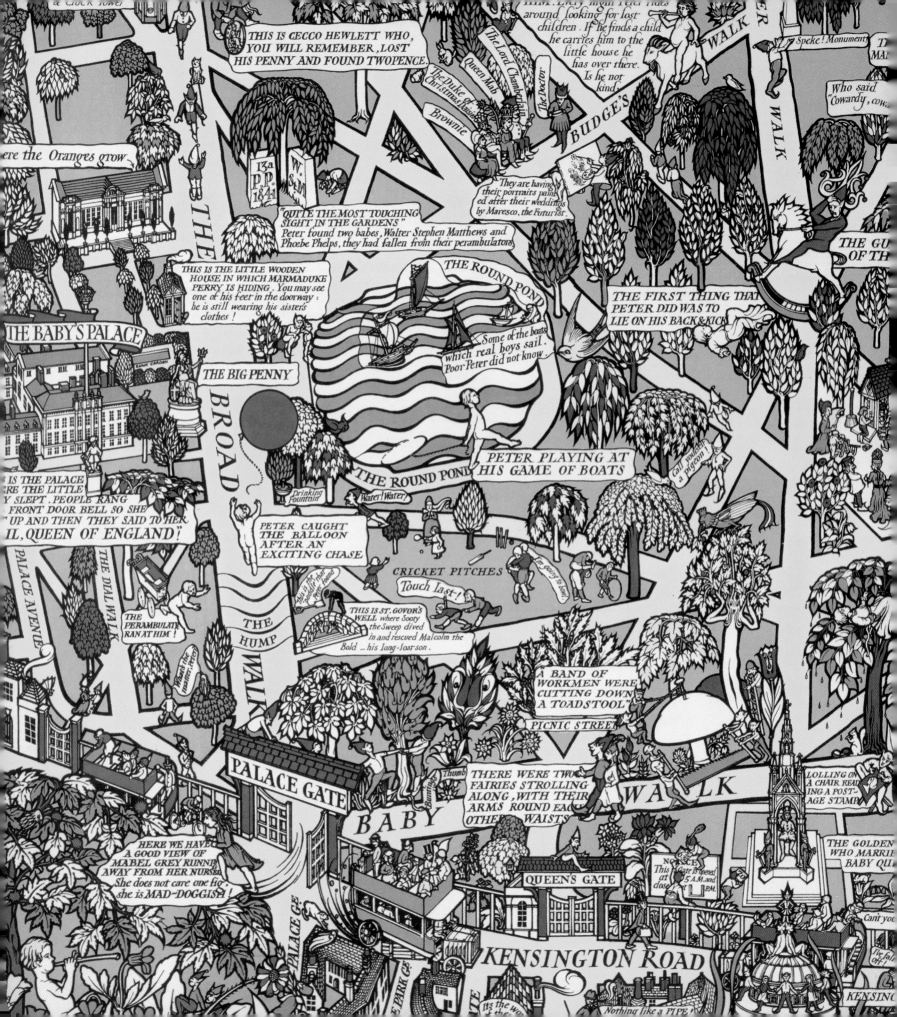

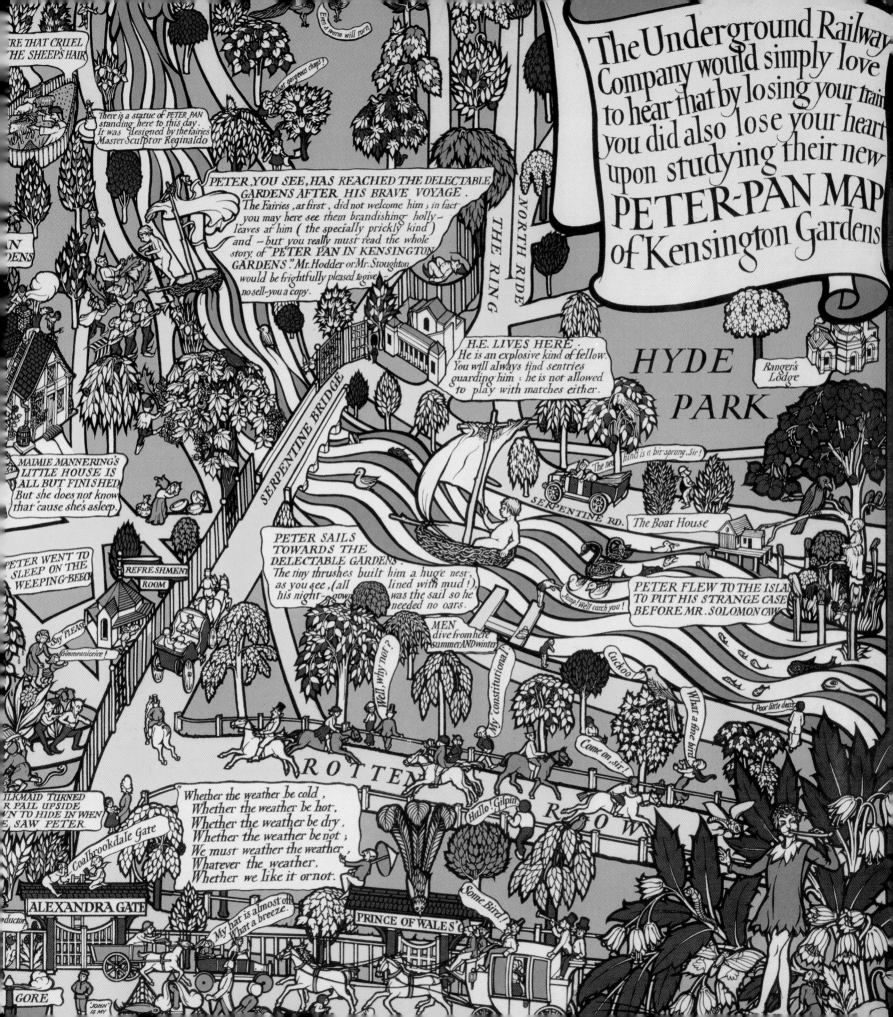

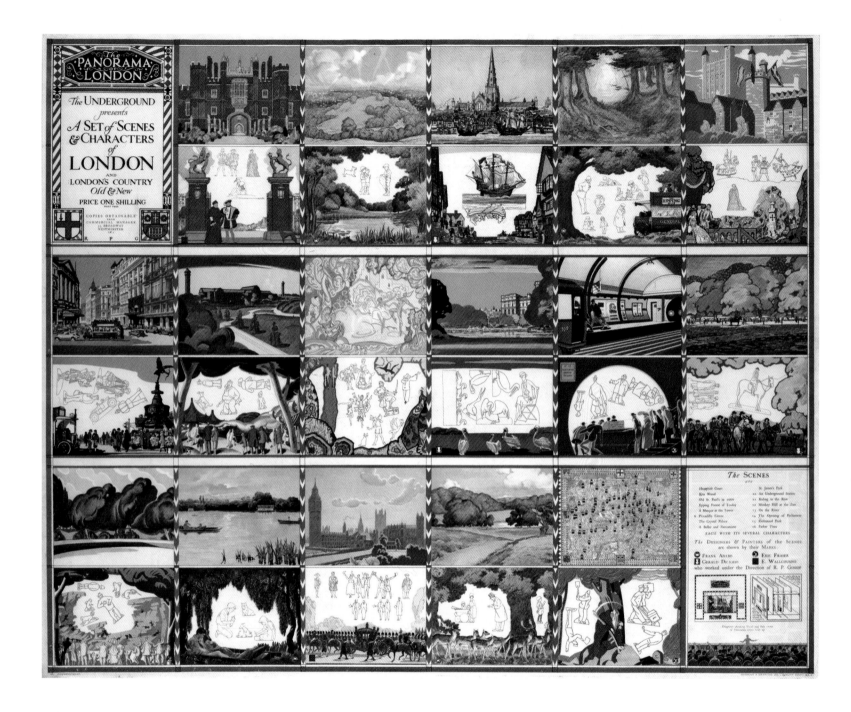

13. *The Panorama of London*
Frank Adams, Gerald Dickson, Eric George Fraser,
Reginald Percy Gossop and Ernest Wallcousins, 1925
Quad royal, 1016 x 1270 mm (40 x 50 in)
Published by the UERL
Printed by Hammond & Griffiths Ltd

Designed to be cut up and
assembled as a toy panorama, this
poster comprises a set of 16 scenes
of London with some elements left
blank for colouring in.

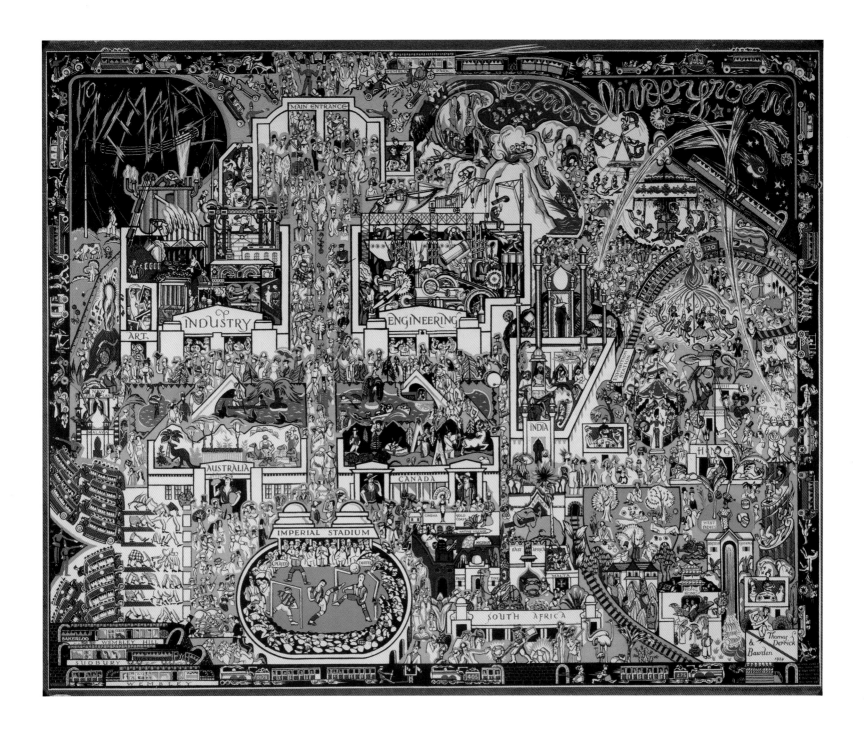

ABOVE AND OVERLEAF:

14. *The British Empire Exhibition*
Edward Bawden and Thomas Derrick, 1924
Quad royal, 1016 x 1270mm (40 x 50 in)
Published by the UERL
Printed by Eyre & Spottiswoode

A bird's eye view of the dazzling displays at the British Empire Exhibition of 1924 encourages passengers to explore the maze of alluring activities and exhibits.

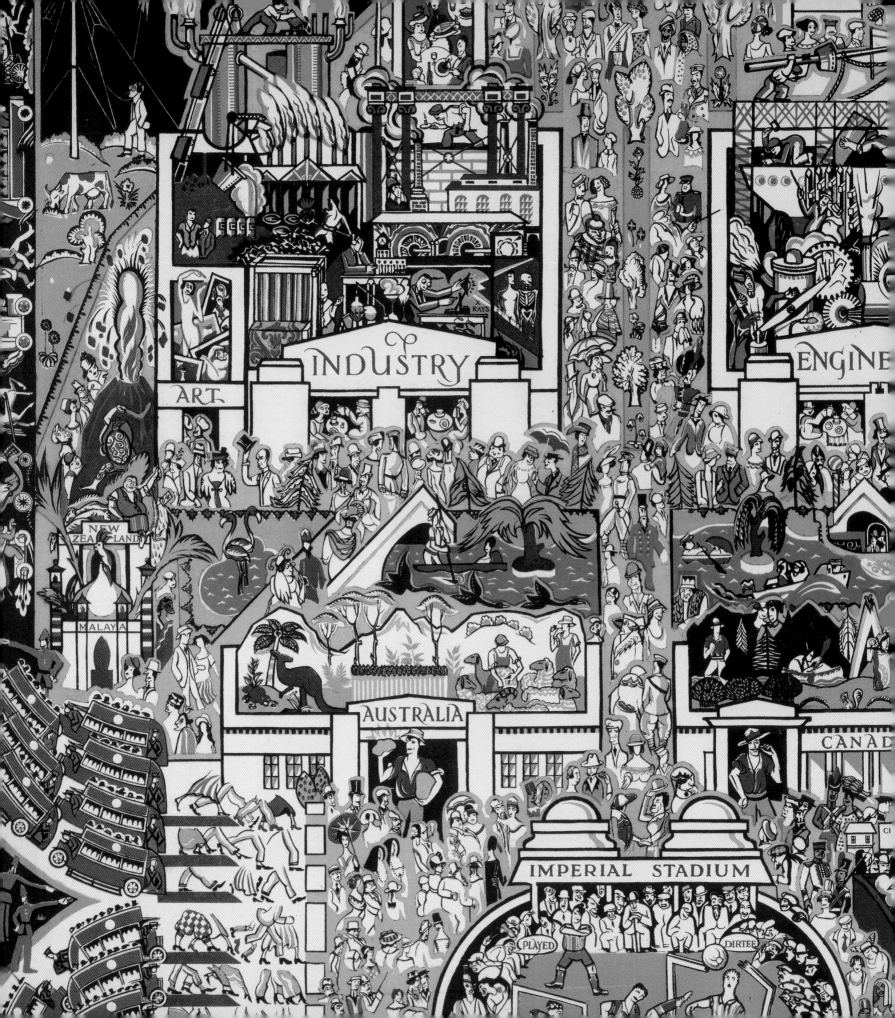

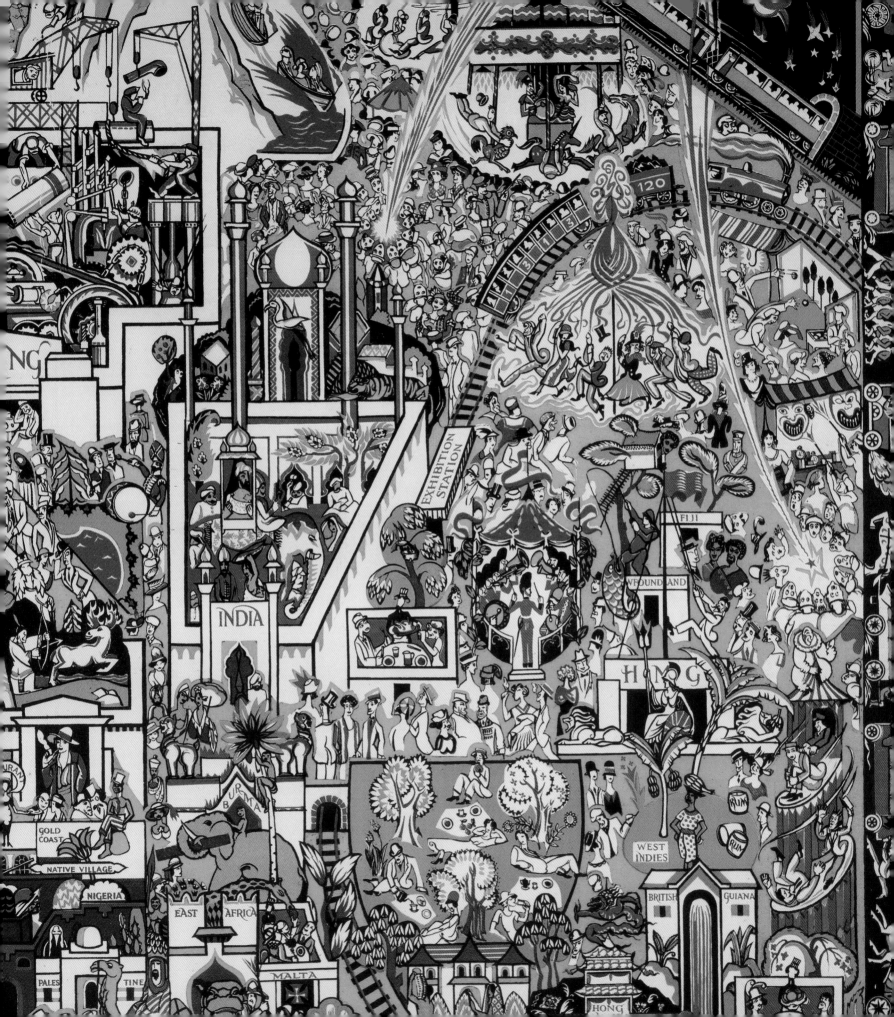

exhibition, entitled *Art in Advertising*, singled out Gill's posters as among the most 'arresting', 'famous' and 'familiar' in the show. [16]

London's green and pleasant suburbs

Gill put everything into his work, his time, skill, passion and a wealth of life experience. Although in many ways a Peter Pan character himself, for whom age certainly never curbed his impish sense of fun, Gill's *The Country Bus Services Map* of 1928 reflects a very different period in his life (pl. 15).

In 1926 he moved to West Whittering in Chichester with his wife and their three children. Their house was a monument to Gill's creativity and versatility as an artist. It was built to his design, full of his own decorative elements and included a studio where many new commercial works unfolded. The home it provided was a happy one filled with laughter, music, games and practical jokes. Gill was an active member of the community. As well as painting the ceiling and designing the furniture for St Bartholomew's church, which the family attended every Sunday, he designed tiling for Hays Court where his youngest daughter Ann went to school.

Although work made huge demands on his time, Gill remained ardently passionate about it, something that made an impression on his children. They took a keen interest in their father's designs from a young age, knowing that his studio door was always open and that his desire to include them in the creative process extended, on occasion, to their actually featuring in a map. Finding themselves in the newly completed artwork became a game. [17]

In the bottom right-hand corner of *The Country Bus Services Map*, a family are playing cricket. Tiny initials on the figures identify Max as the bowler, his

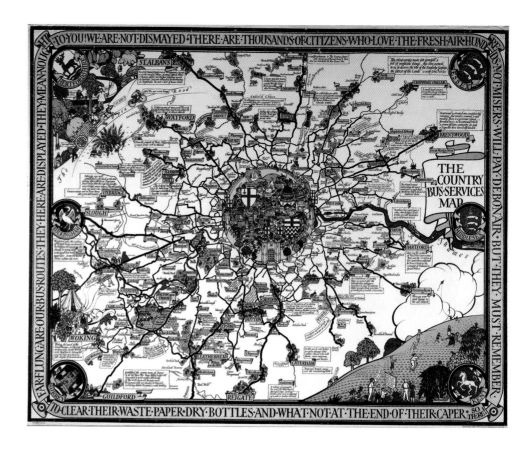

mother in bat, his son John behind the wicket, his daughters Mary and Ann fielding, with his brothers Eric and Evan watching. Gill would make time to join the family on such an occasion, something that his daughter Mary recalls:

> We all played cricket on the beach, quite a lot of us, as children, and Max used to come and join us. One time he came, I saw him in the distance, and I couldn't think why he looked so different. When he got closer I suddenly realised why, he'd got pads, cushions from the sofa, tied round his legs! To come and play cricket with us on the beach – we thought that was terribly funny. [18]

ABOVE AND RIGHT

15. *The Country Bus Services Map*
MacDonald Gill, 1928
Quad royal, 1016 x 1270 mm (40 x 50 in)
Published by the UERL
Printed by Waterlow & Sons Ltd

Less dense than his city maps, but still richly decorative, Gill's country bus map promotes an idealised lifestyle in leafy suburbs beyond the city. On the green field at bottom right Gill and his family play cricket.

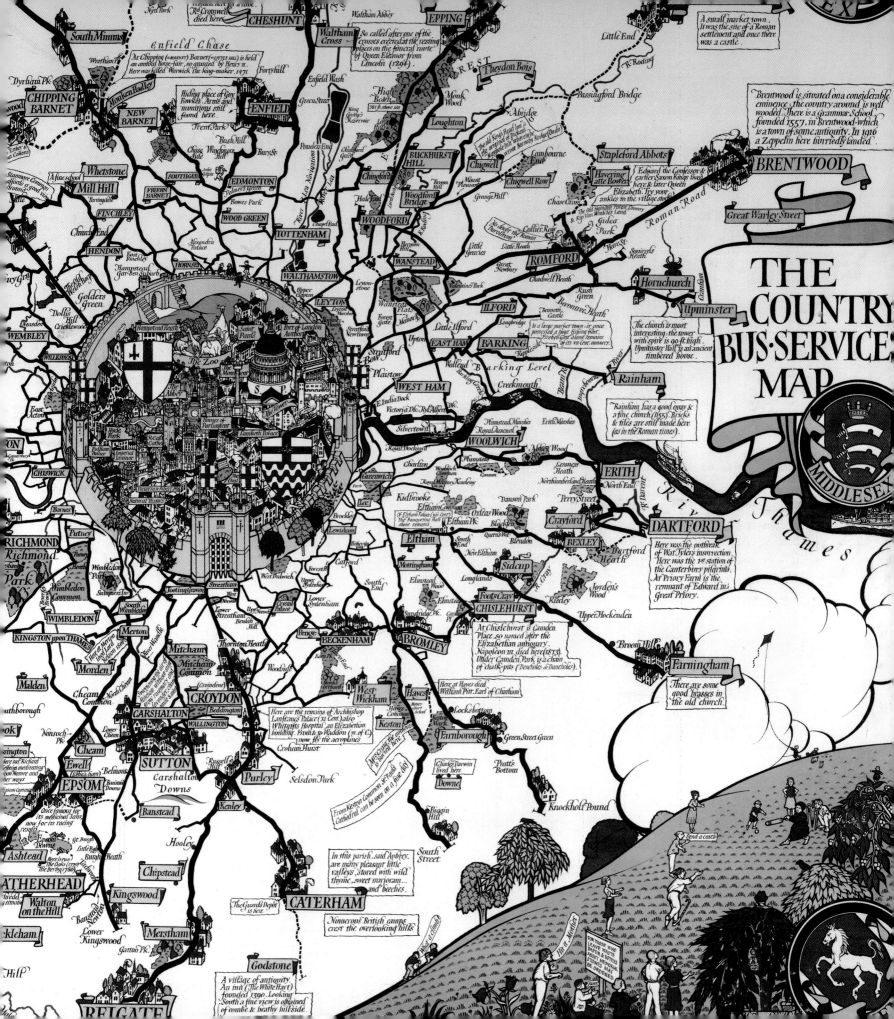

16. *Pipers Green: Edgware*
John Dixon, 1928
Double royal, 1016 x 635mm (40 x 25 in)
Published by the UERL
Printed by John Waddington Ltd

Far from the bustle of the city, the northwest
London suburb of Edgware is pictured as a
'fayre and pleasant' pastoral retreat, where
residents joyfully till the fields, dance, punt,
play and hunt in bygone fashion.

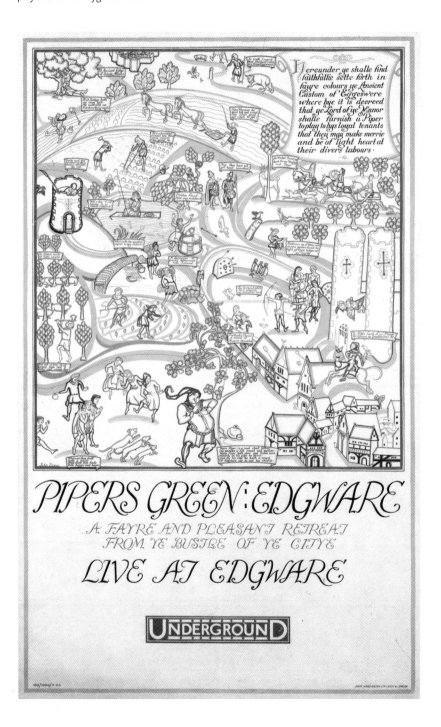

Gill's *The Country Bus Services Map* chimed
fortuitously with contemporary imagery used in
Underground posters promoting life in London's
suburbs. A contented family group, green open
spaces, hearty outdoor pursuits and even public
transport links, between domestic bliss in the
country and a job in the city, were a reality for Gill
who regularly returned to his London studio to
work, albeit from further afield in Chichester.

The Underground played an active role in creating
London's suburbia, both as a practical reality and as
an aspirational ideal. As well as the modernity and
convenience of new transport links, posters focused
heavily on the leisure and lifestyle that such semi-
rural areas permitted. Decorative maps became a
popular medium for promoting new suburbs as day-
trip destinations and desirable places to live. The
promotional use of decorative poster maps helped
construct a sense of identity for London's new Tube
suburbs, in particular. The Northern line extended to
the northwest suburb of Edgware in 1924, and *Pipers
Green: Edgware*, designed by John Dixon, was one of
many posters promoting the commuter community
that sprang up around the new station (pl. 16).

Like Gill, Dixon looked to the past for inspiration.
Reference to transport, work and entertainment,
which had become customary in such posters, all
reside in an age long since passed. Unlike Gill's
stylistic 'Medieval Modernism' (see p.22), there is
nothing modern about Dixon's 'Medievalism'. The
inhabitants of his 'fayre and pleasant retreat from
ye bustle of ye cityе' travelled on horseback,
farmed the land and danced to the Edgware Piper.
In fabricating this entirely fanciful bygone era,
Dixon disguises the rapid erosion of the area's
once rural character.

17. *Morden*
Herry Perry, 1929
Double royal, 1016 x 635mm (40 x 25 in)
Published by the UERL
Printed by Vincent Brooks, Day & Son Ltd

In a poster promoting suburban life in
Morden, the treed landscape is peppered
with a motley mix of dog-walkers and day-
trippers, historic sites and inviting taverns.

The illustrator Herry Perry designed over 50
posters for the Underground between 1927 and 1937.
Although many of her designs featured maps, the
series she produced in 1929 for the Greater London
suburbs of South Harrow, Hounslow, Morden, Kew
and Edgware were the closest in style to that of Gill
(pl. 17). A motley mix of kings and queens, city types
and country folk, dog-walkers and day-trippers drew
public attention to the many activities permitted by
the green open spaces of the semi-rural suburbs. The
landscape is peppered with fascinating facts about
the area and points of local interest, such as notable
church architecture, nice views and an abundance of
public houses. In her *Morden* of 1929, the mandatory
Tube station is pushed up into the top right corner,
shifting some of the more noteworthy sights of the
southeast into view. As well as dutifully performing
suburban leisure pursuits, such as golf, rambling
and horse riding, the characters populating Perry's
Morden seem more intent on pointing out the 'way
to the races', than the way to the Underground. She
reiterated their beckoning with the rhyming couplet:
'On Epsom Downs when racing does begin. Large
companies from every part come in.'

Perry enjoyed a play on words and had a passion
for comic verse, which she regularly submitted to
Punch. Her inclusion of an epitaph from a grave in
Cheltenham brought local history and humour to
her map in a manor akin to Gill's adaptation of
nursery rhymes. The unnamed gravestone, dated
1701, read:

> HERE lie I and my three daughters,
> All from drinking the Cheltenham waters;
> While if we had kept to the Epsom salts,
> We should not be now in these here vaults.

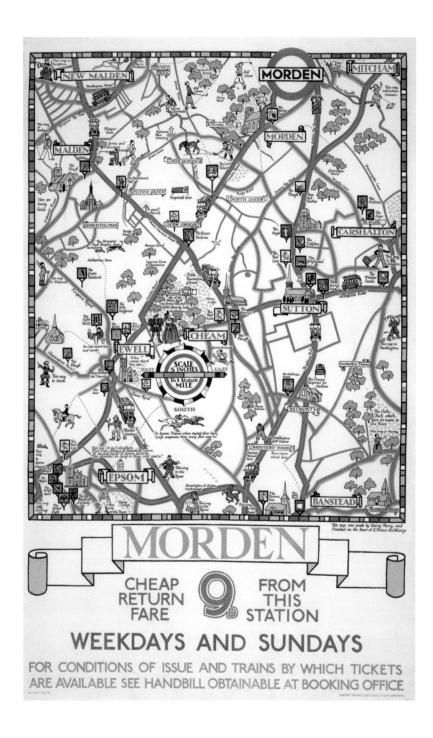

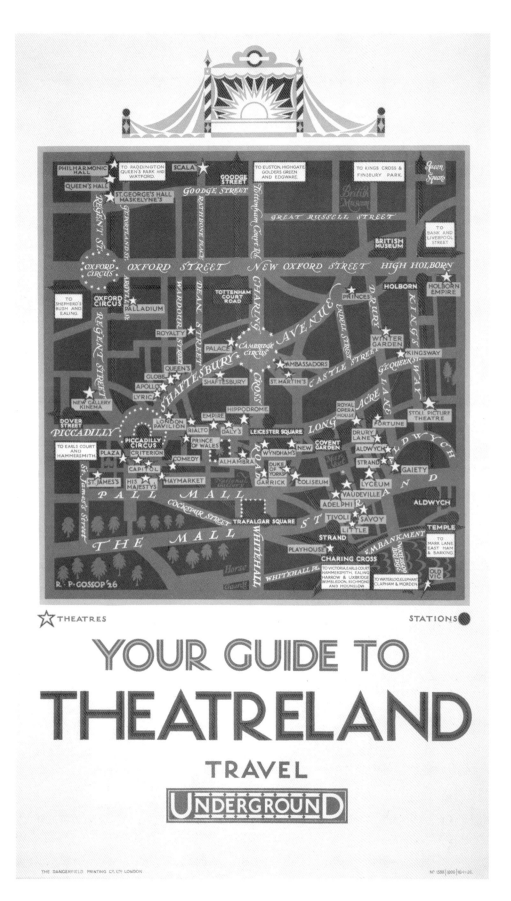

18. *Your Guide to Theatreland Travel*
Reginald Percy Gossop, 1926
Double royal, 1016 x 635 mm (40 x 25 in)
Published by the UERL
Printed by Dangerfield Printing Co Ltd

Sparkling with late-night lights, Gossop's
modernised decorative map presents
London's West End as an inviting
destination for theatre-goers.

Perry signed each of her decorative maps and
dated them in relation to the nearest religious
holiday. The poster map for Morden, for example,
was 'finished on the feast of St Prisca' (18 January).

The charms of the city

Between 1926 and 1928, the UERL commissioned
Gossop to produce two annual poster maps
promoting the capital's West End, one focused
on shopping, (*Your Guide to Winter Sales*), and the
other on the theatre, (*Your Guide to Theatreland*)
(pls 18–19). For Pick, the aim of this type of poster
was to 'bring home to people dwelling in the Suburbs
the facilities which London Transport as a whole
affords'.[19] It was this style of map, an extension of
that introduced by Gill, which Pick praised in a 1933
publicity meeting for its ability 'to build up goodwill
and to impress itself upon the public'.[20]

In his book, *Advertisement Design*, Gossop
commented: 'New maps, cunningly devised, have
the power of giving new charms to old places. We
can be reminded of things forgotten and led to take
a fresh interest in tracks that had become tedious by
constant treading.' He believed that on some level
the map had always promoted travel and that 'we
cannot move without it, and it will often stir us to
move when we had no thought of doing so.'[21] In his
view the inherent aesthetic qualities of cartography
could be harnessed and diverted to the role of
publicity with minimal adjustment. For Gossop, it
was choice of colour, an understanding of lettering
and careful composition, rather than any addition
of ornament, that determined the decorative quality
of his maps. He did, however, applaud the creative
animation of maps such as those produced by Gill
and Perry: 'Without embellishment', he claimed,

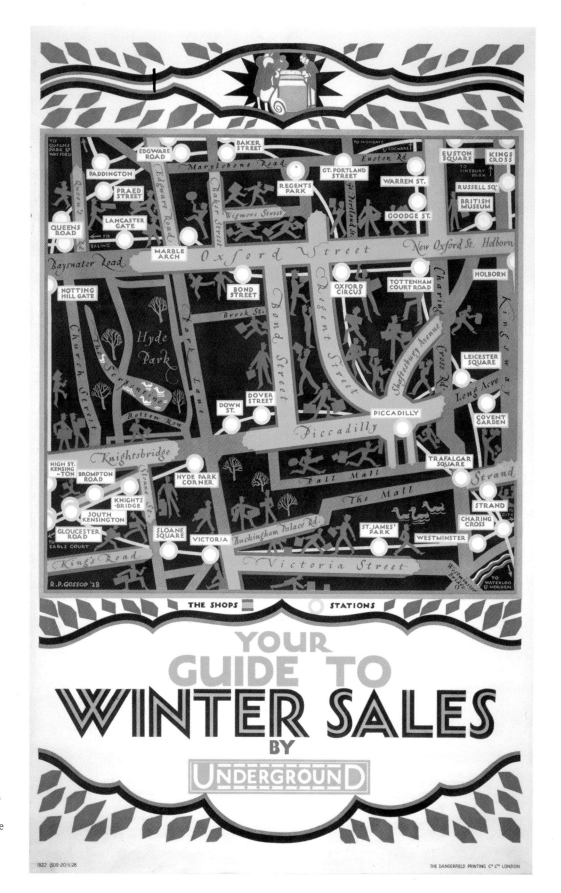

19. *Your Guide to Winter Sales*
Reginald Percy Gossop, 1928
Double royal, 1016 x 635 mm
(40 x 25 in)
Published by the UERL
Printed by Dangerfield
Printing Co Ltd

With vibrant, contrasting colours
and lively silhouettes, Gossop's
graphic poster map highlights the
appeal of the winter sales in
London's West End, encouraging
shopping by Underground.

20. *Map of Central London*
MacDonald Gill, 1932
Quad royal, 1016 x 1270 mm (50 x 40 in)
Published by the UERL
Printed by Waterlow & Sons Ltd

'they would still hold our attention and make our feet itch to move. Nevertheless the delight of adding symbols and jests could not have been resisted, for they make the meaning of the maps fuller.'[22]

In 1932 Gill started what was to be his last decorative poster map for the UERL, the *Map of Central London* (pl. 20). It was during an intensely prolific period in his career, when he spent much of his time in the Hare Court studio. The artwork on his drawing board presented a more central view of London than his *Wonderground* map had done nearly 20 years before. A significant addition to the cityscape, and Gill's map, was the UERL's new headquarters at 55 Broadway. The building, designed by the architect Charles Holden and constructed over St James's Park station, was completed in 1929. Now a Grade 1 listed building and a celebrated monument to Art Deco architecture, 55 Broadway

ABOVE AND RIGHT
20. *Map of Central London*
MacDonald Gill, 1932
Quad royal, 1016 x 1270 mm (50 x 40 in)
Published by the UERL
Printed by Waterlow & Sons Ltd

Gill's last decorative poster map for the Underground presents a contemporary picture of central London, including the Underground's grand new headquarters above St James's Park Tube station.

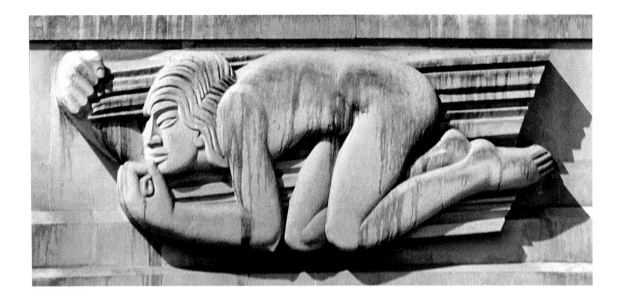

21. *The North Wind*
Eric Gill, 1920
Photographed by Sidney W. Newbery, c.1929

Eric Gill's powerful relief, *The North Wind*, commissioned for the Undergound's new headquarters at 55 Broadway in Westminster, was carved in situ on the east side of the south wing.

22. *A Map of the Cities of London and Westminster*
MacDonald Gill, 1932

Gill (centre, in his artist's smock) unveils his new mural map for St Steven's Porch, the public entrance to the Houses of Parliament in Westminster, central London.

was then the tallest office in London. Decoration was an integral part of its cutting-edge design. The impressive list of artists commissioned to produce the building's external relief sculptures, collectively known as *The Four Winds*, included a young Henry Moore as well as the leading Modernist sculptors Jacob Epstein and Eric Gill, who was Max's brother (pl. 21). Two years older than Max, Eric was one of Britain's principal contemporary sculptors and a prominent type designer, responsible for the Gill sans font.

In his new view of central London, Max included a wind god in each corner, mimicking the display format of the sculptures on the north, south, east and west wings of 55 Broadway. Eric Gill also appears in the map, standing outside 55 Broadway, where he admires the relief he had completed three years earlier. Adopting the punning wit of his younger brother, he quips, 'She's Hold'en on all right'.

In the same year Gill produced two large maps for the Houses of Parliament in the Palace of Westminster on the river Thames (pl. 22). Over 3 m (10 ft) wide, these impressive maps were painted on mahogany panels, reinforced with steel slats, and displayed on either side of St Steven's Porch, the public entrance at the southern end of the palace. The design on the left of the porch, *A Plan of the Houses of Parliament*, which had been commissioned by a private donor, Colonel Tebbutt, presented a

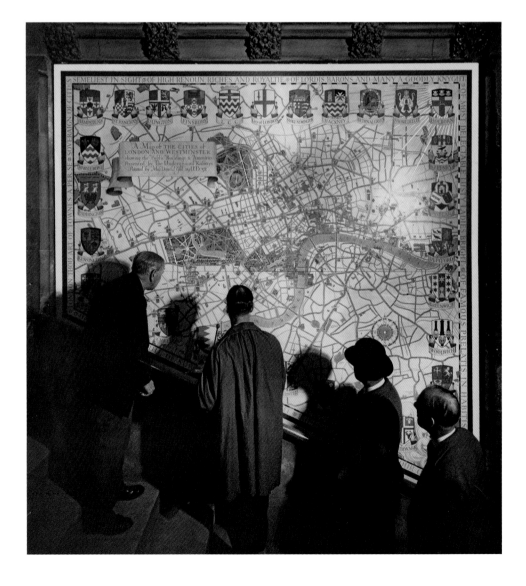

23. *London's Traffic Puzzle*
Artist unknown, 1928
Double royal, 1016 x 635 mm (40 x 25 in)
Published by the UERL
Printed by Waterlow & Sons Ltd

The eye-catching puzzle effect of this modern poster design promotes the Northern line extension to Morden in 1926, which reduced traffic jams by improving services to suburbia.

detailed historic plan of the Houses of Parliament. The right-hand panel, entitled *A Map of the Cities of London and Westminster*, was a gift from the UERL, which had been commissioned by Pick. In a colour scheme similar to that of Gill's *Map of Central London*, the historic places served by the Underground are duly shown. The more formal and permanent nature of the commission did not permit the inclusion of Gill's characteristic quirky references and contemporary humour. He does, however, pay homage to his commissioner by dating it '19 UD 32', rather than '19 AD 32' as he had on the mural opposite for Colonel Tebbutt.

Heart of the Empire

By the late 1920s and early 1930s, Underground posters using the imagery of maps in a variety of innovative ways were appearing in unprecedented abundance (pls 23–6). One example from 1928, *This Old Map of London* (pl. 24), made a powerful statement about the impact of public transport on a city, and on cartography as a whole, by imposing the Underground railways upon John Rocque's eighteenth-century map of London. By contrast, Ernest Michael Dinkel's poster design of 1933, *Visit the Empire*, encouraged Underground passengers to explore the riches of the British Empire in London (pl. 25).

Two maps that were commissioned by the UERL for decoration some way from the Underground's usual hoardings would feature in the booking hall of the new station at Piccadilly, which opened in 1928. The station's subsurface, circular booking hall, designed by Charles Holden to increase the capacity and streamline the flow of passengers, was an impressive feat of both architecture and

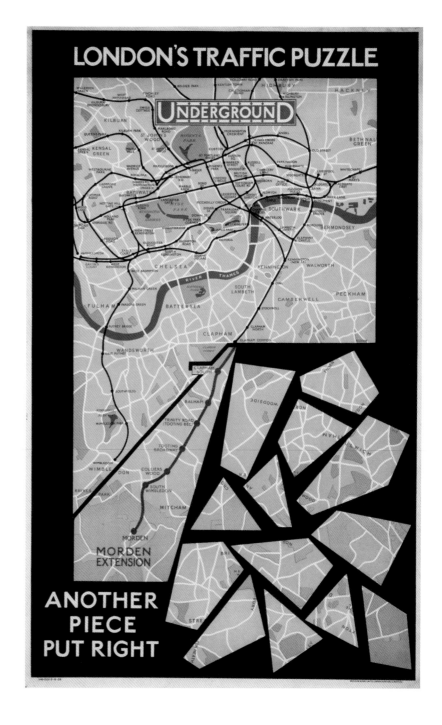

24. *This Old Map of London*
John Rocque and Richard Park, 1928
Quad royal, 1016 x 1270 mm (50 x 40 in)
Published by the UERL
Printed by Edward Stanford Ltd

The Tube network, superimposed in red on a map of London from 1761, highlights its impact on the city. The Latin couplet in red reads: 'This old map of London teaches you how many Underground roads there are today.'

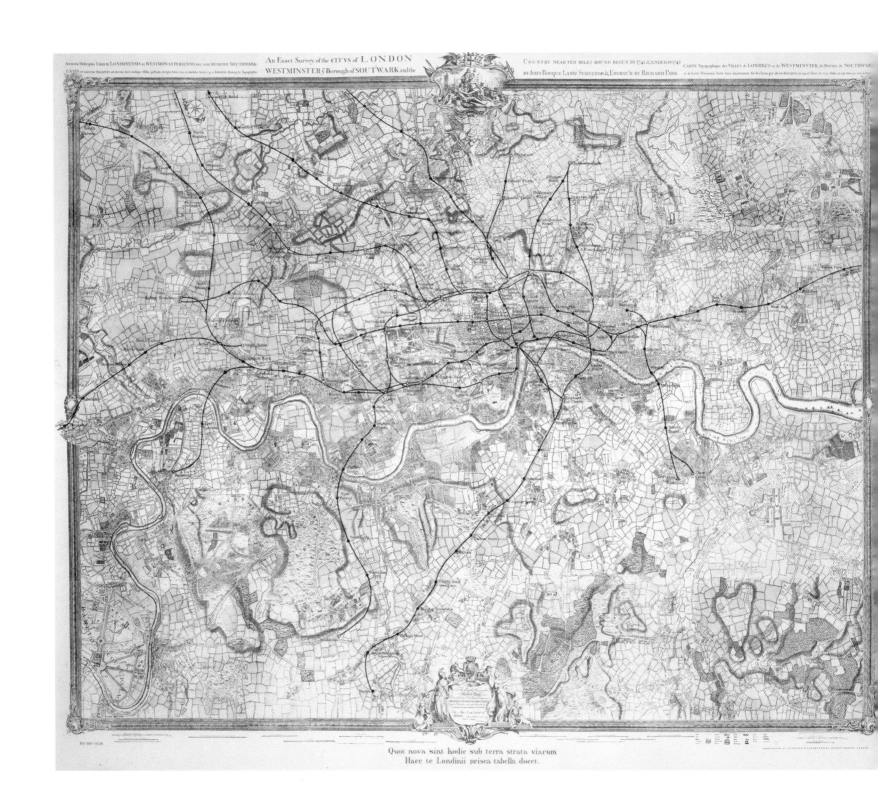

25. *Visit the Empire*
Ernest Michael Dinkel, 1933
Double royal, 1016 x 635 mm (40 x 25 in)
Published by the UERL
Printed by Waterlow & Sons Ltd

A novel map of the British Empire, surrounded by the exotic flora and fauna of its far-flung colonies, encourages passengers to explore its riches at London's cultural centres.

26. *To the Cinemas*
Cecil Walter Bacon, 1934
Double royal,
1016 x 635 mm (40 x 25 in)
Published by London Transport

A variation on Gossop's modern graphic designs (pls 18–19), *To the Cinemas* presents the West End as a desirable leisure resort, easily accessible on the Underground.

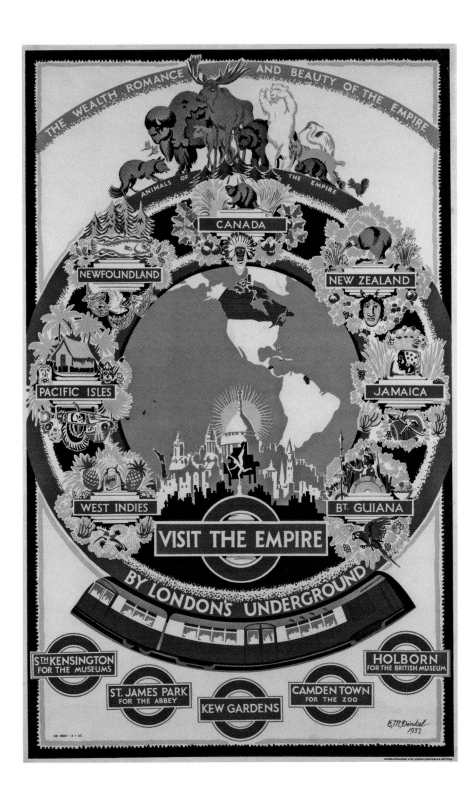

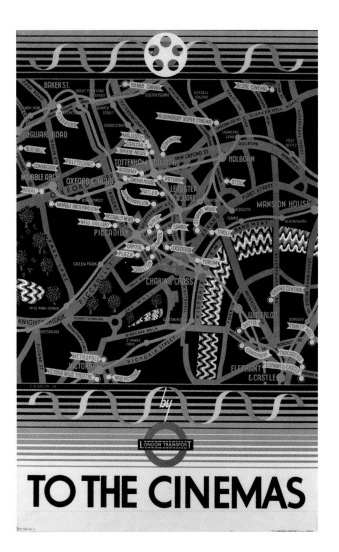

27. *Piccadilly Circus –*
Hub of Empire
Stephen Bone, 1928
345 x 850 mm (13.5 x 33.5 in)

The original artwork for a vast mural presenting London as the hub of the British Empire.

28. Stephen Bone in front of his mural
Photographed by Photopress, 1928

The artist Stephen Bone at work on the centrepiece of his panoramic mural (pl.27), which would fill the wall space above the new escalators at Piccadilly Circus.

29. *School Picnics &*
Pleasure Parties
Freda Lingstrom, 1930
154 x 151 mm (6 x 5.9 in)
Published by the UERL
Printed by the Baynard Press

A promotional leaflet using a decorative map to advertise activities for children provided by the Underground.

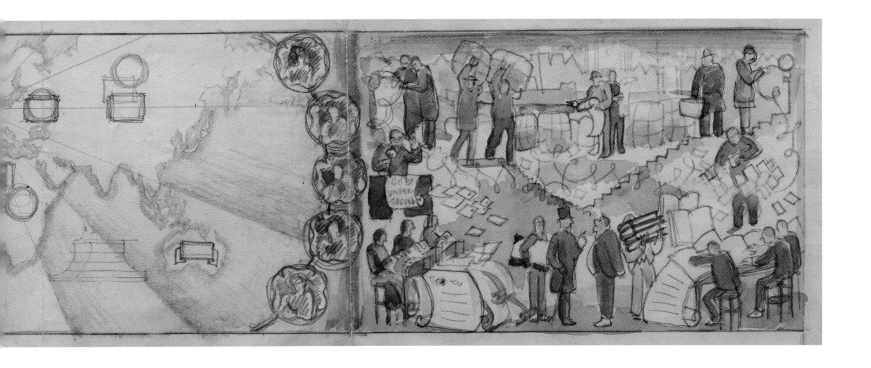

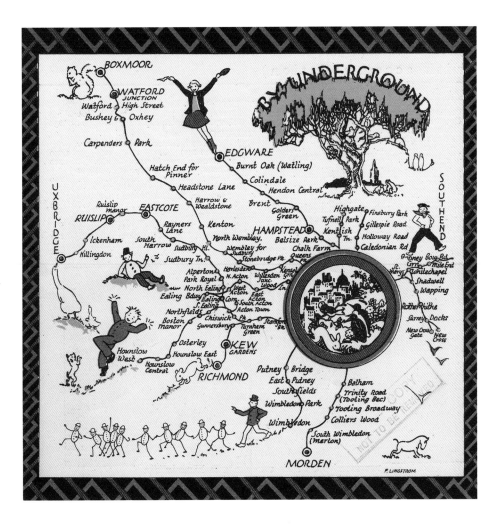

engineering. The first commission was a world map entitled *Piccadilly Circus – Hub of Empire*. Forming the centrepiece of a vast mural by Stephen Bone, it boldly declared London to be 'The Heart of the Empire' (pls 27 and 28). Displayed above the new escalators, the powerful image dominated the view of millions of passengers every day. The second example, a world map clock conceived and built by the Underground's chief clockmaker Frederick Willis, was designed to display the different times of the world's capital cities simultaneously.

By the time London Transport (LT) was formed in 1933 (merging the former UERL and other independent services), decorative poster maps had become a tried and tested form of publicity (pl. 29). Like all modern modes of visual communication, however, they had a finite lifespan. What was once pioneering publicity and design had become a comfortable and familiar strand of commissioning within the UERL's annual poster programme. The next decade would see an expansion beyond the insider view of Gill's *Wonderground* to wider horizons, encouraging more distant travel.

30. *London Town*
Kerry Lee, 1938
Quad royal, 1016 x 1270 mm (40 x 50 in)
Published by Southern Railway

A decorative map in the style of MacDonald Gill,
commissioned by Southern Railway to encourage
travel to London by mainline train. Packed with
cultural appeal, it promises 'Attractions of every kind...'

Wondergrounds of the world

Gill's distinctive decorative poster maps not only
captured the public imagination and inspired a
generation of commercial art commissioning in
Britain, but they also brought about a resurgence
of interest in pictorial mapmaking worldwide. In
the 1920s and 1930s 'Wonder maps' were produced
for cities around the world, including Melbourne,
Mexico City, Boston and Manhattan. Closer to home,
examples such as Kerry Lee's *London Town* poster
of 1938, designed for the Southern Railway,
demonstrate a shift away from the insider view
of Gill's maps in order to promote travel to the
capital from further afield (pl. 30).

In many ways, Gill's ability to put his life
wholeheartedly into his work made it inimitable.
Fascinated by maps since childhood, Gill drew
and redrew the world tirelessly. Ever since his
Wonderground map of 1914 had first revealed
the potential use of decorative maps in modern
publicity, Gill received a steady flow of work from
government departments, civic authorities,
businesses and private individuals. His vast and
varied contribution to cartography included wind-
dial maps (set above fireplaces and linked to an
outside weather vane), tiled maps, maps woven into
tapestry, cut into glass and painted on ceilings.

Gill was indebted to the UERL and to the
patronage and vision of Pick, in particular. In an
article on decorative maps produced for *The Studio* in
1944, he applauded Pick for seeing 'in a revival of the
decorative map a medium of approach whereby
direction, instruction and civic sense might be
unified and fostered for the benefit of all'. [23]

NOTES

1 Pick, Frank, London Transport, publicity
 meeting minutes, TfL archives,
 Aug–Dec 1933.

2 Gill, MacDonald, 'Decorative Maps', *T
 he Studio: An Illustrated Magazine of Fine
 and Applied Art*, vol.128, no.621,
 Dec 1944, p.166.

3 'Personalities in the Realm of Art,
 MacDonald Gill, F.R.I.B.A', *Town and
 Country News*, 29 Sept 1933.

4 First used to describe Frank Pick by
 Michael T. Saler in *The Avant-Garde in
 Interwar England: Medieval Modernism and
 the London Underground*, Oxford
 University Press, Oxford, 1999; the term
 has since been used by Elisabeth Burdon
 to describe Gill in 'MacDonald Gill:
 The "Wonderground Map" of 1913 and its
 influence', *IMCoS Journal,* vol.116,
 Spring 2009, p.10.

5 The *Daily Sketch*, 21 March 1914 (sourced
 from Gill's personal archives).

6 Burdon, Elisabeth, 'MacDonald Gill: The
 "Wonderground Map" of 1913 and its
 influence', *IMCoS Journal*, vol.116,
 Spring 2009, p.10.

7 Claxton, William J., *The Mastery of the Air*,
 Blackie & Son, London, 1914, pp216–17.

8 The *Evening Standard*, 21 Mar 1914
 (sourced from Gill's personal archives).

9 The *Daily Sketch*, May 1914 (sourced from
 Gill's personal archives).

10 Haslam, Andrew and Alexander, Daniel,
 'Immortal alphabets, the work of Max Gill
 for the Imperial War Graves Commission',
 *Out of the Shadows: A MacDonald ('Max')
 Gill Symposium*, University of Brighton,
 22 Jul 2011.

11 The *Daily News*, 14 Nov 1920 (sourced
 from Gill's personal archives).

12 *The Referee*, 7 January 1923 (sourced from
 Gill's personal archives).

13 Gossop, R. P., *Advertisement Design*,
 London, 1927, p.122.

14 *The Referee*, op. cit.

15 The *Evening News*, 6 Oct 1928 (sourced
 from Gill's personal archives).

16 The *Liverpool Post*, 13 Jan 1928 (sourced
 from Gill's personal archives).

17 From an interview recorded by the
 author in 2010 between MacDonald
 Gill's daughter, Mary Corell, and his
 great-niece, Caroline Walker.

18 Ibid.

19 London Transport, publicity meeting
 minutes, TfL archives, Aug–Dec 1933.

20 Ibid.

21 Gossop, R.P., op.cit., p.118.

22 Ibid, p.120.

23 Gill, MacDonald, op.cit., p.166.

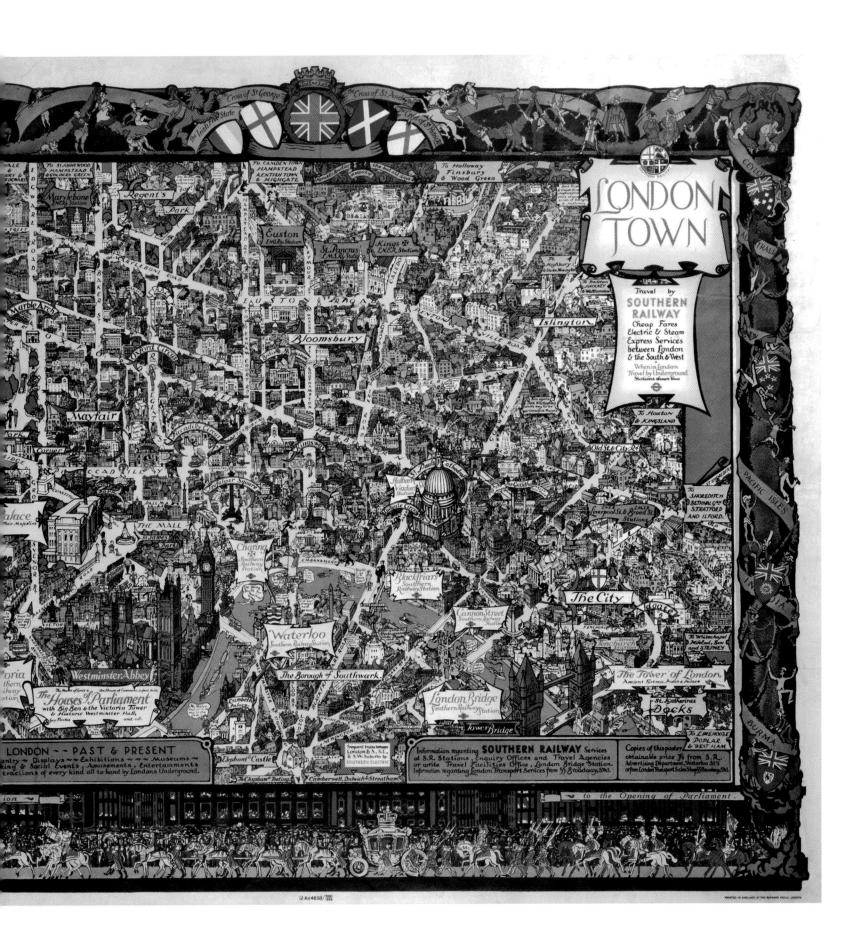

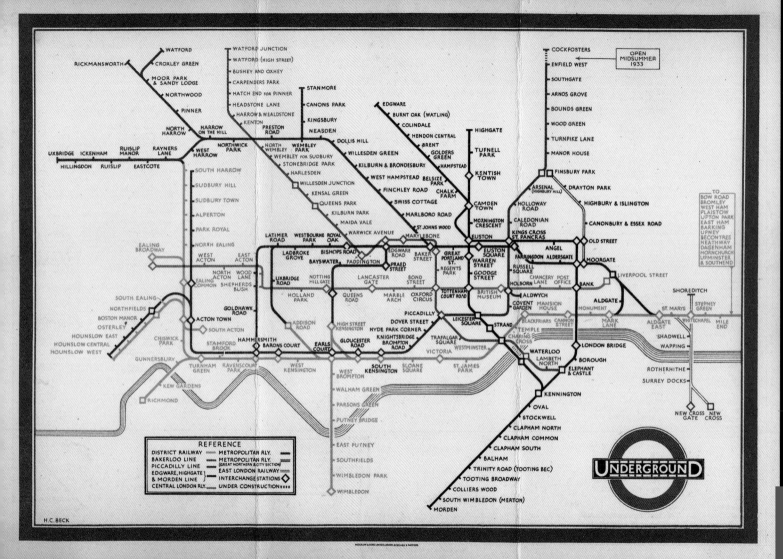

ON THE RIGHT TRACK

HARRY BECK AND THE DIAGRAMMATIC TUBE MAP

*Its bright, clean and colourful design exuded confidence in every line.
Get the hang of this, it said, and the great metropolis is your oyster.*[1]
(Ken Garland, 1994)

*I turned my attention to the greatest of all civilities: the London Underground map.
What a piece of perfection it is, created in 1931 by a forgotten hero named Harry Beck.*[2]
(Bill Bryson, 1995)

LONDON'S CURRENT UNDERGROUND MAP needs little by way of an introduction. Its distinctive geometric design has become as iconic as it is ubiquitous, making it one of the most recognisable maps in the world today (pl. 1). The clarity and character of the map stem from its diagrammatic representation, devised in 1931 by Henry Charles Beck, named on his maps as 'H. C. Beck' but known to his friends, and increasingly to today's Tube-going public, simply as Harry Beck. Abandoning rules defined by scale and geographical accuracy, to which previous maps had adhered, Beck's design followed a new bespoke set of rules determined by geometry, which transformed the map into a diagram. London's first diagrammatic Tube map, based on Beck's design, was issued in January 1933. The formation of the London Passenger Transport Board (LPTB), or London Transport (LT) as it soon became known, was just around the corner and the Underground had come to represent all that was modern, progressive and civilised in twentieth-century urban society (pl. 2).

Frank Pick, the Underground's managing director at the time when Beck's map was produced, was passionate about good design and its vital importance to a well-run business. 'Art', he declared, 'must come down from her pedestal and work for a living.'[3] The use of modern graphic posters for publicity, a standard unifying typeface for signage, and a distinctive logo for what we would today call 'corporate branding', were all products of Pick's vision. During the previous 25 years, he had established a design philosophy and graphic identity for the Underground centred on quality and 'fitness for purpose' (see chapter 1).

Maps, like signage and poster design, were the responsibility of the Underground's publicity office. During the 1920s and 1930s, design and display standards were established to ensure that communication with London's travelling public would be as effective and efficient as possible. Station signs, along with maps and publicity material, were continually reviewed and refined. Even station architecture was designed specifically to accommodate and accentuate each element of the Underground's unified 'corporate branding'. 'The Carr-Edwards Report', an internal document compiled by London Transport in 1938, outlined the organisation's standardised approach to signage. In the introduction it stated that:

1. The first diagrammatic Tube map
Harry Beck, 1933
228 x 160 mm (9 x 6 in)
Published by the UERL
Printed by Waterlow & Sons Ltd

Distinctive, efficient and modern, the first diagrammatic representation of London's Tube network was issued as a pocket map in January 1933.

The entrances to the Board's stations are the railways' shop windows, and are the best form of publicity which the railways possess. It is therefore important that the entrances to all stations should be provided with symbols and signs of standard type and pattern, so that the public will always recognise the Underground station whenever they see it.[4]

Distinctive, efficient and modern, Beck's map slotted into the Underground's 'shop window' like the missing piece of a jigsaw puzzle. This seemingly happy coincidence was, in reality, more the result of judgement than of luck. Having worked for the Underground as a draughtsman for seven years and been a commuter for even longer, Beck was familiar

with the maps that preceded his own and with their struggle to present the rapidly expanding network with adequate clarity. Even though his design was not directly commissioned by the Underground Electric Railways of London (UERL), they did share his concerns for the lack of clarity that his new map so fittingly resolved.

The lead-up to Beck's breakthrough

Beck did not design in a vacuum. By 1933, when his map first made its appearance, the Underground's cartographic baton had been passed between skilled hands for a quarter of a century. Each designer added new elements, tested on the public by each map in turn. Beck inherited many design features and innovations from preceding maps. These included

2. Balham Underground station
Photographed by Topical Press, 1934

Beck's new Tube map on display outside Balham station in south London in 1934. Designed by Charles Holden, the station was opened in 1926 as part of the Northern line extension to Morden in south London.

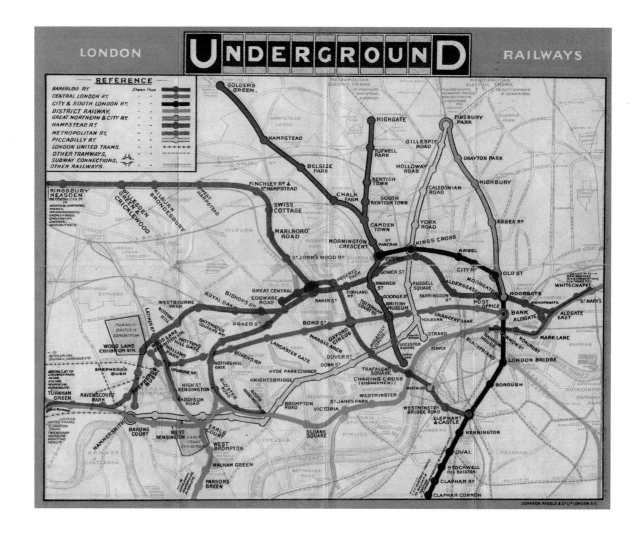

3. *London Underground Railways*
Artist unknown, 1908
203 x 272 mm (8 x 10.7 in)
Published by the UERL
Printed by Johnson, Riddle & Co Ltd

For the first time in 1908, all of London's Underground railways appear as one integrated network on a free, compact pocket map.

the idea of distinctive colours for individual lines, as well as coordinated colour linking lines with their station names; greatly reduced surface detail; and even the idea of expanding the central area to make the map more legible. The design directly preceding Beck's (pl. 9), along with 25 years of prior lessons learned, presented Beck with a far from blank canvas.

The UERL was established in 1902 as a holding company for many of the city's deep-level, electric lines (see pp 14–15). Although several different operating companies ran individual lines, making them essentially competitors, they were not performing well financially and recognised the potential of a more coordinated approach to fares, services and publicity. As a result, the UERL's first free pocket map, which was published in 1908,

presented the Underground railways as one 'complete' system (pl. 3). Although in fact the Waterloo & City Railway opted not to participate, its line was shown anyway. The resultant map was the first example of joint marketing by the separate companies under a single brand, signified by its distinctive 'UNDERGROUND' lettering – what today would be called its 'logotype'. This was used on publicity material and signage outside stations from 1908, marking a significant step towards establishing a coherent graphic identity for the Underground. Also in 1908, the Underground's roundel symbol made its first appearance, albeit in nascent form, as a graphic device to give greater prominence to the name of the station on platforms. By the mid 1920s, the Underground's logotype had found its logical

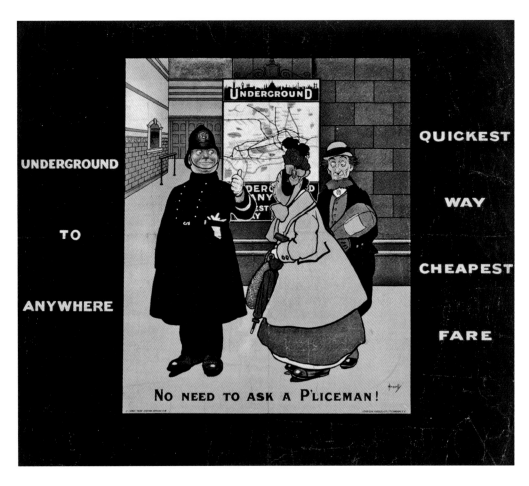

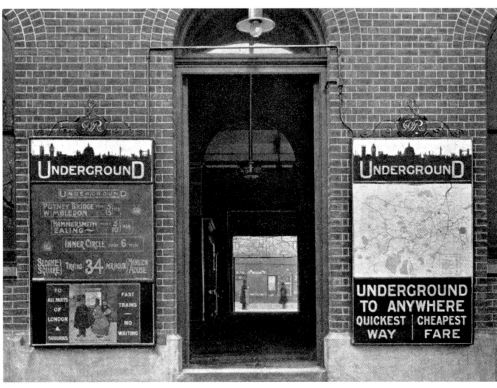

4. *No need to ask a P'liceman!*
John Hassall, 1908
533 x 600 mm (21 x 23.5 in)
Published by the UERL
Printed by Johnson, Riddle & Co Ltd

A fun graphic poster with a cheerful London 'bobby' pointing passengers in the right direction – towards the Underground's new coordinated map (pl. 3).

5. Charing Cross station (now Embankment)
Photographer unknown, 1908
Published in *Tramway and Railway World*, 1909

Charing Cross station in 1908 with the Underground's new map displayed outside, along with the graphic poster designed to promote it (pls 3–4).

6. *London's Underground Railways*
George Morrow, 1909
Published in *Punch*, 1909

In a contemporary *Punch* cartoon of 1 September 1909, a Londoner proudly presents the city's Tube map to visitors as 'Absolutely simple!', although the tangled web of lines looks anything but.

HAVE YOU GOT
A MAP
FOR YOUR PURSE?

———

ASK FOR ONE AT
ANY STATION.

———

MOUNTED ON
LINEN.

UNDERGROUND

7. *Have you got a map for your purse?*
Artist unknown, *c.*1911
95 x 200 mm (3.7 x 7.8 in)
Published by the UERL

A leaflet cleverly designed in the form of an opening purse promotes the new pocket-sized maps being issued free by the London Underground.

and long-standing home across the centre of the Underground's roundel symbol.

Pick commissioned the established commercial artist John Hassall to design a promotional poster, *No need to ask a P'liceman!*, for the new 'Underground' map in 1908 (pl. 4). The map itself was also produced in a larger format for display in stations, some alongside Hassall's poster (pl. 5). In his distinctive comic style, well known to the public, Hassall's *No need to ask a P'liceman!* reassured passengers that the map was so simple to use that there was no need to ask for directions. A cartoon published in *Punch* the following year suggested otherwise (pl. 6). In it, a proud Londoner shows off a map that looks anything but simple to his travelling companions from the country.

The notion of a Londoner being proud of the Tube was a positive one, although the *Punch* cartoon suggests that passengers, particularly those who were unfamiliar with the city and its transport system, required more clarity from the map.

Pocket and poster maps of the time were similar in style, with lines running as closely as possible to their geographical course. The specific demands of Underground travel, however, called for pocket maps to be more practical, portable and efficient than earlier Victorian railway maps, some of which were the size of broadsheets. The greatly reduced dimensions this required posed quite a challenge for designers. Some degree of simplification was inevitable when representing a city the size of London on a map that could fit comfortably into a pocket or purse (pl. 7).

Experiments to increase the clarity and navigability of the network resulted in maps with varying degrees of reference to the street plan above ground. In some cases roads were greyed out, in others they were removed altogether. Any geographical distortion, however, was more pragmatic than systematic. It was usually a means of simplifying a specific area of the map for the designer, rather than of reducing the complexity of a journey for the passenger. For example, in the first 1908 map, the trajectory of the most westerly section of the Metropolitan Railway has been flattened out to run neatly underneath the key.[5]

Up to World War I (1914–18), the Underground's standard pocket map steadily increased in quality and clarity. As well as developments to lines, new designs accommodated a range of logos, commercial advertising and lists of leisure destinations accessible from each station. Although the wording on the front varied during this period, it always reflected the map's key purpose – to aid navigation and promote ease of travel: 'What to see and how to see it', 'How to travel in and round London' and 'London's guiding star' are just a few examples.[6]

In 1919 the Underground put an advert in *The Railway Gazette* to promote their standard network map's return to colour and form after the restraints of the war years when maps were printed in monochrome. Highlighted features included the different colours for every line, clear interchange information, a plan of 'Theatre-land' on the back and 'much other useful information'. The advert urged Londoners and visitors alike to 'have one in your pocket for reference'.[7]

The first signature to appear on the Underground map, in 1920, was that of MacDonald Gill. In stark contrast to his decorative poster maps, for which he was well known to both the Underground's publicity department and the public, Gill's network maps are stripped of all topographical detail (pl. 8). This went some way to improving their clarity and useability. Gill was a skilled and versatile calligrapher who, like his brother Eric, received lessons in lettering from Edward Johnston whose typeface by this time was used as standard on all Underground signage and, increasingly, on publicity material. Gill's choice of lettering on the map was quite ornate in comparison to that of his teacher, which appears on the front cover, suggesting that the publicity department called upon Gill to bring something of his popular decorative style to the standard network map.

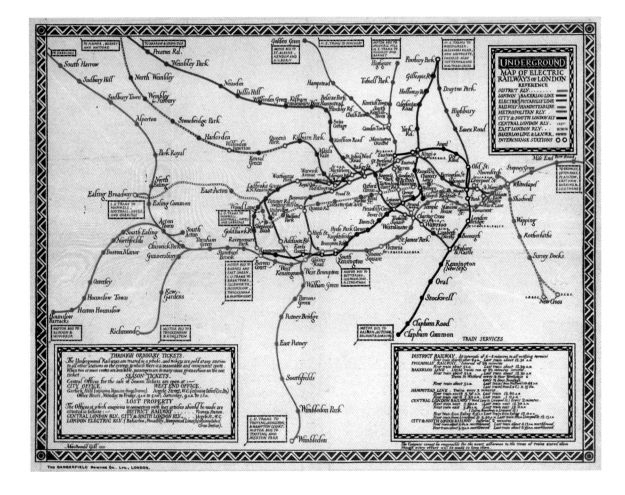

8. *Underground Map of Electric Railways of London*
MacDonald Gill, 1920
277 x 348 mm (11 x 13.7 in)
Published by the UERL
Printed by the Dangerfield Printing Co Ltd

Gill's first pocket map of the Underground, stripped of all conflicting street-level detail, but embellished with decorative borders and ornate lettering.

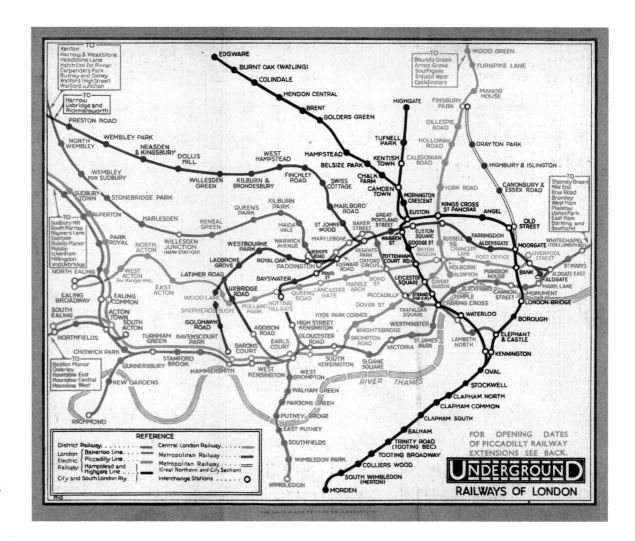

9. Stingemore's final Tube map

F. H. Stingemore, *c.*1932

167 x 144 mm (6.5 x 5.6 in)

Published by the UERL

Printed by the David Allen

Printing Co Ltd

In the last of Stingemore's pocket Tube maps, station names appear in neat Johnston lettering in the same colours as the station lines, affording greater clarity. The only surface detail, the river Thames, provides a helpful landmark.

Gill continued to design the Underground's pocket map until 1924.

The next name to appear on the Underground map was F. Stingemore. Unlike Gill, Fred Stingemore was a permanent Underground employee, who worked within the publicity manager's office as a draughtsman, eventually rising to head up the commercial drawing office until his death in 1954. Between 1925 and 1932, Stingemore produced 13 editions of the Underground's pocket map. Initially they had no surface detail, much like Gill's, although he introduced the river Thames in April 1926 to give the user a better sense of topographical orientation, just as it does today. Stingemore's hand-drawn Johnston lettering undoubtedly lends a more ordered, standardised feel to the design. However, a reduction in the dimensions of the map, which had

occurred since Gill's version, prevented Stingemore's developments from initiating a significant step forward in the quest for greater clarity. Fitting all the station names into the congested central area remained as difficult as ever. Stingemore went some way to addressing the problem by slightly expanding the proportions of the central area in relation to the outskirts of London. In his final maps of 1931 and 1932, he also adopted distinctive line colours for station names, making it easier to match stations with their corresponding lines (pl. 9). This was a feature of Beck's 1931 presentation map, with which Stingemore would have been familiar, but it is unclear to whom the innovation belongs (pl. 11).

Retrospectively, it is clear that Stingemore took the map as far as it could go within the boundaries of an essentially geographical representation. His

layout and lettering partially improved legibility, although small arrows were still required to link the names of some stations to their exact locations on the map, and space was sometimes crushed. The lettering of Bishop's Road in north London, for instance, cut rather clumsily across the course of a line. Stingemore understood better than anyone the need for a fundamental shift in the map's design. When Beck proposed a solution in 1931, Stingemore recognised its potential and, after its initial rejection by his superiors, he encouraged Beck to try again.

'A proper solution'

Like Stingemore, Beck was employed by the Underground as a draughtsman. From 1924 he worked in the signal engineer's office before moving to the drawing section of the establishment office. It was during a brief spell of redundancy in 1931 that

Beck first put pen to paper. Even in the early sketches, which he made in an exercise book over 80 years ago, the characteristics of the map we use today are clearly recognisable (pl. 10). The presentation drawing that Beck submitted to the publicity office in 1931 was a meticulously accurate prototype, giving fully functional form to his radical new approach (pl. 11).

Beck knew that the Underground map was first and foremost a navigational tool. He also recognised that the most important information that passengers needed, in order to get from A to B by Underground as quickly and as simply as possible, was not primarily geographical. For passengers, the priority was the sequence of stations, the ultimate direction of lines and the interchange options available. Beck's design used exclusively straight lines and angles of either 90 degrees or 45 degrees,

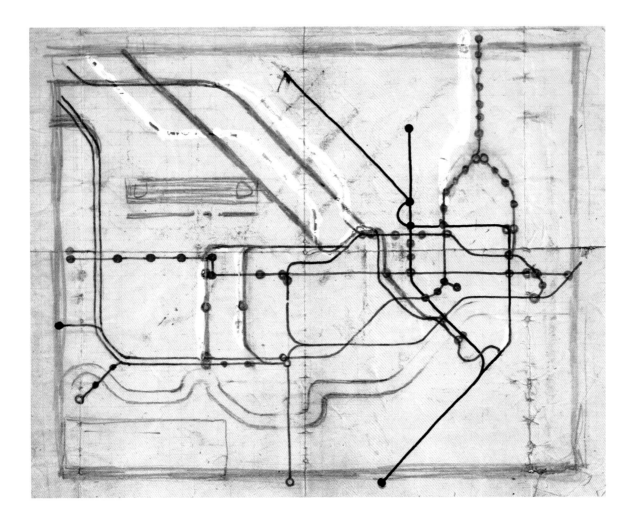

10. **Sketch for the first diagrammatic Tube map**
Harry Beck, 1931
190 x 241 mm (7.5 x 9.5 in)

A preliminary sketch for the first diagrammatic map of the Underground done in an exercise book in pencil and coloured ink by the engineering draughtsman Harry Beck.

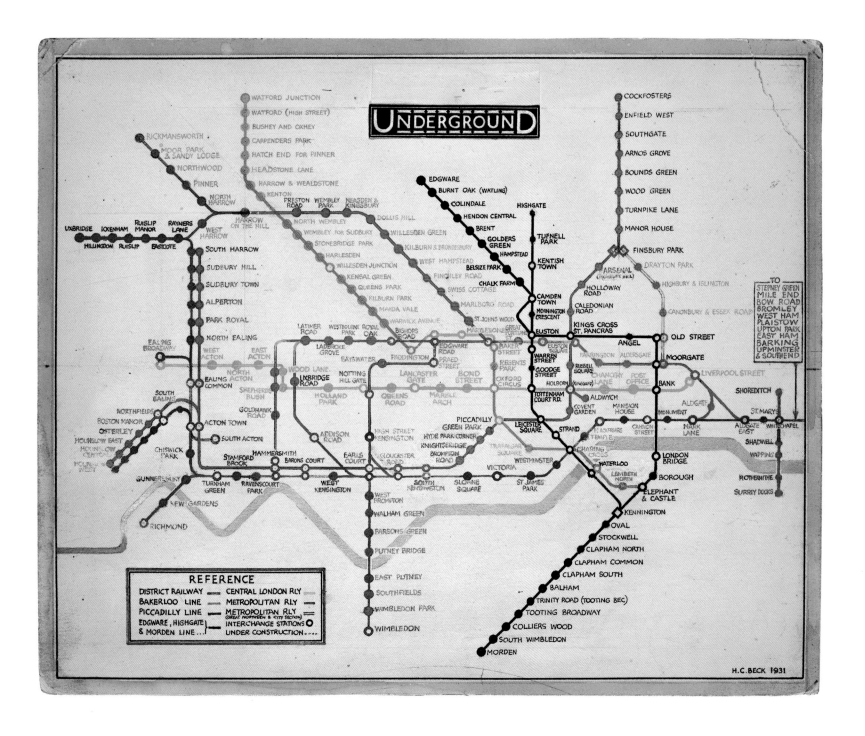

11. Presentation drawing for the diagrammatic Tube map
Harry Beck, 1931
237 x 290 mm (9.3 x 11.5 in)

The radically new map that Beck submitted to the UERL's publicity office in 1931. It focuses on the sequence of stations and interchange options, rather than on true geography or scale.

which he found not only permitted the visualisation of all the key information, but also made it clearer.

Pick always aimed to 'find a proper solution to the problems of everyday life'.[8] Beck's map embodied the very essence of the modern functionalism that underpinned the Underground's design philosophy in the 1930s. In theory, however, and without the benefit and testimony of hindsight,

this radically new approach to mapping London's Underground presented a risk. Hard-earned trust and goodwill among passengers was not something with which the publicity office was prepared to gamble. 'My underground map was handed back to me', Beck recalled, 'and it seemed that that was the end of it. But I did not lose hope and the following year I decided to have one more try.'[9]

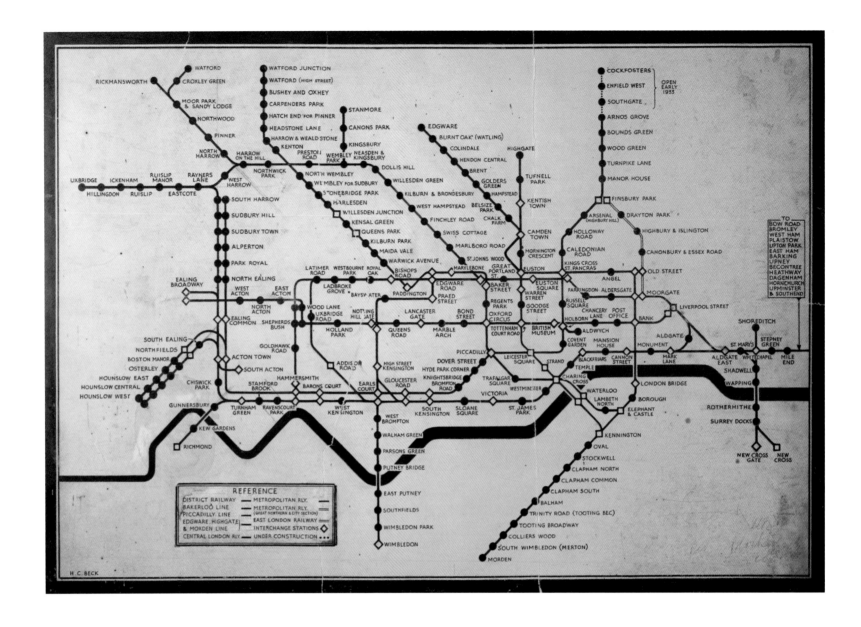

With absolute confidence in the design, Beck resubmitted his presentation drawing of 1931. On close inspection, it is possible to see where he carefully scratched away the stations between South Kensington and Piccadilly Circus with a razor blade, in order to update the name of Dover Street to Green Park, and to redistribute other stations after removing Down Street, which had closed in May 1932. On reviewing his presentation drawing again, the publicity department decided to go ahead with Beck's new design. He later recalled, 'I will never forget Mr Patmore's, "You'd better sit down: I'm going to give you a shock. We're going to print it!"

Thus it was and only through my perseverance, that the London Underground diagram was born.' [10]

A proof was printed from Beck's updated presentation drawing of 1931. He then made rough amendments in pen, such as the extension of the Metropolitan line to Watford in Hertfordshire, before redrawing the entire map again in black in 1932 (pl.12). In this interim monochrome artwork, non-interchange stations were shown as blobs rather than as the ticks that would later appear on the printed edition, suggesting that Beck redrew the entire map at least once more before the first pocket edition was printed in January 1933. [11]

12. **Preliminary drawing for the diagrammatic Tube map, 1932**
Harry Beck, 1932
341 x 475 mm (13.5 x 18.7 in)

An interim artwork in black ink and pencil for Beck's diagrammatic map with updated amendments to his presentation drawing (pl.11), including the Metropolitan line extension to Watford.

13. Pocket Underground map cover
Harry Beck, 1933
160 x 228 mm (6 x 9 in)
Published by the UERL
Printed by Waterlow & Sons Ltd

Front cover of the first diagrammatic
pocket Tube map of 1933, inviting the
public to write in with any comments
on the radical 'new design'.

An instant hit with Tube travellers

It is clear from the print run figures that the map
was an instant success with the public. After
750,000 copies of the pocket map were issued
in January 1933, a further 100,000 were printed in
February. In March the first poster version of the
map was printed in an edition of 2,500, followed
by another 2,000 copies in August. [12]

On the front cover of Beck's first pocket
Underground map, an open invitation encouraged
passengers to write in with their comments (pl. 13).
Commitment to such a high quantity, however, sug-
gests that the first print run of 750,000 was in no
way a trial. Despite their initial hesitation, the
Underground had clearly found full faith in Beck's
design even before it was printed (pl. 14).

The Railway Gazette reproduced an image of the
new map 'prepared in modernist form by H. C. Beck'
in July, claiming that 'Invitations to the public to
suggest improvements have resulted in a very large
number of replies, some of which, we understand,
the L.P.T. Board [London Passenger Transport Board
(LPTB)] intends to adopt.' [13] If the publicity office of
the LPTB did receive comments with suggested
changes to the map, neither mention nor evidence
of them was recorded in the company minutes since
the time of its formation in July 1933. Neither was
there any press coverage of the new design
between January and August, making it wholly
plausible that there was simply little by way of
comment from the public.

Between 1933 and 1934, many minor changes to
the map were considered by the publicity office. It
is possible, of course, that some of these may have
originated from the public, although this is not
specified in the meeting minutes. Any additions

or 'improvements' to the map were decided by
committee. Although usually executed by Beck, the
collaborative nature of the decision-making process
meant that, on occasion, these changes challenged
his better judgement. The addition of a north arrow
to the August poster map, for example, was certainly
not the idea of a designer. The incongruity of such a
conventional, and ultimately redundant, orientation
device misses the point of Beck's diagram entirely.
It was removed for the subsequent edition.

A short piece in the Underground's *T.O.T.* (*Train,
Omnibus, Tram*) *Staff Magazine*, claimed in March
1933 that:

> **Schools of artistic thought are waging wordy
> warfare over the new Underground folder map,
> which has just been issued. There is much to be
> said on both sides. For years untold our maps
> have been more or less geographically accurate.
> There is value in that to the passenger. Yet the
> diagrammatic map with its straight lines, gives
> an impression of directness. Which is the more
> useful, and which the better advertisement?** [14]

The reference to 'schools of artistic thought', and
the fact that the article featured in a company
magazine, suggest that this was a rather academic,
rhetorical questioning of the map's design. If words
of warfare were waged beyond the four walls of the
Underground, they certainly were not committed
to paper. Remarkably, in fact, widespread public
momentum behind the 'diagrammatic versus geo-
graphic' debate is a relatively recent development.
At the time of its introduction, the new
diagrammatic approach to mapping the Tube
appears to have been unanimously accepted.

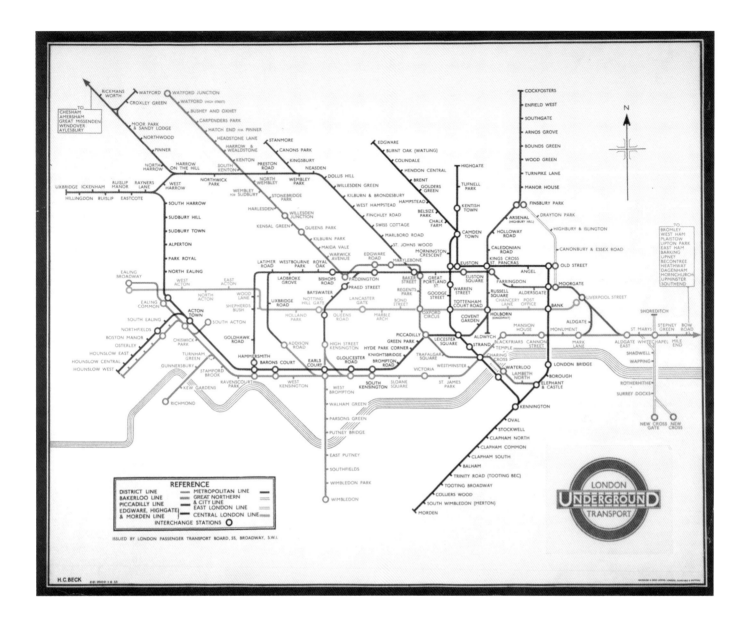

14. **Underground map poster**
Harry Beck, 1933
Quad royal, 1016 x 1270 mm (40 x 50 in)
Published by London Transport
Printed by Waterlow & Sons Ltd

The large-format, quad royal poster map, for display in stations, highlights the simplicity, clarity and elegance of Beck's diagrammatic design. The blobs that represented stations on his earlier drawings (pls 11–12) have now been replaced with ticks.

To have agreed such high initial print runs, Pick clearly had confidence in Beck's design. Confirming that he was also satisfied with the outcome, Pick stated in a memo to his publicity manager in August 1933: 'I had a look at your quad royal map. I confess that upon a large scale this looks very convenient and tidy and is a better map than any we have had so far.' [15] 'Convenient and tidy' may sound like rather underwhelming approval, but Pick was renowned for his habit of 'damning with faint praise'. Man Ray, Eric Ravilious and Edward McKnight Kauffer are but a few of the prestigious artists whose poster designs fell short of the Underground's exacting standards under Pick. In all cases, rejection was down to his idea of 'fitness for purpose', rather than personal taste.

An inspired design

At the time of his breakthrough, Beck was surrounded by modern design that could have informed the evolution of his new map. To have come up with such a winning design solution in 1931, Beck must have been responsive to a broad range of influences, and have drawn pragmatically on his experience as both an Underground commuter and an Underground employee.

THE UNDERGROUND "STRAIGHT EIGHT" ALL-ELECTRIC SKIT-SET CIRCUIT DIAGRAM

H.T.1. · H.T.2 · H.T.3 · North Pole · Aerial · H.F. Miners & Tappings · Transformer · Terminal · Amp. · Long Spiral Coil · 6 Point Switch · Bakerlite Tube · Grid Leak (Roof) · L.F.2 · L.F. Inner Circuit Slow motion drive) · Insulating tubing removed to shew new pick-up stage · Great tension · High resistance (push-pull) · Nuts, Variable MU. · Holborn Ampere · B. Re-A.C. Mains · Output Trainsformer · T.O.T. Band-pass filter & Tuner · H.F. Choke Gang Condenser · Wander plug · screen grid · Chassis Mfd. Moving Oil Units · Ideal Ohms (GRR) · Short Stage turns: "Non-stop" variety · High Selectivity · Earthing screen · Bus pick-up & Step-down · Parallel feed · Multiple choke · Cabinet & C.I.D. Lightning-Arresters · Wave Trap · Continental Stations · Weak signals strengthened · D.C. Wave-band Short waves across Earth · HQ+ Headphones & Loudspeakers · Crystal- · Input: Field-winding (Motorboating) · Logarithmic, or "Straight line" curves · H.T. All Mains · Earth · UNDERGROUND · T

SPECIFICATION
London Regional Stations, connecting H.T. Output Cells with Ohms. Bare copper inductance with minimum or no Resistance.

H.C. BECK. A.E. Inst. O.U.

15. *The Underground 'Straight Eight' All-Electric Skit-Set Circuit Diagram*
Signed H.C. Beck, 1933
Published in *T.O.T* (Train, Omnibus, Tram) *Staff Magazine*

A spoof Tube map presenting London's Underground in the guise of a radio-wiring diagram, with the names of stations and lines replaced by associated technical terms, such as 'Amp' for Hampstead and 'Bakerlite Tube' for the Bakerloo line.

A popular misconception is that Beck's design was based on electrical circuit diagrams. It is certainly not something to which Beck ever testified. In the staff magazine *T.O.T.*, an article of March 1933 claims that 'geographists likened the map to a wiring diagram and have submitted "a playful burlesque" of the map entitled *The Underground "Straight Eight" All-Electric Skit-Set Circuit Diagram*' (pl. 15). [16]

For the readers of *T.O.T*, the new map's superficial likeness to an electrical circuit drawing would have been little more than an in-house joke. It was signed 'H. C. Beck', but could just as easily have been drawn by Stingemore, who shared Beck's sense of fun, and regularly contributed cartoons to the magazine. The circuit cartoon, though, is certainly in line with Beck's sense of humour. On returning to Underground employment in 1932 after a short spell of redundancy, Beck began to produce cartoons for *T.O.T.* (pl. 16). He later said of the time, 'I think that my joy at my recall to the "old firm" may have sharpened an impish sense of satire, for at home I was mostly to be found doubled up over a drawing board: I kept the staff magazine well supplied with my particular brand of humorous drawings.' [17]

Bryce Beaumont, who worked with Beck in the 1930s, remembered him as 'always bubbling over

THIS FLAT TO LET

with his infectious wit', and described him as having 'a kind of inspired lunacy that lifted the horizons of the dullest hours' (pl. 17). As an example, Beaumont recounted the time that Beck arrived late one morning and offered by way of an apology the excuse that he had been 'attending a mass meeting of all the virgins in Highgate'. 'Unfortunately', Beck added, 'it was pouring with rain so they had to hold it in a telephone kiosk.'[18]

If, instead, the in-house joke were one of Stingemore's, rather than Beck's, it would have been made in good faith, a gentle quip at the expense of the man whose map had so spectacularly taken over from his own. His likening of Beck's map to an electrical wiring diagram would have been done in the same playful manner as Beck's likening of Stingemore's maps to vermicelli, which we can also safely assume was not a direct inspiration for the design.

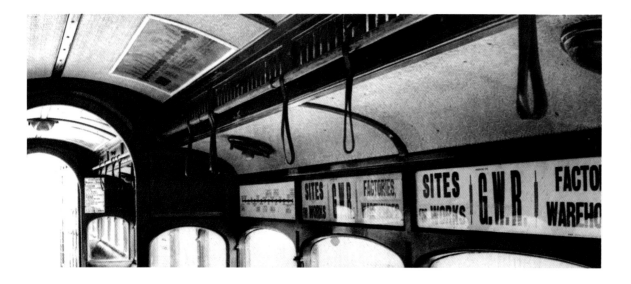

19. Bounds Green
Underground platform
Photographed by Topical Press, 1932

A Piccadilly line diagram on display above
the tracks at Bounds Green Underground
station in 1932.

20. Manor House Underground station
Photographer unknown, 1932

An Underground line diagram displayed
above a geographical network map at the
entrance to the sub-surface booking hall
at Manor House station in north London.

In reality, a map can no more be based on a circuit diagram than a circuit diagram can be based on a map. In neither case would the end product work.

In terms of orderly precision, the technical engineering drawings and signalling diagrams that Beck encountered in his work would have been more fitting inspiration for his map than an electrical circuit. Even closer to home, Beck might well have been influenced by the line diagrams that were displayed above passenger seats in both Underground and mainline suburban train carriages of the late 1920s (pl. 18). They showed evenly spaced stations running in sequence along a straight line. George Dow's carriage diagrams for the London & North Eastern Railway (LNER), for instance, even presented multiple lines and interchanges in diagrammatic form, and would have been a familiar sight to Beck since their introduction in 1929.[19] Larger enamel line diagrams were also displayed at Underground stations and were often shown directly above geographical system maps (pls 19–20). Diagrammatic signs and maps of such types would have accompanied Beck as his ideas evolved on journeys to work from his home in North London.

Posters would also have provided inspiration for Beck's design. In the late 1920s and early 1930s, modern graphic posters had reached a stylistic peak, and the Underground had become a leading patron of the most cutting-edge designs (see chapter 1). In some of its posters, such as *Fares from Here* and *Piccadilly Line Extensions* (pls 21 and 22), schematic representations were used to convey complex information about routes, fares, times and proposed extensions.

As well as providing a possible influence for Beck, these posters may well have prepared passengers

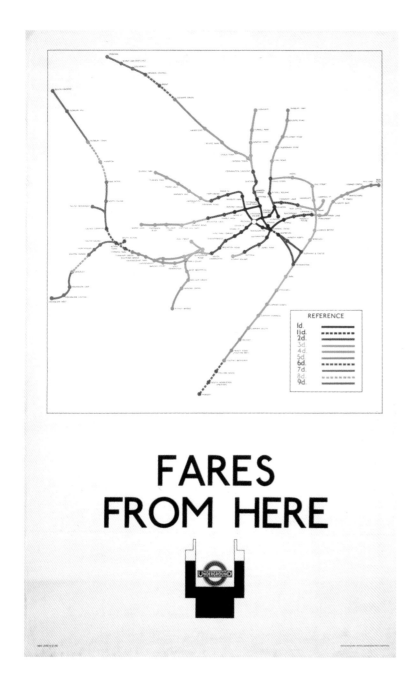

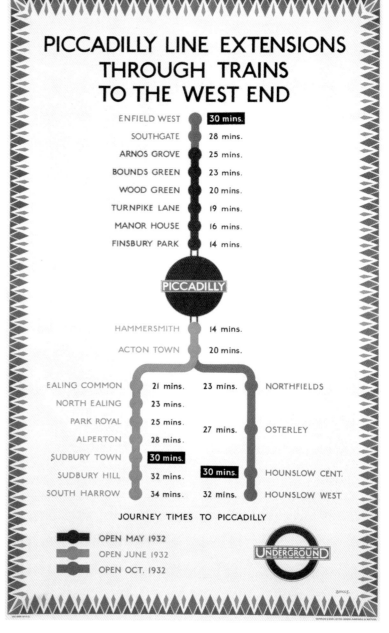

21. *Fares from Here*
Artist unknown, 1930
Double royal, 1016 x 635 mm (40 x 25 in)
Published by the UERL
Printed by Waterlow & Sons Ltd

With its colour-coded map, this modern
poster design successfully simplifies and
communicates complex information
about fares and ticketing.

22. *Piccadilly Line Extensions*
Briggs, 1931
Double royal, 1016 x 635 mm (40 x 25 in)
Published by the UERL
Printed by Waterlow & Sons Ltd

The timetable of planned extensions to the
Piccadilly line are presented schematically with
a colour-coded index, reflecting trends in
contemporary design and communication graphics.

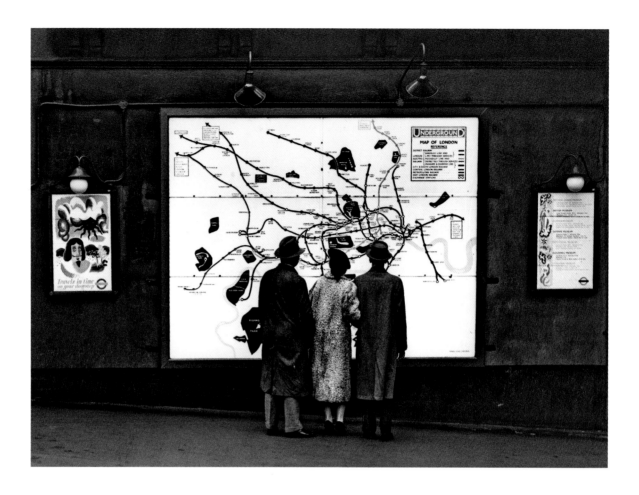

23. Enamel network maps
Photographer unknown, 1937
Three passengers outside the Strand
(later Charing Cross) station in 1937
scrutinise one of the large enamel
network maps that were traditionally
displayed outside Underground stations.

for the Tube map's 'radical' new direction, since some of the abstract and geometric elements of contemporay art had been used by poster artists for over a decade. It is possible that, like the public's familiarity with line diagrams, the powerful geometry and abstraction of modern posters unwittingly mitigated the stylistic challenges that Beck's new map might otherwise have posed.

An enduring model

After its introduction in 1933, Beck's map became the standard, authoritative representation of London's Underground network. The diagrammatic design was more flexible and versatile than its predecessors. It worked in different sizes, for different audiences, and it could accommodate expansion and change. Before Beck's map, Gill and Stingemore had had to produce two versions of their respective pocket maps, one showing central London and another, larger version covering the complete

network. With Beck's design, the two versions were no longer necessary. Equally, the vast vitreous enamel maps traditionally displayed outside stations, which could not be easily replaced when lines extended, were gradually phased out (pl. 23).

In the first publicity meeting of the newly formed LPTB in August 1933, it was agreed that all London Transport maps in use should be reviewed and standardised. The display, distribution and design of maps became regular themes for discussion at subsequent meetings. For the Underground map, regular reviews meant entertaining not only new provisions for incorporating line extensions, but also fresh ideas for stylistic development. Beck, however, was not in attendance when decisions on future changes to his map were made, as he was not a member of the publicity office or the senior management team. Isolated from the collaborative decision-making process, Beck found it impossible to retain any official sense of ownership over his design.

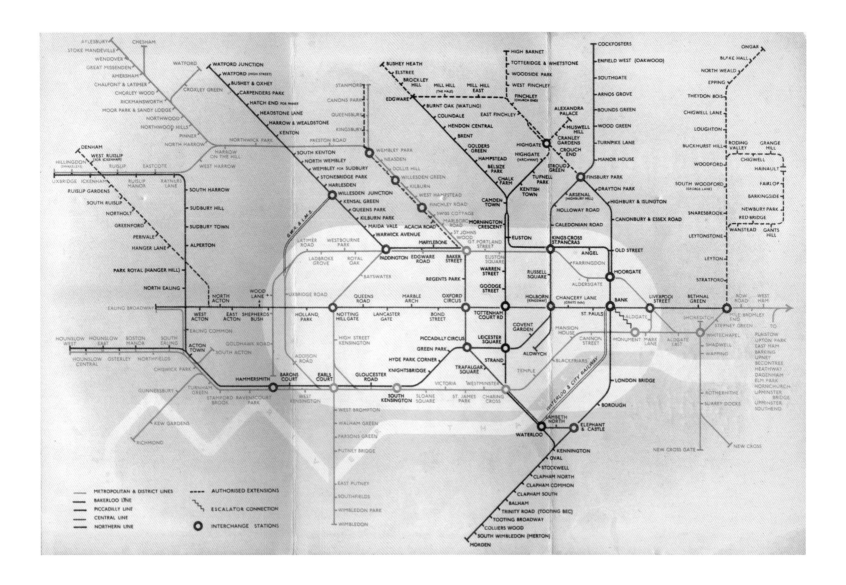

Metropolitan & District Lines
Bakerloo Line
Piccadilly Line
Central Line
Northern Line

Authorised Extensions
Escalator Connection
Interchange Stations

However, he remained the principle designer commissioned on the map until 1959. Generous with his ideas, he demonstrated genuine passion, if not obsession, for maintaining the excellence and efficiency that his first map had introduced in 1933. Beck made a map for life, and in doing so, a life's work for himself.

Expansions and extensions

A programme of major work to the Central London line was approved in 1936. The extensions east to Ongar and west to West Ruislip would have a profound impact on the line, on London and, of course, on the map itself. The authorised and proposed extension routes of the Central London

line, subsequently known as the Central line, were added to Beck's maps from 1937, and also to a new pocket map issued in the same year, not by Beck but by the prolific graphic artist Hans Schleger (pl. 24). Best known for his modern graphic posters signed 'Zero', Schleger had in 1935 also redesigned the roundel logo used on bus-stop flags.

Schleger's design for the new Underground map, although clearly diagrammatic in form, introduced a slightly different graphic style in 1937. Beck had established the Central London line as the compositional backbone of his map in 1933. This was emphasised further the following year by its colour change from orange to red, as it remains today. The Bakerloo line, which had been red up to this point,

24. Pocket Underground map
Hans Schleger, 1938
154 x 228 mm (6 x 10 in)
Published by London Transport
Printed by Johnson, Riddle & Co Ltd

A variation on Beck's contemporary design for the Underground pocket map, Schleger's version shows the lines in the same diagrammatic configuration, but in a slightly different graphic style, using airbrushed colour.

25. **You need never get lost in London**
Richard Beck, 1938
Double royal, 1016 x 635 mm (40 x 25 in)
Published by London Transport
Printed by John Swain & Son Ltd

A poster promoting the Underground
pocket map of 1938 designed by Hans
Schleger, which featured a geographic
map of central London on its back.

now became brown, also the colour that it is today.
In his 1937 design, Schleger's characteristic use of
airbrushing creates a colourless inner zone, which
draws attention to the centre of the map. The use
of green for an outer zone contrasts with the red line
and leads the eye out to the east and west. If this
effect were intentional, Schleger's commission may
have been more about publicity for the extended
Central line, than a call for a new map.

In 1947 Schleger also designed a series of posters
to promote the opening of the extension (pl. 32),
suggesting that his pocket map was simply part of
an integrated campaign to publicise the Central
line extension, rather than to produce a new
Underground map. Although his posters promoting
the Central line appeared sometime after his 1937
map, World War II (1939–45) had caused delays to
the extension, making the time lapse plausible.

Another difference in Schleger's pocket map of
1937 was the information provided on the reverse.
Whilst Beck's version showed details about
interchange options, Schleger's presented a
geographical street plan of central London. An
Underground publicity poster of the time promoted
Schleger's map, promising, 'You need never get lost
in London' (pl. 25).

Neither Beck's nor Schleger's name appeared on
the 1937 version of the Underground map. However,
its being commissioned and produced without
Beck's knowledge or supervision remained a sore
point, something he expressed in a letter to
Christian Barman in 1938. Barman had been
appointed London Transport's new publicity officer
in 1935. Like Schleger, he was a Modernist. He took
a radical approach to commissioning that, on
occasion, was at odds with that of Pick, whose

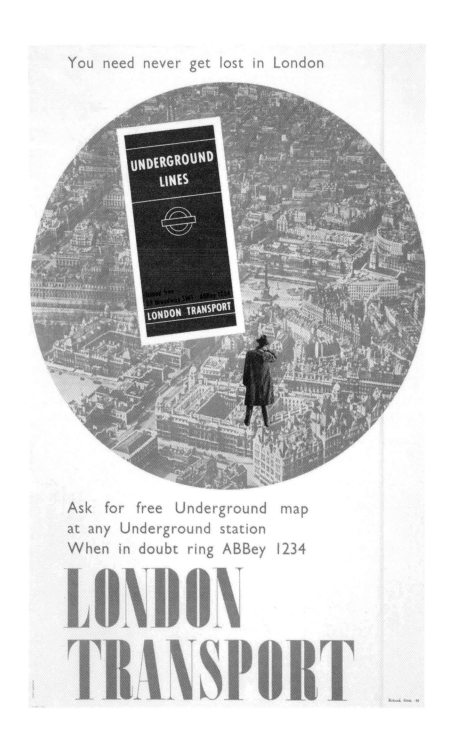

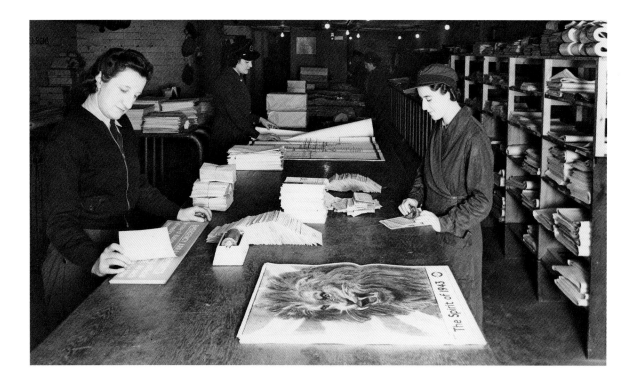

26. Advertising store in wartime
Photographed by Topical Press, 1943

Female staff at work during World War II (1939–45) in the advertising store located in the basement of Shepherd's Bush Underground station in west London.

commissioning style was comparatively traditional. In response to Beck's letter of 1938, the only reason Barman offered for commissioning a 'new' map (something for which he did not take personal responsibility), was the need for greater emphasis at interchange stations.[20] The question of how best to symbolise interchange connections on the Tube map had been a hot topic at many publicity meetings.

The Underground in wartime

World War II had a profound impact on London Transport's publicity office (pl. 26). The role of posters, in particular, changed dramatically. The promotion of leisure travel and general company advertising ceased, with new and crucial information on wartime procedures now taking priority. Topics included sheltering in the Underground, safety procedures, compulsory fare increases and nighttime blackout regulations to minimise light from doors and windows aiding enemy aircraft during air-raids. Depleted resources made it vital for every notice to be communicated as effectively and efficiently as possible.

Lighting restrictions, imposed by the fuel crisis and blackout procedures, required some posters to be printed in special luminous inks. Colour-coded borders for text-based posters were also introduced to help passengers differentiate between specific types of information. Red was used for war notices, orange for travel details, and green for general passenger information. Blue remained the border colour for poster maps, since it had already been established by the Underground in that role and in the minds of the public.

The production of maps was regulated nationally as part of the government's civil defence measures. Many maps were banned from being issued to prevent the risk of attack if they fell into enemy hands. The Underground's diagrammatic map, however, was exempt from these measures on the basis of its not being geographically accurate enough to pose a threat. The Beck map, it would seem, was not only truly, but exclusively 'fit for purpose'.

The design and display of maps in Underground stations actually changed very little during wartime. Their fundamental navigational role, like that of signage, stayed the same. The specific circumstances of war simply required them to work a bit harder. There was an increased percentage of passengers travelling across London every day, who were

unfamiliar with the city and its transport system. The reduced light levels, along with a depleted workforce, meant that services were less frequent, with fewer people on hand to offer directions. Due to paper shortages, the distribution of pocket maps was also heavily restricted. From 1940, the network lines on maps still in circulation were printed in monochrome. [21]

By this time, Beck was experimenting with new ways of presenting interchange information more clearly, such as the use of ring symbols. The elaborately large ring symbols of his 1941 map, however, were dropped from the following edition. Beck's 1941 map also introduced the use of 60-degree angles in place of the 45-degree convention established by his original map (pl. 27). The steeper angle went some way to accommodating the network's expansion east and west, but Beck

abandoned this experiment the following year when the proposed extensions were temporarily shelved due to the war.

In his 1941 map, Beck actually reduced the number of diagonals altogether, giving the map a more rectangular look and feel. The focus on horizontal and vertical lines made it more compact and easier to revise. It is now thought that this kind of map is also easier to use, in spite of being geographically less accurate. [22] Looking back on how his design evolved, Beck observed: 'I have rather tended to work on the assumption that elimination of unnecessary bends in the lines has made the diagram progressively easier to use.' [23] We know that the move to reduce diagonals was encouraged by Barman, so it is possible that Beck's experimentation was motivated by attempts to improve the navigational problems highlighted during wartime.

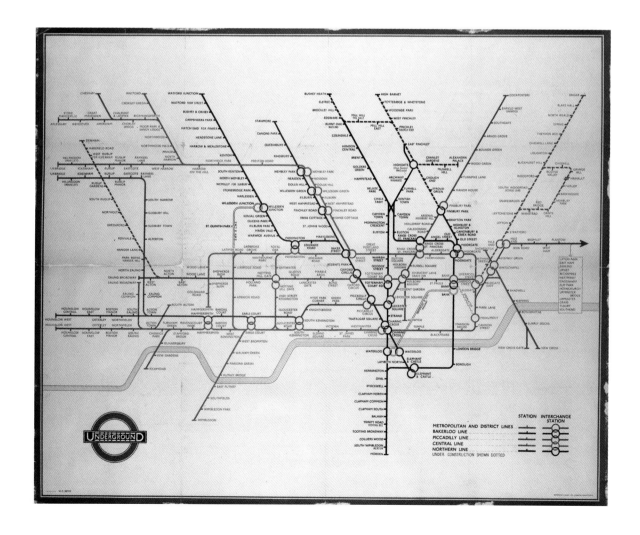

27. Poster Underground map
Harry Beck, 1940
Quad royal, 1016 x 1270 mm (40 x 50 in)
Published by London Transport
Printed by Waterlow & Sons Ltd

In his 1940 map design, Beck experimented with large rings for interchange symbols and the use of 60-degree angles to help accommodate the expansion of the network east and west.

In response to reported difficulties experienced by servicemen travelling across London, many of whom were unfamiliar with the Underground, London Transport increased the number of diagrammatic system maps posted in Underground and mainline railway stations in January 1944. Displaying additional poster maps was considered a more effective and efficient solution than supplying military headquarters with the pocket maps that they had requested. At the same time, a new smaller poster map was printed, focusing on the central area of the diagrammatic map, with a colour-coded index beneath, which showed interchanges with mainline railways (pl. 28). An information poster was also commissioned to explain the significance of the distinctive colour of each line on the Tube map, as well as the related line diagrams and signage that were displayed in carriages and on platforms. A text-based version was drafted, but rejected by the Underground's publicity office on the grounds that a graphic poster would be more effective. The resultant poster, *Be Map Conscious*, produced by the design duo Lewitt-Him, was issued in early 1945 and posted at stations throughout the network, alongside the Underground map (pl. 29).

Back on track

Beck's map proved its versatility and resilience during the war. It consistently and competently served the city in spite of challenging times for London Transport and its passengers. Reverting to a more geographical representation was no longer an option. The diagrammatic concept, which had seemed so fundamentally radical a decade before, had been wholeheartedly accepted. In fact, the publicity office decided, as part of their preparations for post-war map production, that a more schematic approach should be adopted for all London Transport travel modes. A proposal from Beck for a diagrammatic Green Line coach map was submitted to the publicity office for approval in 1934, but it was 'decided that the suggestion be held in abeyance for

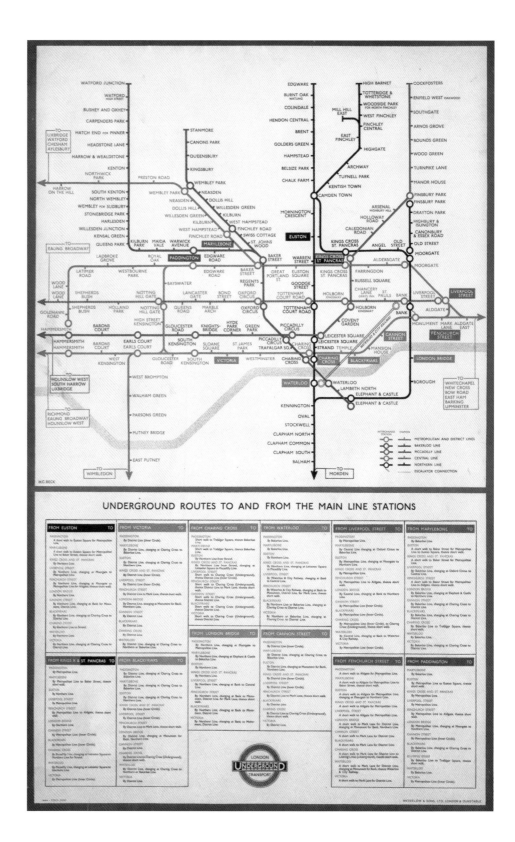

28. **Underground routes map**
Harry Beck, 1944
Double royal, 1016 x 635 mm (40 x 25 in)
Published by London Transport
Printed by Waterlow & Sons Ltd

A poster map produced during World
War II provides additional information
about interchanges between Tube and
mainline services with the aid of a
colour-coded index system.

29. *Be Map Conscious*
Lewitt-Him, 1945
623 x 502 mm (24.5 x 19.7 in)
Published by London Transport
Printed by W.R. Royle & Son Ltd

A quirky, graphic poster designed to
help unfamiliar passengers find their
way around wartime London. With
the help of a friendly, colour-coded
station guard, it clarifies how to use
the Underground's distinctive maps
and signage.

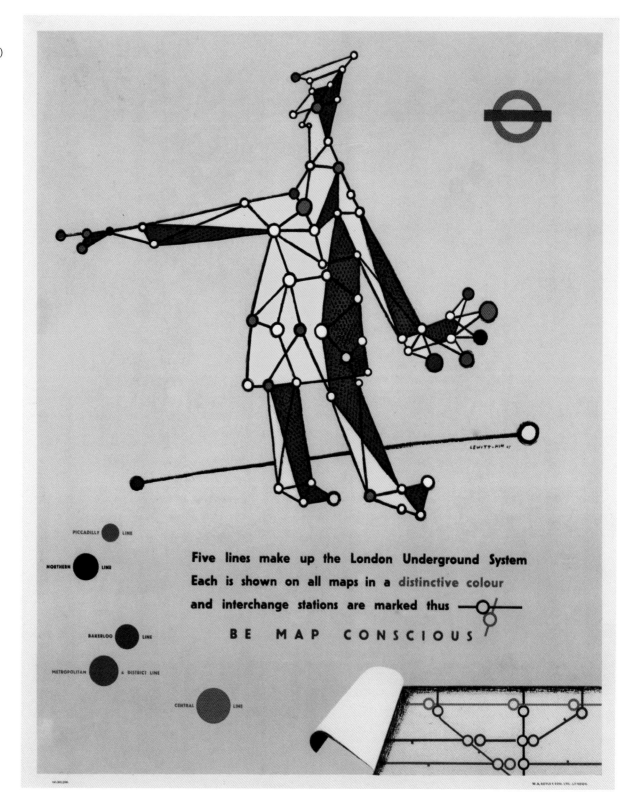

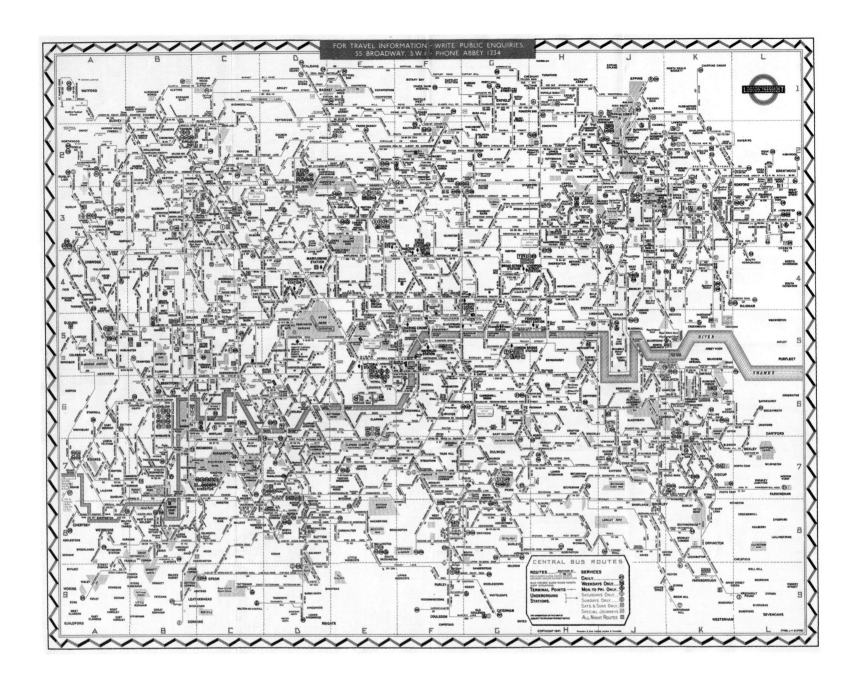

30. *Central Bus Routes*

the time being'.[24] Although the Green Line map was never realised, a more diagrammatic representation for bus, tram and trolleybus maps was introduced in 1946 and 1947 (pl. 30). It was initially described positively by London Transport as 'Modernistic', but two years later in 1948 the maps reverted to their former geographical representation, which proved more appropriate for navigation above ground.

The first Underground poster map produced after the war in 1946, retained the rectangular feel established by Beck's minimal use of diagonals (pl. 31). Developments to the design included presenting the Circle line as a distinct line in its own right, rather than as adjoining sections of the Metropitan and District lines, from which it had originally been formed; the proposed extensions to the Central and Northern lines were also accommodated. Changes to colour involved the use

30. *Central Bus Routes*
Fred J. H. Elston, 1947
456 x 577 mm (18 x 22.7 in)
Published by London Transport
Printed by Waterlow & Sons Ltd

A short-lived diagrammatic map of London's bus services. Although hailed optimistically as 'Modernistic', the design failed to provide sufficient geographic, street-level information to orientate passengers travelling by bus.

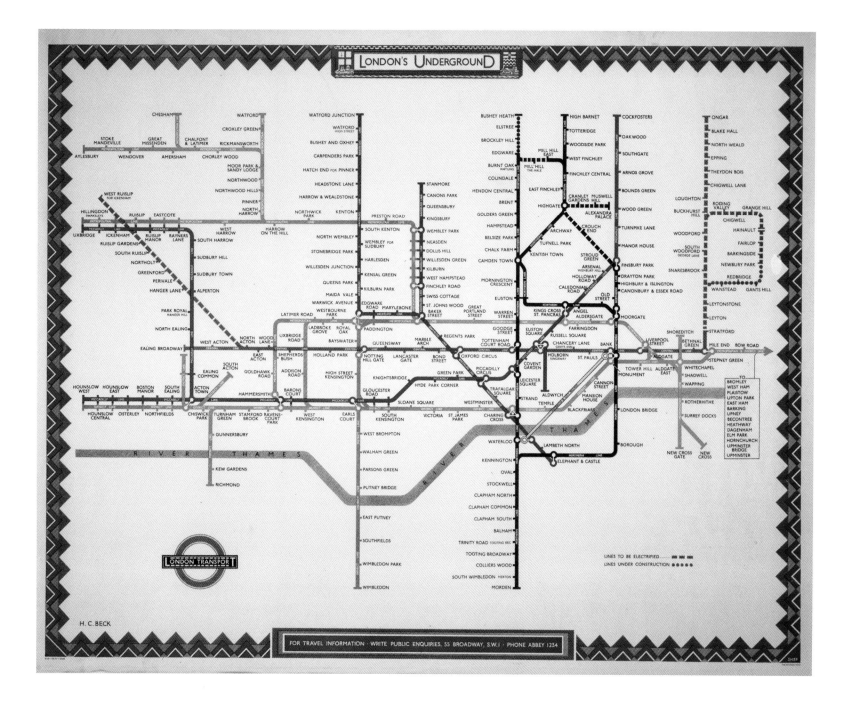

31. Poster Underground map

Harry Beck and Charles Shephard (border), 1946
Quad royal, 1016 x 1270 mm (40 x 50 in)
Published by London Transport
Printed by the Baynard Press

The first post-War new Underground map featured a bunting-style decorative border by Charles Shephard. All station names are now clearly shown in black for the first time in 15 years.

of a white line linking interchange stations; and the use of black for station names, abandoning the 15-year-old practice of printing station names in the same colour as their lines. That rule had become even more complicated since 1939, when London Transport's chairman, Lord Ashfield, had requested that station names appear in all the colours of the lines they served. The result, much to Beck's dismay, had been the encumbering duplication,

and even triplication, of station names in different colours for stations that operated on more than one line. This unpopular rule was finally dispensed with in Beck's 1946 map.

Another novel feature of the 1946 poster map is its distinctive, decorative border, designed by Charles Shephard (Shep). Although originally intended for use in 1939, the border's progress had been delayed by unresolved discussions between

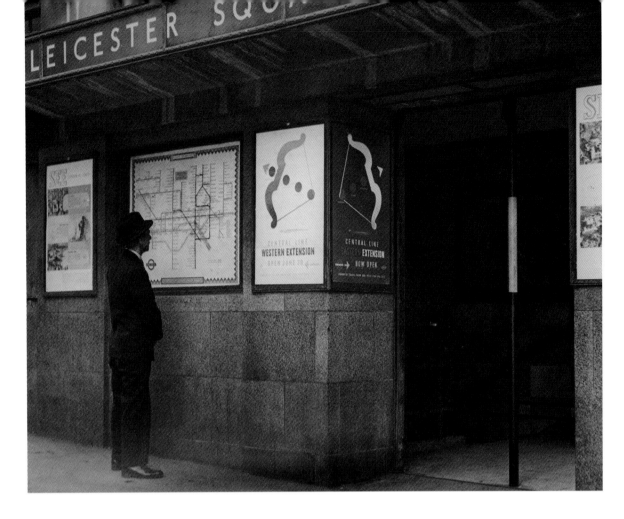

London Transport and the Baynard Press on the cost
of production. With the outbreak of war in 1939,
priorities moved fundamentally away from
ornamentation. After the war in 1945, London
Transport's acting publicity officer, H.T. Carr, wrote
to Shep expressing his intention finally to use the
border in the following year.[25] At the time, it was
unusual to embellish a standard issue poster map
with a decorative border. In the past, decorative
borders had been principally reserved for maps
aimed at tourists, in order to give a friendly,
approachable feel to the information presented.
Although Shep's border was slightly extravagant, its
bunting-like pattern conveyed an appropriately
positive, optimistic message for the time, marking
perhaps the beginning of a new post-war era for the
publicity office, and indeed for the map itself (pl. 32).
Nevertheless, in the following year, Shep's border
was replaced by a more understated version, which
remained almost unchanged for more than 20 years.

The quest for greater clarity

H.T. Carr had been London Transport's acting
publicity officer since Barman had left in 1941.
In 1947, Harold F. Hutchison was newly appointed
to the role. Hutchison recognised that the
circumstances of post-war London demanded a new
chapter for publicity. As well as hoping to repair the
damage to the Underground network, he believed
that good publicity on the Underground could
restore the morale of the public it served.

A report on signage compiled in 1948 by George
Dodson-Wells, London Transport's chief public
relations officer, stated that 'the lack of uniformity
and standardisation noticed in 1938 of course
increased during the recent war and its speedy cure
is still restricted by the shortage of materials and
staff; but leeway is gradually being restored'.[26]

London Transport map production, however, was
back on track. New pocket maps were printed ready
for distribution, and the service of posting them out

to the public on request resumed. One completely new use of the Underground map was the Sperry route indicator (pls 33–4). This machine was introduced at interchange stations in response to a problem first identified in 'The Carr-Edwards Report':

… a defect of the present system of signs is that a stranger entering a station for the first time is not given, by means of signs, any information as to the stations which it is possible to reach from that station. In most cases his only means of obtaining such information is by asking at the ticket office.[27]

At the time no ideal solution to the problem could be found through the use of signage alone. The new Sperry route indicator, however, responded to the apparent defect in signage by combining the diagrammatic map with new technology. With one press of a button, all available routes to the selected destination were illuminated on an electronic version of Beck's map. By presenting passengers with bespoke route information specific to their immediate needs, the Sperry route indicator could be seen as a prototype for today's online 'Journey Planner', available on TfL's website.

An early trial at Leicester Square station in 1947 revealed that in a week the route indicator was used 23,000 times. After the initial novelty had worn off, further testing over a longer period ascertained an average of 8,000 uses per week, of which well over half were still for 'experience and amusement', rather than used 'intelligently for service'. Although London Transport's operating department concluded that the new machine did not sufficiently satisfy the requirements of its intended function, the publicity office 'reported in its favour from the publicity and amenity point of view'.[28] The machines that had already been installed remained in use at interchange stations until the 1980s, when they were phased out due to the difficulty of keeping service information up to date.

Beck considered his 1949 map to be his best, in terms of both clarity and useability (pl. 35). It was this version of the map that the National Institute for the

33. Sperry route indicator
Photographed by Topical Press, 1947

Two women operate the new Sperry route indicator in the booking hall at Leicester Square station in 1947. Installed at interchange stations, the new machines provided clear route information at the press of a button.

34. Sperry route indicator standards and specifications drawing
Published in *London Transport Signs Manual*, 1948

A drawing outlining the standards and specifications of the new Sperry route indicator machines installed at interchange stations in the late 1940s.

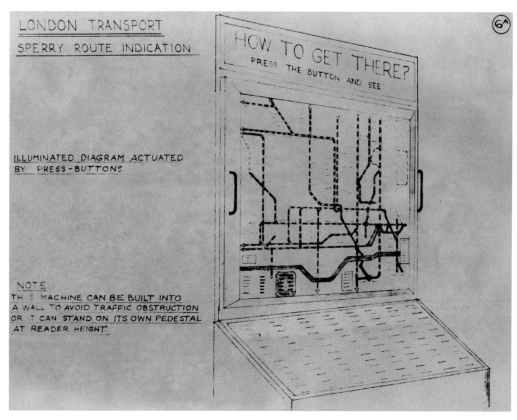

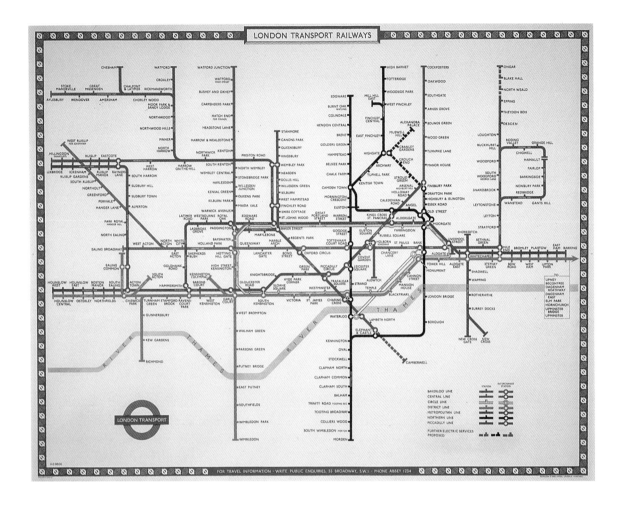

35. Poster Underground map
Harry Beck, 1949
Quad royal, 1016 x 1270 mm (40 x 50 in)
Published by London Transport
Printed by Waterlow & Sons Ltd

In Beck's view, his 1949 poster map was
the clearest and most user-friendly. It
was used by the National Institute for
the Blind for their first Braille Tube
map, issued in 1950 (pl.36).

Blind used for the first Braille Underground map,
issued in March 1950. Comprising 27 separate
Braille sheets, the map was a far cry from the
contemporaneous pocket map in terms of
portability, but it was a significant step forwards
in terms of user accessibility (pl. 36).

Over the next ten years Beck made very few
stylistic changes to his design. The rectangular
feel was retained and the colours, still in use
today – green for the District line, maroon for the
Metropolitan line and yellow for the Circle line –
were set in stone. A new feature, added in 1955,
was the grid system of coordinates. The introduction
of coordinates, linking station names to an index,
was of especial use to visitors who were unfamiliar
with the city and its maps. Although particularly
pertinent on the eve of a tourist boom, Beck
originally put the idea forward in 1933 at the
suggestion of his father. The number of grid squares

and the weight of their lines has gradually reduced
over time, in response to the ongoing quest for
greater clarity. Beck produced his last Underground
map for London Transport in 1959.

The new look

In April 1960 London Transport claimed in a press
release that their 'famous diagrammatic poster
map of the Underground, familiar to Londoners
and visitors for the last 30 years, has been given a
completely "new look".'[29] The name on the map
was Harold Hutchison who, unbeknown to Beck,
had spent the last year preparing the 'new' design
(pl. 37–8). Highlighted features included improved
information on airport and mainline station
connections to cater for an increasing level of
tourism, as well as being 'more geographical in
layout'. One reason given for the map's redesign
was the planned introduction of the so-called 'train

maps', which showed just the map's central area. They were intended for display inside every carriage alongside the traditional line diagram of the relevant section of the Tube journey (pl. 18). The train map, which remains in use today, was undoubtedly a valuable addition to the map format family, but it did not really warrant a completely new design.

While remaining essentially schematic, Hutchison's design does successfully make the map more geographically accurate, most notably in closing the gap between the two Wimbledon stations in southwest London. However, its relative geographic accuracy was a rather spurious measure of success in light of the fact that Beck's 'famous diagrammatic poster map' had disproved the need for an Underground map to be geographically accurate in order to perform its core function. The confident and somewhat premature claim in the press release that the new map was 'easier to read' was not proven in practice.

Criticisms of Hutchison's design have centred on its harsh angular characteristics, which lacked the elegance of Beck's design. The loss to the map, however, was not purely aesthetic. The offending jerky zigzags in Hutchison's version, which interrupted the flow of lines, ultimately made the map harder to read. Both in form, and in the lack of any real function, Hutchison's new map is reminiscent of the Modernistic bus maps of 1946 and 1947, whose arbitrary schematisation is now deemed counterproductive (see p. 84).

Hutchison was a talented and well-respected 'advertising man', who had brought a great deal of experience and direction to London Transport's publicity department since taking up his post in 1947. He recognised how high the bar had been set in terms of design standards, declaring in 1950: 'We hold to the Pick tradition and yet we move with the times.'[30] In the post-war era, budget restraints permitted far fewer poster commissions than in the past. Hutchison, however, was responsible for commissioning many leading artists, including William Roberts, Edward Bawden and David Gentleman. Like Pick and Barman before him, he was not afraid to reject anything falling short of 'fitness for purpose'. In 1951, after more than a year's correspondence about a design in progress by the renowned landscape painter John Nash, Hutchison finally rejected the artwork, explaining in a letter to the artist: '... so that you cannot accuse me of not being frank may I say, with the greatest respect, that while I would love to have the painting you have done on my own walls, I think on coming back to it that its colour tempo is too quiet for the walls of our stations.'[31]

Hutchison was not an artist, designer or even a draughtsman like Stingemore or Beck. Presumably the 'pepping up' he suggested for Nash's artwork was not something that he felt compelled to tackle himself. That he thought he could improve on Beck's design seems remarkably and uncharacteristically naïve. High design standards and a culture of quality at London Transport had become both a tradition and an expectation of the organisation's publicity. The 'change in style after 30 years' trumpeted by London Transport's press office turned out to be a miscalculation. Although Hutchison did seek and accommodate suggestions for improvement from colleagues, it would appear that no one had the courage, authority or perhaps the knowledge to be as respectfully or influentially 'frank' with him as he had been with Nash. Hutchison's design was sent off

36. The first Braille Tube map
Photographed by Walter A. Curtin, 1950

The first Tube map in Braille was produced by the National Institute for the Blind in March 1950. It comprised 27 separate sheets, embossed with raised Braille patterns, designed to be felt, rather than seen.

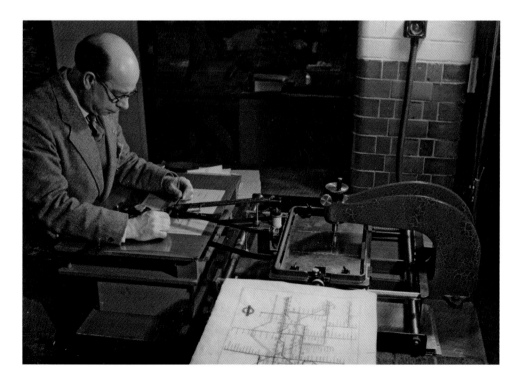

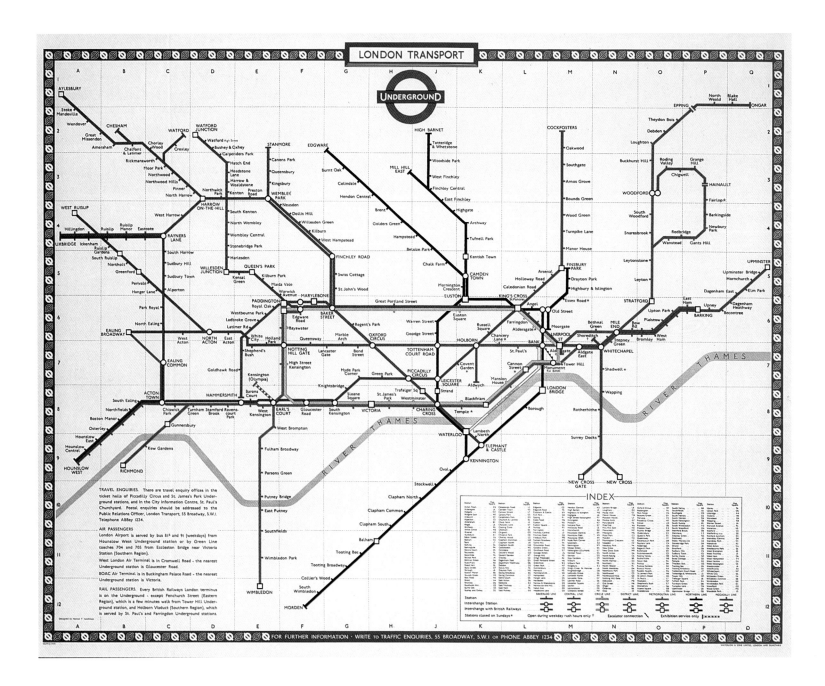

37. Poster Underground map
Harold Hutchison, 1960
Quad royal, 1016 x 1270 mm (40 x 50 in)
Published by London Transport
Printed by Waterlow & Sons Ltd

The jerky, angular lines of the Tube map's 'new look' design by Harold Hutchison lacks the elegance and flow of Beck's earlier maps.

to be drawn up professionally at London Transport's drawing office, and was printed in April 1960 as a poster map. It was followed by a pocket version later in the year.

If Hutchison felt that Beck's fairly static design of the past decade was not dealing with the Underground's rapidly expanding network, a better solution could have been found, if not by Beck, then by another experienced designer. Beck's map had managed to make the fundamentally complex physicality and concept of an underground railway network appear simple, so simple, in fact, that it gave the impression that its design might also be. The dissatisfactory result of a year's work by Hutchison, however, is testimony to just how difficult it is to make such a sophisticated design look simple.

Hutchison's design of 1960 ended Beck's direct relationship with the Underground map. By this time, Beck was no longer a London Transport employee, having left in the late 1940s to take up

a teaching post at the London School of Printing (now the London College of Communication). As he had only an informal arrangement with Barman about his consultation on all map designs, there was little that Beck could do. His status as the designer of the map was never officially or exclusively part of his job description, which ultimately made the role much easier to terminate. Beck was deeply hurt by what he felt was unfair treatment from London Transport. It was not fame or fortune that he expected from London Transport, just recognition and respect for what he had dedicated such a generous proportion of his working life and personal time to over the past 30 years.[32] He was a remarkably modest man. Ian McLaren, one of his students between 1958 and 1959, recalled:

> The majority of my colleagues and I were intrigued by his signature on the London Underground diagram; but he was extremely reticent about his part in this, which we callow

youths found excessively modest, and even a little perverse. He deftly and with great charm deflected our constant probing. This only added to the allure of the mystery; and we sensed that much remained to be said.[33]

Back to the Beck model

Hutchison's map was not replaced until almost four years later in 1964. It was Paul Garbutt, London Transport's assistant secretary, who finally redesigned or 'rescued' the Underground map after spending a large amount of his own time painstakingly reapplying Beck's principles (pl. 39). Garbutt's name appeared on subsequent maps for his restorative efforts and he remained the principal custodian of the design for nearly 20 years. Although regularly taking on board suggestions from the public and publicity office, he was mindful to avoid anything that might compromise the map's clarity. Many fundamental developments to the map were required during this time. These have included accommodating the new Victoria line in 1969; the

38. An Underground employee pasting up Hutchison's 'new look' map
Photographer unknown, 1960

At a station entrance on the Bakerloo line, the 'new look' Tube map designed by Harold Hutchison is displayed for the first time.

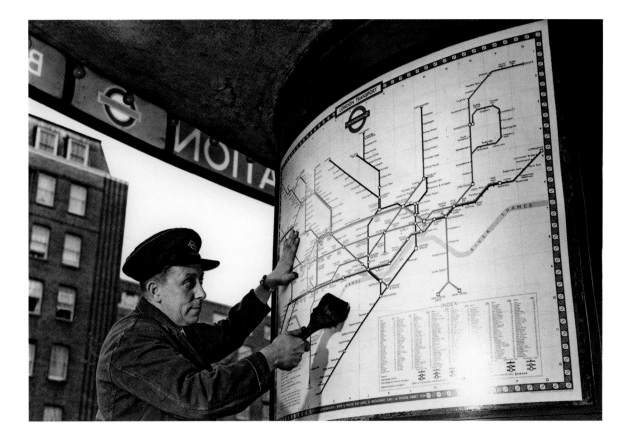

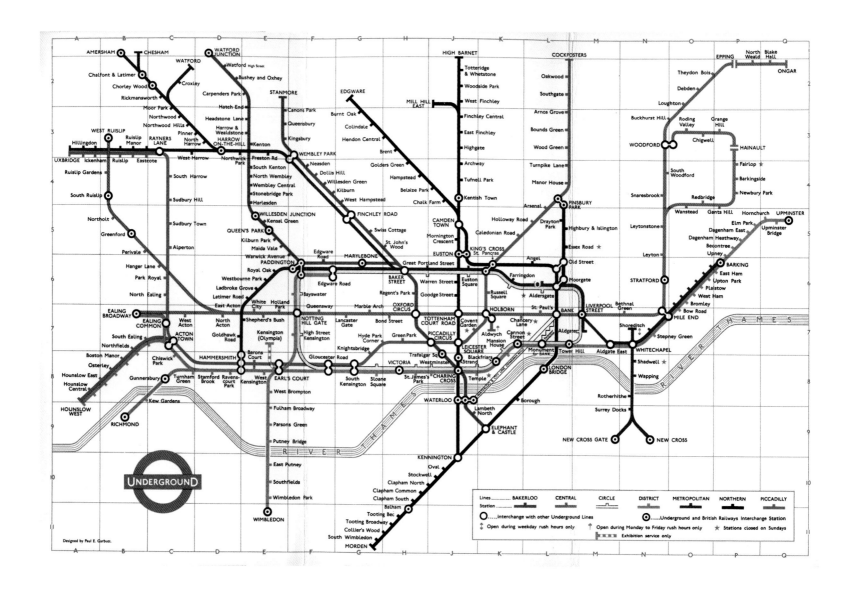

39. Pocket Underground map
Paul E. Garbutt, 1964
147 x 225 mm (5.7 x 8.8 in)
Published by London Transport
Printed by Johnson, Riddle & Co Ltd

Piccadilly line extension to Heathrow in 1977; the North London line in 1977; and the new Jubilee line in 1979 (pls 40–41). The maps of the Garbutt era, many of which were produced by or with the input of in-house designer Tim Demuth, took on all these challenges in the style of Beck, if not in his name.

In 1933 Beck's diagrammatic approach had been 'fit for purpose'. After the brief spell between 1960 and 1964 when Beck was no longer regarded as the map's principal designer and Hutchison's map instead held sway, London Transport returned to the Beck model with Garbutt at the drawing board. It has continued to serve its purpose ever since.

A huge amount of work goes on behind the scenes to ensure that the public face of London's Tube map remains characteristically clear. Doug Rose, who designed a number of the Underground's official maps from the mid to late 1980s, whilst working for the information design agency FWT, aptly puts it:

> Designing a successful diagrammatic map is much harder than it looks and simply joining lines on fixed angular trajectories, according to a shallow understanding of the supposed 'rules', can achieve a map that is much harder to use

A return to the Beck model, after Harold Hutchison's short-lived, 'new look' (pls 37–8). Although Beck had now left London Transport, his fundamental design principles would be applied by Garbutt over the next 20 years.

than may be expected ... There is a lot more to a virtuoso musical performance than playing the notes in the right order ... The rules in themselves are important, but it is the execution of them, with understanding, that is crucially important.[34]

Beck's design was successful because he fully understood the problems that the map needed to solve. He knew how to prioritise the information required by the user and, perhaps more importantly, he knew what information was superfluous. He also understood that nothing was static. London's Underground system is a dynamic, growing entity. By definition, the design of its map should have the capacity to accommodate change. Beck was the first person to fully acknowledge and address this challenge as a governing principle of his design. He recognised the need not just for a new map, but for a robust design solution for all future maps.

Growing pains

The versatility and adaptability of Beck's design has allowed a multitude of extensions and additions to be fitted in over the years. In 1973 the first comprehensive diagram of all the surface and Underground railways of Greater London was designed in London Transport's publicity office by Tim Demuth (pl. 42). Coordination between mainline railways and the Underground over the use of their maps, however, has a much longer history. In 1937 space was allocated to display an Underground map within the London Transport area of all mainline station booking halls. At the time, Beck had responsively drafted a speculative design accommodating London's entire rail network above and below ground, which he proposed the following year. The map was never published, however, due to the negative impact of so many additional lines on the clarity of the design. When Demuth produced his

40. *Can you see the join?*
Artist unknown, 1971
Double royal, 1016 x 635 mm (40 x 25 in)
Published by London Transport

Catching the reader's eye with a teaser, this publicity poster highlights the Victoria line's seamless extension to Brixton in 1971, through the interchange station at Stockwell.

41. *London Transport presents a new line in stations.*
Artist unknown, 1979
Published by London Transport
Printed by C. J. Petyt Ltd

The opening of the Jubilee line between Stanmore and Charing Cross in 1979 was promoted by an upbeat poster, forming part of a series using the slogan, 'We'll bring London to your door.'

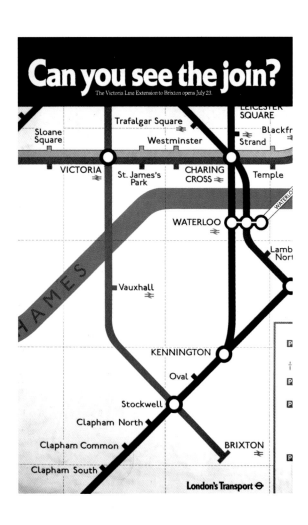

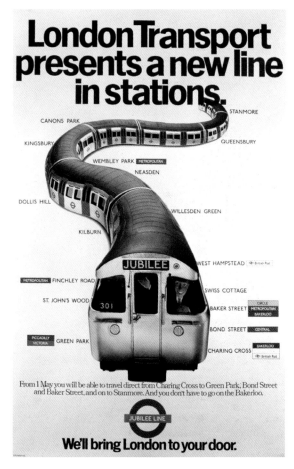

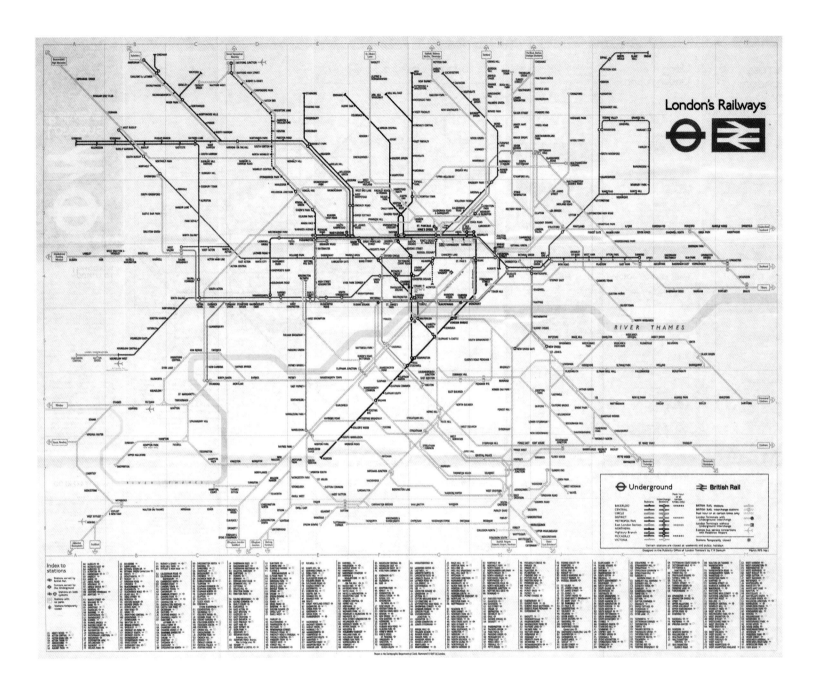

London's Railways

42. *London's Railways*
Tim Demuth, 1973
435 × 554 mm (17 × 21.8 in)
Published by London Transport
Printed by C. J. Petyt Ltd

1973 design, he acknowledged with great modesty that he was basically expanding Beck's 1938 model to accommodate a larger area and more services.

Since 2009 the introduction of mainline rail fares to the Oyster ticketing system has required a combined rail and Underground map to be displayed at all interchange stations (pl. 43). The appearance of these combined railway maps is becoming increasingly cluttered. They lack the simple intelligibility that the public have come to

expect and which designers have learned to strive for. The standard Underground map, which is usually displayed alongside the combined railway map, appears reassuringly clear by comparison.

Today, the standard pocket Tube map retains the same dimensions as in 1933, although it now includes nearly twice as many stations. With the incorporation of London rail services, such as the Docklands Light Railway (DLR) and the London Overground network, the clarity of the map's design

The first combined rail and underground map to successfully present all mainline and Underground services in the London and Greater London area.

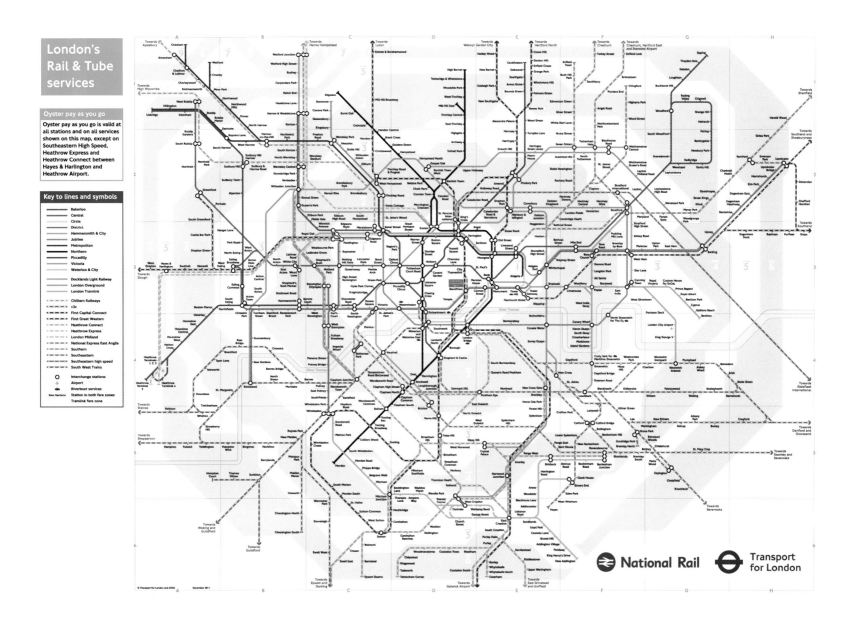

43. *London's Rail & Tube Services*
Artist unknown, 2011
Quad royal, 1016 x 1270 mm (40 x 50 in)
Published by TfL and the Association of
Train Operation Companies, National Rail

Since the introduction of the Oyster
ticketing system to accommodate mainline
services in 2009, combined mainline and
Underground maps are now displayed at all
interchange stations to help passengers
travelling across the two systems.

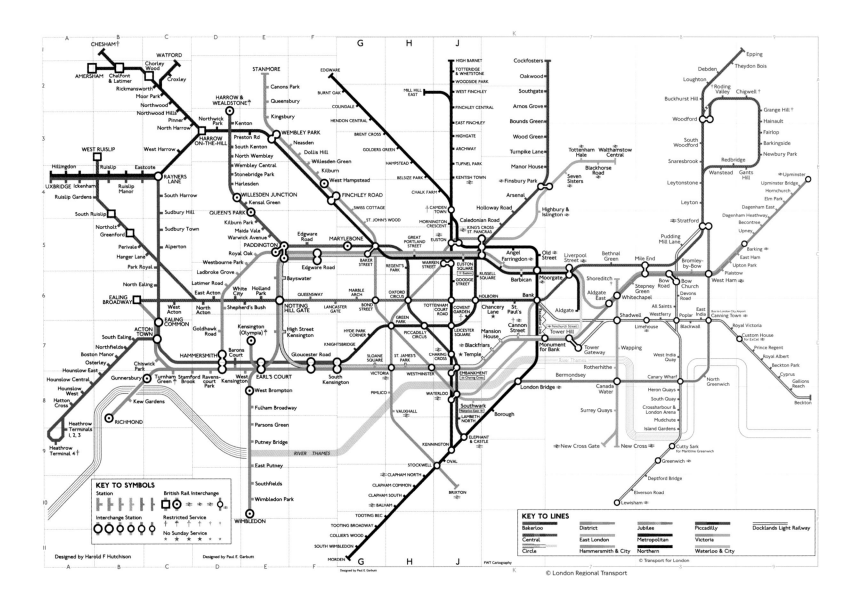

is understandably beginning to buckle under the pressure (pl. 44).

In addition to TfL's own research and revision of the Tube map, a number of unofficial experiments have been carried out over the last ten years to address the challenges presented by an increasingly cluttered design. Rather like Beck 80 years ago, the psychologist and designer Maxwell Roberts has produced over 50 alternative approaches to mapping London's Underground.[35] To develop a greater understanding and awareness of what makes a good design work, Roberts' maps apply, revise and break rules. As well as exploring Beck's use of 45-, 60- and 90-degree angles further,

Roberts' extensive range of maps even includes one, the *Curvy Map*, that abandons angles, and the straight lines that they necessitate, altogether. The feedback from Roberts' evaluation of his *Curvy Map* of 2007 (pl. 45), suggests that public opinion is usually divided. What some passengers found valuable, fun or easy on the eye, others felt lacked the structure of geometry, deemed essential in the absence of any geographic accuracy.

It has become more vital than ever for every element of the map to earn its keep. The alternative to an entirely new design is to remove any superfluous details, which Roberts has termed 'information pollution', and Doug Rose refers to as

44. *Underground Maps after Beck*
Maxwell Robert, 2005
Digitally created

From left to right this clever composite map merges the designs of standard Tube maps from the early 1960s to 2000, demonstrating the subtle changes that have been made by designers over time.

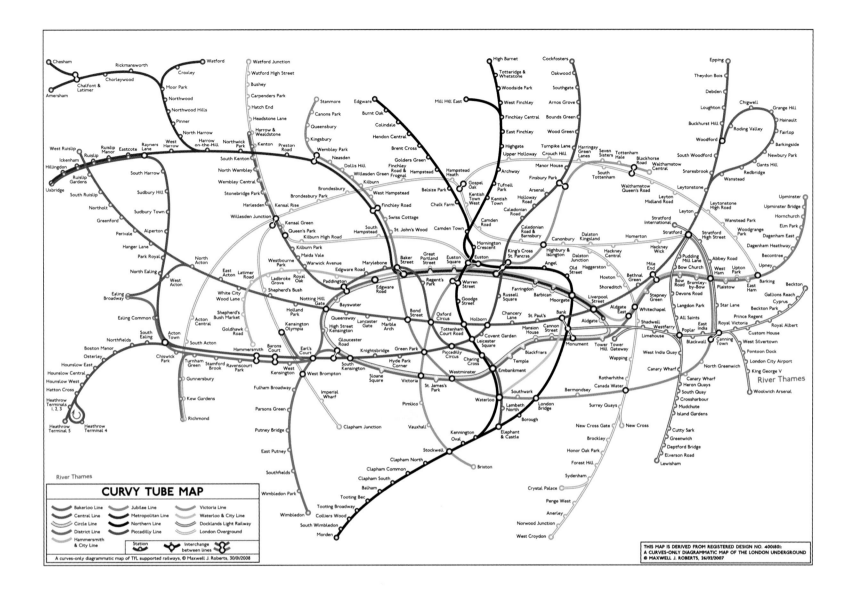

CURVY TUBE MAP

Bakerloo Line	Jubilee Line	Victoria Line
Central Line	Metropolitan Line	Waterloo & City Line
Circle Line	Northern Line	Docklands Light Railway
District Line	Piccadilly Line	London Overground
Hammersmith & City Line	Station	Interchange between lines

A curves-only diagrammatic map of TfL supported railways, © Maxwell J. Roberts, 30/01/2008

THIS MAP IS DERIVED FROM REGISTERED DESIGN NO. 4001801:
A CURVES-ONLY DIAGRAMMATIC MAP OF THE LONDON UNDERGROUND
© MAXWELL J. ROBERTS, 26/02/2007

45. *Curvy Map*
Maxwell Robert, 2007

One of the many alternative London Tube map designs produced by the psychologist and author Maxwell Roberts. His experimental *Curvy Map*, as its title implies, removes all angles and straight lines.

'visual noise'. One feature that seems to have earned a place in passengers' hearts, as well as its keep on the map, is the river Thames. The river has been the only topographical feature on the map since 1926, albeit a varying and essentially diagrammatic one. When a design without the river was submitted for approval in 1939, Pick advised that it be reinstated before the map was printed.

Ken Garland, the graphic designer and author of the first definitive text on Beck and his design, carried out an informal questionnaire in 1968 to ascertain whether London's contemporary travelling public still found the presence of the river useful. Without exception, he discovered that

they did.[36] The response to its removal nearly 40 years later in 2009, although somewhat sensationalised through social media, proves that public opinion has not changed (pl. 46). The river is still believed by the majority of users to help orientation and navigation, which is the reason that Stingemore added it in 1926, and the official reason that it was restored in 2009. In response to the latest public debate over the Tube map, Peter Vujakovic's cartoon, *Great minds of the past grapple with the big issues of today* (pl. 47), appeared in the autumn edition of the British Cartography Society's magazine, *Maplines*. His witty adaptation of a sixteenth-century portrait of Queen Elizabeth I

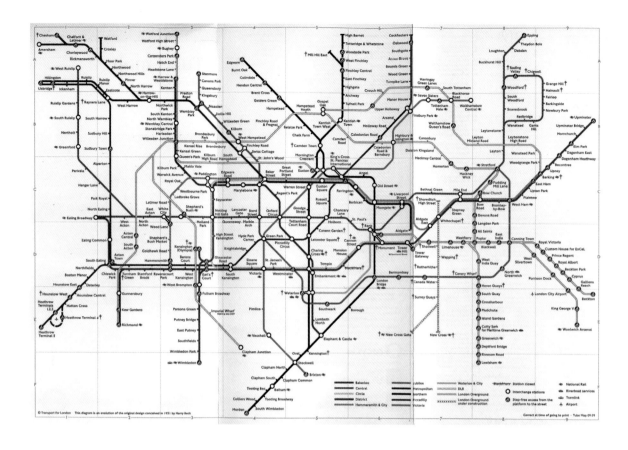

46. Pocket Tube map
Published by TfL, 2009
300 x 147 mm (11.8 x 5.7 in)

The river Thames, which has served as a user-friendly landmark on the pocket Tube map for over 80 years, was briefly removed in September 2009.

employed the same sense of fun as had George Morrow's cartoon for *Punch* 100 years earlier (pl. 6).

Today the public clearly holds a very personal and powerful sense of ownership over the Underground map. Remarkably, however, this has only really surfaced during the last 20 years. In 1994 Ken Garland's book celebrating *Mr. Beck's Underground Map* was published, marking the first significant step towards the limelight for Beck's designs. It was followed at the time by a BBC documentary on the subject and by the permanent display of the 1931 presentation drawing at the London Transport Museum. Eventually, in 2001, TfL added a credit to the contemporary Underground map stating: 'This diagram is an evolution of the original design conceived in 1931 by Harry Beck.'

References to Beck's map also began to appear in more mainstream literature. The glowing reference from Bill Bryson in *Notes from a Small Island* in 1995 has undoubtedly introduced the

'forgotten hero' to more people than all subsequent books on the map put together.[37] The following year, in his novel *Neverwhere*, Neil Gaiman describes his protagonist's feelings on experiencing London for the first time: '... huge, odd, fundamentally incomprehensible, with only the Tube map, that elegant multi-coloured topographical [topological] display of underground railway lines and stations, giving it any semblance of order.'[38]

Beck's map is now recognised as a landmark achievement in the history of design, but it has also become thoroughly embedded in popular culture (pl. 48). For its more recent designers, the growing iconic status of the map has presented yet another barrier to contend with. For any significant change to be accepted, it would need to have such a profound effect on the map's useability that it remains hard to believe there will ever be a major move away from the 'Beck Map' model.

47. *Great minds of the past grapple with the big issues of today*
Peter Vujakovic, 2009
Published by the British Cartography Society in *Maplines*

A witty cartoon alluding to a social media-fuelled public debate surrounding the river's removal from the pocket Tube map in 2009 (pl.46).

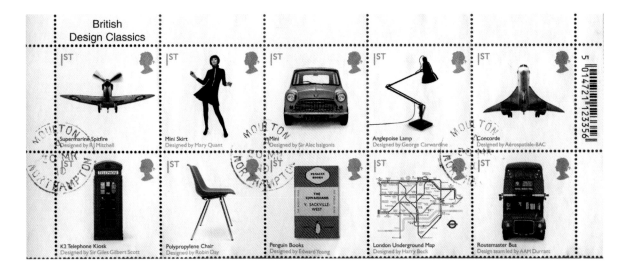

48. British Design Classics:
London Underground Map
HGV design group, 2009
46 x 100 mm (1.8 x 4 in)
Published by Royal Mail Ltd

Now an undisputed design icon, Beck's
Tube map takes its place alongside
the miniskirt and Concorde in a
contemporary set of Royal Mail stamps
celebrating British design classics.

NOTES

1 Garland, Ken, *Mr Beck's Underground Map*, Capital Transport, Harrow, 1994, p.9.

2 Bryson, Bill, *Notes from a Small Island*, Transworld, London, 1995, pp 53–4.

3 Pick, Frank, 'Art and Commerce', Pick archives, the London Transport Museum, February 1916, p.16.

4 'The Carr-Edwards Report 1938', London Transport internal documents, the London Transport Museum, 1938.

5 Garland, Ken, op.cit., p.8.

6 Leboff, David and Demuth, Tim, *No Need to Ask! Early Maps of London's Underground Railways*, Capital Transport, Harrow, 1999, pp58–9. The book provides a full and fascinating account of London Underground maps from the 1860s to 1933.

7 Ibid, p.62.

8 Frank Pick quoted in *The Journal of the Royal Institute of British Architects*, 25 Apr 1936.

9 Garland, Ken, op.cit., p.17.

10 Letter to Mr Robbins, chief publications officer, 7 Apr 1964 in Leboff, David, 'The London Underground Map', unpublished dissertation, 1985, p.xxiii.

11 We know that Beck was paid just ten guineas for his initial design, which was completed whilst he was out of work. However, as he became an Underground employee again in 1932, there is some uncertainty as to whether he received any further additional payment to his salary for his subsequent work on the map. Beck was, however, quite casual about fees, stating that his commissions had long been by his own choice on a 'no printing, no fee' basis.

12 Garland, Ken, op.cit., p.19.

13 *The Railway Gazette*, 14 Jul 1933.

14 'The New Underground Map', *T.O.T. (Train, Omnibus, Tram) Staff Magazine*, Mar 1933, p.77.

15 Garland, Ken, op.cit., p.21.

16 'The New Underground Map', *T.O.T.*, op. cit., p.77.

17 Garland, Ken, 'The design of the London Underground diagram', *The Penrose Annual*, vol. 62, 1969, p.71.

18 Garland, Ken, *Mr Beck's Underground Map*, op. cit., p.78.

19 Dow, Andrew, *Telling the Passenger Where to Get Off: George Dow and the Evolution of the Railway Diagrammatic Map*, Capital Transport, Harrow, 2005. George Dow's son, Andrew Dow, provides a definitive account of his father's work for the London & North Eastern Railway (LNER), and a detailed history of the origins of diagrammatic maps within the context of railways.

20 Garland, Ken, *Mr Beck's Underground Map*, op.cit., p.32.

21 London Transport, publicity meeting minutes, TfL archives, minute 7, 18 Oc 1939.

22 Roberts, Maxwell J., *Underground Maps Unravelled: Explorations in Information Design*, Colchester Institute, University of Essex, Essex, 2010, p.11.

23 Letter to Mr Robbins, chief publications officer, 7 Apr 1964 in Leboff, David, 'The London Underground Map', unpublished dissertation, 1985, p.xiv.

24 London Transport, publicity meeting minutes, TfL archives, 20 Sept 1934.

25 Correspondence between H. T. Carr, London Transport's acting publicity officer, and Charles Shephard (Shep), the London Transport Museum collection, 1939–1945.

26 Dodson-Wells, George, 'The Carr-Edwards

Report 1938 with Suggested Amendments 1948: Signs at Stations', London Transport internal document, the London Transport Museum Library, 1948.

27 Ibid.

28 Ibid.

29 London Transport press release, TfL archives, 19 Apr 1960.

30 Hutchison, Harold, 'Publicity Relations at London Transport', London Transport internal document, the London Transport Museum Library, 1950.

31 Letter from Harold Hutchison to John Nash, 30 Nov 1951, the London Transport Museum collection, 1951.

32 A full account of Beck's difficult relationship with his inspired creation, which became almost a curse and an obsession, including the pained correspondence with Harold Hutchison, is fully documented in Ken Garland's *Mr Beck's Underground Map*, Capital Transport, Harrow, 1994.

33 McLaren, Ian, 'Harry Beck would have been amused', *Baseline*, no.21, 1996, p.33.

34 'The London Underground Map', an internal report compiled by the design agency FWT for London Underground, 2007, p.3.

35 Some are included in Roberts, Maxwell J., *Underground Maps After Beck: The Story of the London Underground Map in the Hands of Henry Beck's Successors*, Capital Transport, Harrow, 2005. More can be viewed on Roberts' website, www.tubemapcentral.com

36 Garland, Ken, *Mr Beck's Underground Map*, op.cit., p.18.

37 Bryson, Bill, op.cit., p.54.

38 Gaiman, Neil, *Neverwhere*, BBC Books, London, 1996, p.8.

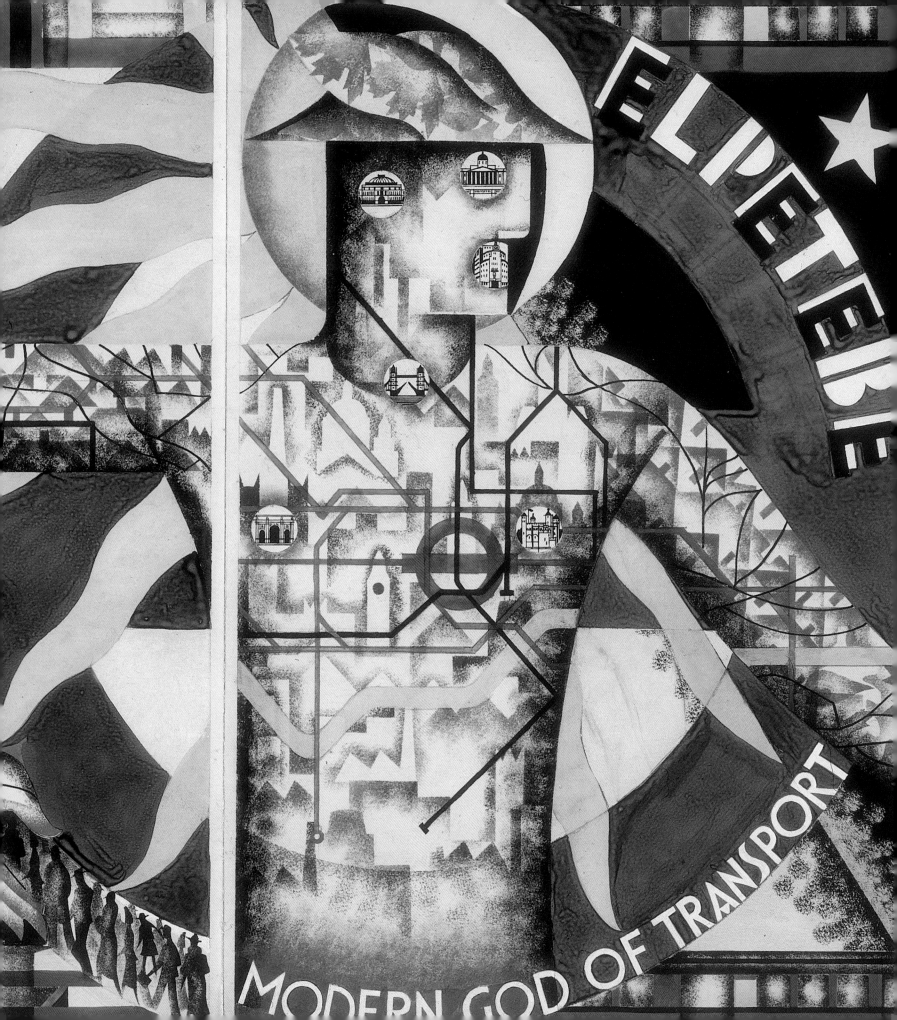

BECK AND BEYOND

INSPIRING MAPS, PUBLICITY, ART AND DESIGN

The London Tube map is now so iconic that it has
become a symbol of civic pride, something you are as likely to see
on a bag or T-shirt as you are on an Underground station platform.[1]
(Peter Barber, 2011)

LONDON'S UNDERGROUND MAP can be printed as many as a hundred million times a year. In addition to the vast quantities published as navigational aids – for platforms and ticket halls, diaries, tourist guides and the *London A–Z* – many more are purely illustrative. The map features in magazines, newspapers and books on London, its history and environs, as well as on a plethora of commercial products, from T-shirts to board games. It has inspired cartography, art, advertising, academic theory and the public imagination worldwide. Over the last 80 years, Beck's distinctive diagrammatic design has been analysed, canonised and plagiarised.

Transport mapping worldwide

The diagrammatic approach, while not a universal 'one style fits all' method, has been successfully applied for the mapping of train, metro and tramway systems, as well as airline services, cycle paths and ski resorts. Rather surprisingly, however, in the light of its instant success in 1930s London, Beck's diagrammatic map was not widely adopted by other transport systems until later in the century. The London & North Eastern Railway (LNER) had from the late 1920s displayed carriage diagrams

representing its suburban rail network, but these were not given out to passengers as free network maps and did not have an equivalent status to that of the Underground map (see pp. 74–75).

As early as 1931, other international metro systems, such as the Berlin S-Bahn, had been developing concurrently to Beck diagrammatic mapping principles including the exclusive use of 45-degree angles (pl. 3).[2] In Sydney, Australia, a Beck-style pocket map was produced for the city's suburban railway system in 1939 (see pl. 2). Although it is likely that the design was produced in consultation with London Transport (LT), t carries no acknowledgement in spite of its striking similarity to Beck's design.

Some airlines, too, experimented with diagrammatic route maps. Just six years after Beck's map had appeared in London and the year before the Sydney map was published, James Gardner displayed a modern route diagram in a poster from 1938 to promote Imperial Airways, whose services spanned the globe between the two cities (pl. 4).

Beck applied his own diagrammatic principles to the Paris Metro in 1951, although not at the request of the Régie Autonome des Transports Parisiens

1. *Modern God of Transport* (detail)
Lilian Dring, *c.*1938
379 x 762 mm (15 x 30 in)

An unused poster artwork presenting London Transport in the guise of a modern god of transport. The powerful design, intended as a triptych, was unfortunately deemed too expensive to print.

2. Berlin S-Bahn map
Designer unknown, 1931
Published by S-Bahn

A diagrammatic map, predating the publication of Beck's design by two years (chapter 2, pl. 1), it uses straight lines and 45-degree angles to present Berlin's S-Bahn rail network.

3. Sydney Suburban and City Underground Railway map
Designer unknown, 1939
165 x 248 mm (6.5 x 9.7 in)
Published by the Commissioner for Railways, New South Wales

The Sydney railway map is strikingly similar in design to Beck's diagrammatic Tube map, introduced in London six years earlier in 1933 (chapter 2, pl. 1).

4. *Imperial Airways*
James Gardner, 1938
Published by Imperial Airways
Double royal, 1016 x 635 mm (50 x 40 in)

A poster promoting Imperial Airways'
international airline services spanning
the British Empire from London to
Sydney. A diagrammatic map is featured
in the bottom left-hand corner.

(RATP), London Transport's French counterpart,
which had been set up in 1948 to run the Metro and
bus services in Paris (pl. 5). An original preparatory
drawing for the design signed by Beck was
discovered and acquired by the London Transport
Museum in 2006 (pl. 6). Head Curator at the time,
Oliver Green, stated: 'No correspondence survives,
but the Paris transport authority (RATP) presumably
said 'non' and their Metro map continued to look
like a tangle of coloured spaghetti.' [3]

Other established systems, such as the New
York Subway in the USA, were not suited to Beck's
approach. New York's network called for the
simultaneous presentation of both express and
local lines, which made it particularly difficult to
simplify into diagrammatic form. Despite various
attempts to improve the map's design over the
years, including a number of schematisations, the
current official 'pocket' map still unfolds into
something very large, unwieldy and difficult to
interpret. The American design to have drawn most
directly on Beck's model, especially in its exclusive
use of 45- or 90-degree angles, is that created by
Massimo Vignelli in 1972 (see pl. 7). A copy of
Vignelli's map, which has become a design icon in
the USA, is on display at the Museum of Modern
Art (MoMA) in New York. As a travel map, however,
it was apparently unpopular with passengers who
found the lack of geographical accuracy frustrating.
In 1979, it was replaced with a design by Michael
Hertz Associates, which included more
topographical features.

By contrast, the success of Sydney's suburban
railway map was due in part to the much smaller
size of its railway system compared to that of New
York. In effect, the most efficient appropriations of

the 'Beck-style' diagrammatic approach have tended to be on relatively small and simple networks, such as Copenhagen's S-train in Denmark, St Petersburg's Metro in Russia and San Francisco's BART system in North America.[4]

Over the last ten years, Transport for London (TfL) has also successfully applied Beck's design principals to mapping the rather unruly dynamics of London's bus network. For greater clarity, the bus services were divided into smaller geographical 'chunks' or areas that could be presented as clear poster diagrams. Known as spider maps, each poster diagram provides location-specific route information tailored to every bus-stop. Together with local area maps, line diagrams and ibus technology, which communicates real-time service arrival information, passengers are now afforded unprecedented clarity when navigating through London by bus.

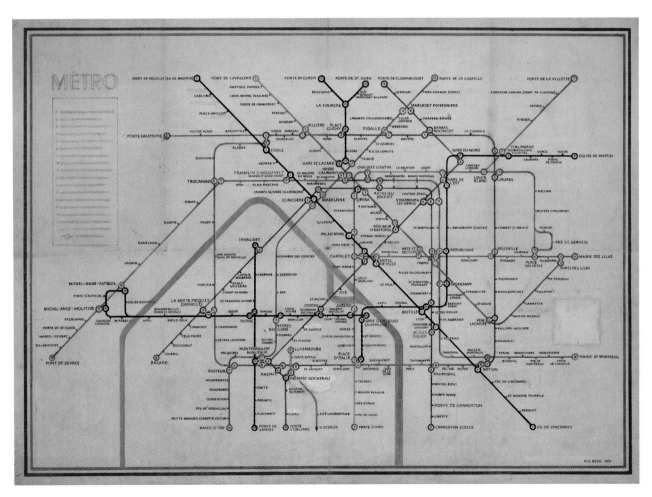

5. The Paris Metro map
F. Lagoutte, 1949
155 x 300mm (6 x 11.8 in)
Published by the Régie Autonome des Transports Parisiens (RATP)

A more geographical representation of the city's Metro system than was in use in London, where Beck's diagrammatic design of 1933 had become the standard map for the Underground.

6. Presentation drawing of the Paris Metro map
Henry C. Beck, 1951
545 x 766 mm (21.5 x 30 in)

An unpublished proposal for a diagrammatic-style Paris Metro map, submitted speculatively by Beck to the RATP (the French equivalent of London Transport).

7. The New York Subway
pocket map
Massimo Vignelli, 1972
Published by the New York
City Transit Authority

A short-lived, diagrammatic
design for New York's subway
system that was more popular
with designers than with New
York's travelling public. It was
replaced three years later by
a more geographically
accurate map.

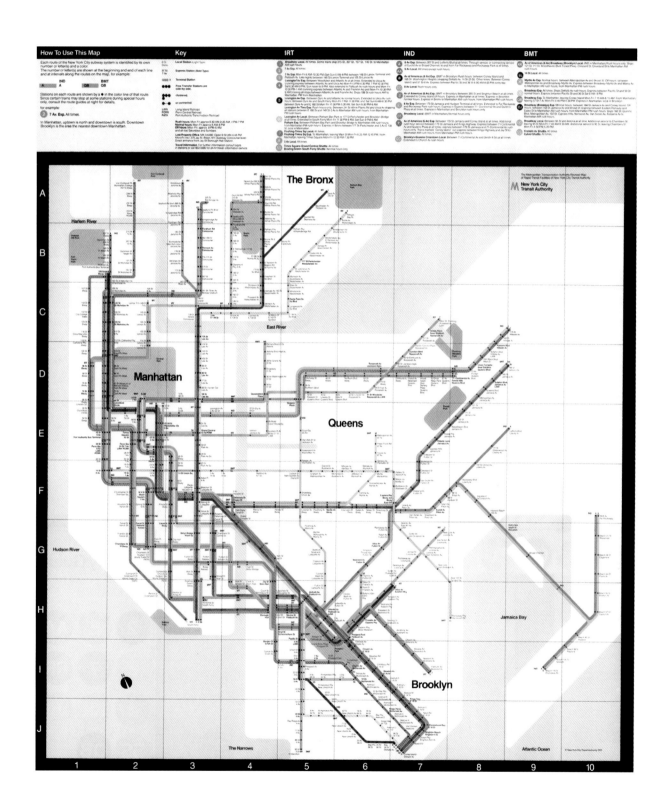

8. Cigarette case
Artist unknown, *c.*1938
140 x 50 mm (closed) (5.5 x 2 in)

Produced by Mayfair Cigarettes
A gold-coloured, electroplated cigarette case, engraved inside with a handy map of the London Underground from *c.*1938.

Souvenir value

The souvenir potential of London's Tube map is not a recent phenomenon. Remarkably, Beck's design began to appear on all manner of products before it was acknowledged as an iconic or influential map (pl. 8). By the late 1930s, London Transport's publicity office had received requests both for permission and financial support in using the map in various products and games, as well as in guidebooks.

The outbreak of World War II (1939–45) heavily restricted London Transport's publicity budget and objectives. It was no longer able to support the development of ideas that were not simply navigational. Less functional products, even ones with some promotional potential, such as Alex Strasser's board game, *Round and Round the*

Underground, were rejected during wartime. Strasser's proposal, submitted in 1940, was essentially a family game harking back to nineteeth-century parlour games, such as *Labyrinthus Londinium*, which invited players to race across London. With modern developments in public transport, particularly the Underground, this traditional genre could now be enriched with an exciting new dimension. At the time of Strasser's submission, however, Pick was unable to justify the expense of producing a parlour game, in spite of its promotional value. In response, Pick wrote: 'I have had a look at your game. It seems as though it might be quite an amusing and interesting one and certainly is a variant upon present race games.' In light of the contemporary climate, however, he was forced to conclude: 'In these days of war it

is manifestly impossible for the Board itself to consider taking up your game for publicity purposes. Our expenditure upon publicity must be curtailed within narrow limits and must be strictly utilitarian in character.'[5]

It was not until the late 1940s that post-war Underground map production was fully resumed. As well as printing their own Tube maps, London Transport authorised their reproduction in many railway and tourist guides. Since the introduction of Beck's design in 1933, Pick maintained that London Transport 'should be prepared to subsidise maps and other printed matter required by visitors to London in particular'.[6] As well as performing a civic duty, the extended use of the map also provided publicity, which sufficiently outweighed any supplementary production costs.

Fees for reproducing the map were not imposed until the 1980s. In fact, in the 1930s and 1940s, many publishers believed that they should be paid for reproducing the Tube map, or that a reciprocal degree of advertising should be offered in return. The publisher George Bradshaw, for instance, felt in 1946 that the inclusion of the Underground map in their railway guide should incur a fee of £15 an issue, which was eventually waived in exchange for the use of London Transport's printing plates.[7]

Pick had been quick to recognise and embrace the promotional return that the new map's ubiquity brought London Transport. As demand for its commercial use grew in the post-war period, the first tentative attempts were made to harness the benefit of the map's widespread reproduction. In 1947, London Transport's newly appointed publicity officer, Harold Hutchison, established a set of guidelines. These were intended to help make

decisions on which proposed ventures should be supported, particularly in the area of toys and games. The minutes of a publicity office meeting record his concession that: 'The value of this free publicity media was considered sufficient to justify granting these requests', provided:

> No use was made in any circumstances of the Board's bullseye sign.
> The accuracy of details was checked by the Board.
> Permission was granted only to reputable commercial undertakings.[8]

By the 1960s, in addition to a record sleeve, products featuring the Underground map included table-cloths, a snakes-and-ladders board game, scarves and even a powder compact case (see pls 9–11). These products were principally sold in select stores in London's West End.

The expanding tourist market

In 1964 London Transport opened a shop at Griffith House on Marylebone Road, London, which sold London Transport posters, postcards and publications (pl. 13). It was not the first. An earlier shop at 55 Broadway had sold posters between 1933 and 1939, but closed due to the impact of Purchase Tax, as well as wartime and post-war paper shortages. The new store on the busy Marylebone Road was driven more by public relations than by profit. It provided the main sorting and distribution point for the bulk stock of maps and leaflets, as well as serving as an entry point to London Transport's photographic library. The shop also stocked surplus quad royal poster maps, although they were not actively promoted for sale.

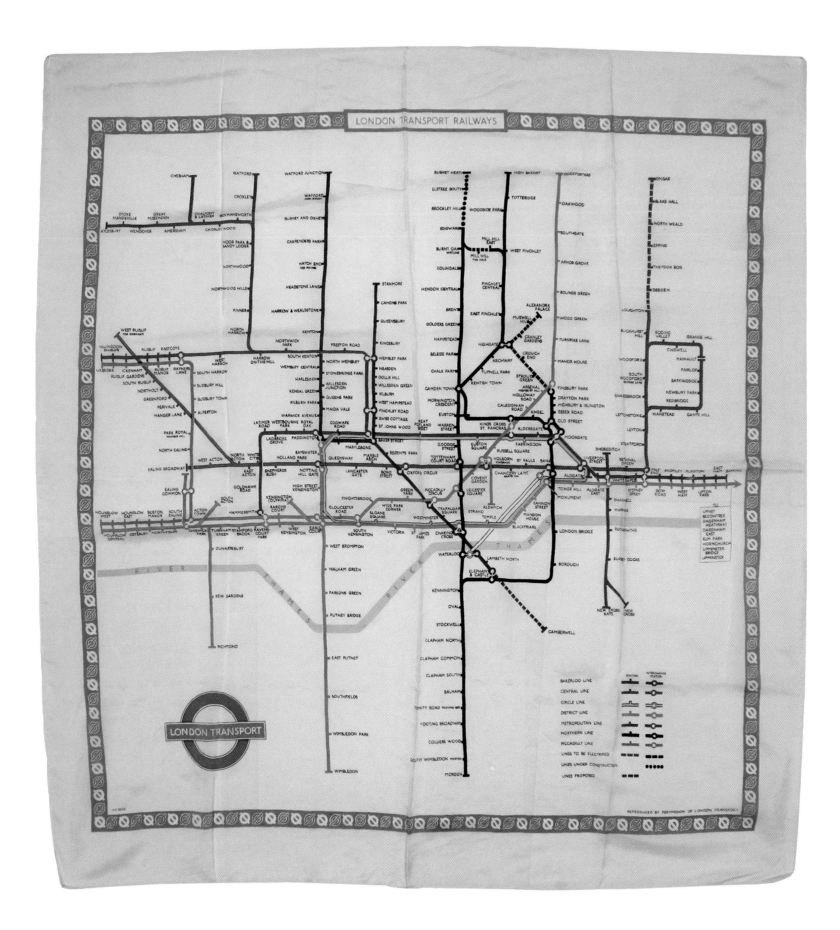

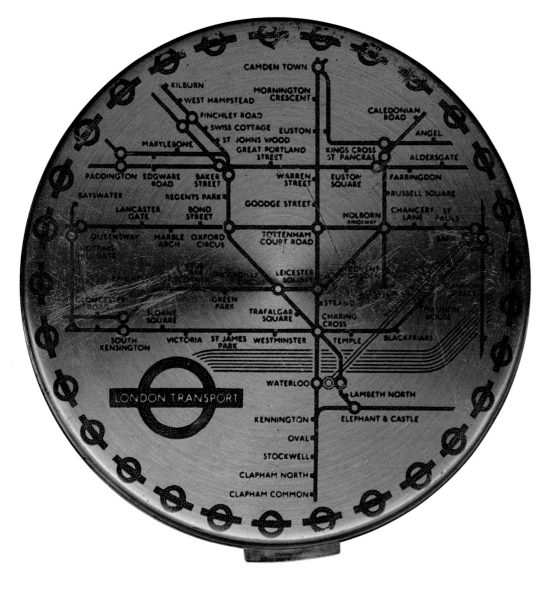

10. Powder compact case
Artist unknown, c.1955
87 x 84 x 12 mm (3.4 x 3.3 x 0.5 in)

A ladies' brass, powder compact
case decorated on the outside of
the lid with a map of the London
Underground in the mid 1950s.

This filtered down from a company-wide
commercialisation of the business, which had
sparked the complete reconfiguration of London
Transport's approach to publicity. A consultant,
Richard Fagg, was drafted to Griffith House to set up
what today might be referred to as a 'merchandise
strategy'. At the same time, a commercial manager,
Paul Castle, was recruited to centralise the function
of licensing, and to establish a programme of retail
commercialisation. He employed the development
company Photo Precision to design and distribute
souvenirs, and it was from this point on that the true
value of the Underground map as a commercial
asset began to be realised. Two additional but short
lived shops opened at Charing Cross station, one
selling posters and one souvenirs. Along with the
shop at Griffith House, they were stocked with the
new map-related product range. Apart from a few
items that never took off, like Tube map soap, many
are still in production today.

Up to this point there had been no obvious
demand for the bulky Quad Royal poster maps,
which at 102 cm x 127 cm (40 x 50 in) were designed
for display in station ticket halls and on platforms.
But the smaller line diagrams, at least half the size,
which appeared above passenger seats in Under-
ground carriages, were available for sale from the
mid-1970s. These were more popular than the quad
royal due to their less cumbersome size.

As part of Photo Precision's new product range,
a smaller version of the quad royal poster map was
printed for sale, aptly proportioned to home décor at
63.5 x 76.2 cm (25 x 30 in). Maps in this more compact
size, which have been printed ever since, consis-
tently outsells any other London Transport poster
or Underground map-related product.

9. Underground headscarf
Artist unknown, c.1950
910 x 859 mm (35.8 x 33.8 in)

A fashionable rayon headscarf
printed with the 1948 London
Underground map, it would have
been sold in London's West End
department stores.

It was not until the mid-1970s that London
Transport began to exploit the souvenir value of
their own map. Starting with T-shirts in 1977,
products were developed in-house for sale in the
shop (pl. 13). This coincided with the Queen's Silver
Jubilee celebrations and an increased demand for all
things British. The Tube map, like the roundel logo,
was beginning to reveal itself as a powerful
and popular symbol of London. Products featuring
the map were occasionally advertised on the
Underground network, but no comprehensive sales
strategy was established until 1979, when there was
a big push to improve the return on shop sales.

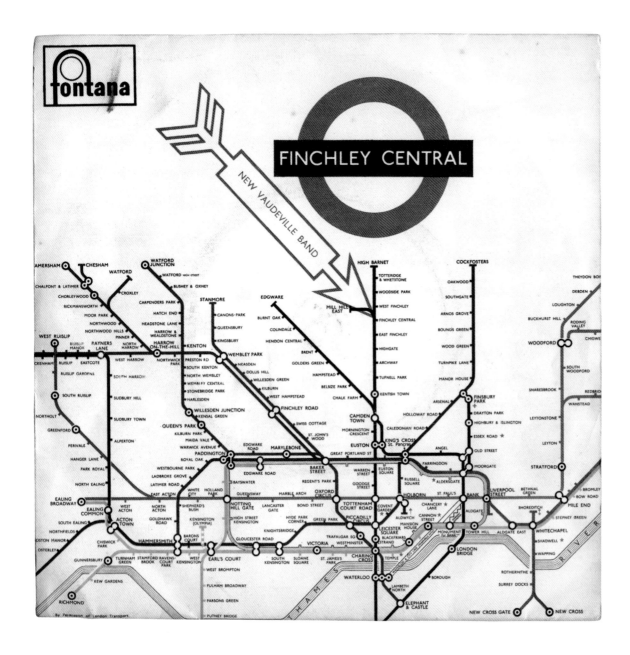

11. *Finchley Central*:
The New Vaudeville Band
Designer unknown, 1967
180 x 180 mm (7 x 7 in)
Published by Fontana Records

The pop single *Finchley Central* was
in the charts for nine weeks in the
summer of 1967. In tune with its title
song, the record sleeve was designed
around the Underground map, with a
Finchley Central roundel for its title.

Exploiting the brand

By the time that London Transport Museum opened
in London's Covent Garden in 1980, the celebrity
status of the Tube map was more evident in its shop
than in its galleries. In 1984, the responsibility for all
map licensing, product development and retail
activity, headed up by Paul Castle, was transferred to
the Museum, while the shop at Griffith House was
closed, and the services of Photo Precision phased
out. Over the next few years, foundations were laid
for the robust licensing programme in place today.
This was divided into two areas of work. One

covered the administration of straightforward
requests for map reproductions in diaries,
guidebooks and publications; the other managed the
licensing of a rapidly expanding souvenir market.

It was at this time that fees were first introduced
for reproducing the map. Although this caused some
regular patrons to end their contracts, their custom
was only briefly withdrawn before they realised that
the value of the official map to their product far
outweighed its licence fee.

Over the next 20 years, as the Tube map evolved
to accommodate the expanding Underground

network, the design has been both protected and exploited by TfL. When the current head of intellectual property, David Ellis, joined the Museum as licensing manager in 1990, the Underground map was already recognised as a valuable and lucrative commercial asset. Ellis took an active and strategic approach in promoting licensing opportunities. As well as maintaining necessarily rigorous regulations to control the use and abuse of the Tube map brand, he also increased awareness among both TfL staff, and any potential perpetrators, of the perils of the map's unauthorised usage. In 2005 the intellectual property team moved to Windsor House, one of TfL's London head offices, from where it manages the map's commercial licensing, while the Museum continues to issue licences for non-commercial and academic reproduction.

Today London Transport Museum sells an extensive and creative range of products featuring the Underground map. Although T-shirts continue to be the most popular item, the clothing line now ranges from socks to hats, flip-flops and even underwear. As well as quirky gifts and token souvenirs, the range has recently expanded to cater for a more exclusive, high-end market, with products being stocked by clients including the West End department stores John Lewis, Heal's and Conran. In line with current trends in digital mapping, which favour the personalisation and bespoke selection of geographical data, the Museum's online Rail Order service now even allows customers to select the area of a map that they would like reproduced on a particular product.

As well as supporting the development of its own products, TfL continues to license the Tube map for a broad range of commercial uses and a myriad of non-

commercial ventures. It has been requested for inclusion in exam paper questions and dissertations, as a teaching tool in foreign language schools, for printing on a one-off set of kitchen tiles and even as the repeat pattern on a groom's wedding suit.

Not all applications are successful. The guidelines for acceptance are actually remarkably similar to those sketched out by Hutchison in 1947 (see p. 107). In the early 1990s, for example, the shoe manufacturer Ecco requested the use of the map as a tread pattern, but the proposal was rejected due to their unsatisfactory use of the roundel.[9]

Alternative Tube maps

Since its introduction, Beck's innovative design has spawned an array of 'alternative' Tube maps, some serious, some playful, some licensed, some plagiarised. The first creative adaptation of London's Underground map appeared in LT's staff magazine, *T.O.T.*, just two months after Beck's new diagrammatic design was introduced in January 1933 (see chapter 2, pl. 1).[10] *The Underground "Straight Eight" All-Electric Skit-Set Circuit Diagram* (1933) casts the Underground in the guise of an electrical circuit diagram – allegedly one source of inspiration for Beck's radical new design. The cartoon's text revolves around a series of witty puns that draws parallels between the Underground, the map and the electrical wiring of a radio (see chapter 2, pl. 15).

Technical terms, such as 'condenser', 'choke' and 'tension' cluster around busy interchange stations. At Westminster station, the label 'Cabinet & C.I.D. Lightening Arresters' indicates the stop for the Houses of Parliament and New Scotland Yard, while 'HQ + Headphones & Loudspeakers' at St James's Park station alludes to London Transport's

headquarters and, perhaps, the vocal tendencies of the authority figures within. A dot added by the river Thames in Battersea, where Lots Road power station provided the Underground's central supply of electricity at the time, is labelled 'H.T. All mains'. The dotted line for the extension to Cockfosters station takes the symbolic form of an aerial and, at the most southerly point on the system, Morden is marked 'Earth'. The arrow pointing to 'Crystal', south of the East London line, refers both to the route to Crystal Palace in South East London, and to the crystal-set receiving process of contemporary wireless radios. The end of the Piccadilly line at Aldwych station (now closed), is aptly labelled 'Wander plug', a contemporary term for an extension lead.

13. Shopping for souvenirs
Photographed by London Transport Advertising & Publicity, *c.*1979

A variety of Underground posters, prints, postcards, maps and map-based souvenirs on sale in the late 1970s in London Transport's Shop at Griffith House on Marylebone Road in central London.

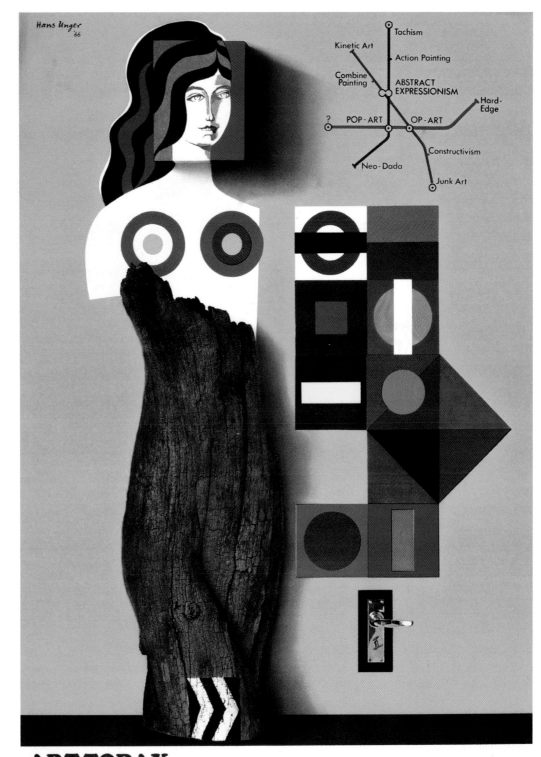

14. *Art Today*
Hans Unger, 1966
Double royal, 1016 x 635 mm (40 x 25 in)
Published by London Transport
Printed by C. S. and E. Ltd

A Pop Art style collage combining
Underground graphics, bold abstract
shapes and a miscellany of photographic
elements, Unger's poster promotes travel
to London's art galleries by Underground.
The schematic map at top right plots
contemporary art movements as stations
along the Tube lines.

ART TODAY The Tate, re-hung with taste and logic, offers the academically approved, the Whitechapel the young and middle-generation painters. The Greater London Council sets contemporary British sculpture against the simpler pleasures of Battersea Park. Complete your survey with the commercial galleries of deepest Mayfair and Chelsea, and the avant-garde extremes. For all these new frontiers, the explorer's kit is simple—an open mind, Underground and bus maps, and a sense of humour. For The Tate Gallery: Underground or bus to Westminster, then bus 77B. For The Whitechapel Art Gallery: Underground to Aldgate East. For Battersea Park: Underground to Sloane Square, then by bus 137.

The Great Bear

Another creative adaptation of the Tube map appeared in *Art Today*, an LT publicity poster of 1966 promoting travel to the capital's contemporary art galleries (pl. 14). The modern design by the prolific graphic artist Hans Unger adapts Beck's diagrammatic form and distinctive colours to chart the course, not of Tube lines, but of avant-garde art movements.

In 1991 London Transport granted a licence request that was to change the face of London's Tube map, both literally and intellectually. The now internationally acclaimed artist Simon Patterson, who was then a promising young graduate from Goldsmiths, University of London, requested the use of the map as the basis for a conceptual artwork, now known as *The Great Bear* (pl. 15).

15. *The Great Bear*
Simon Patterson, 1992
Quad royal, 1016 x 1270mm (40 x 50 in)

A witty adaptation of the London Tube map, replacing station names with those of famous people plotted along themed lines, such as philosophers on the original 'Circle' line, explorers on the 'District' line, and footballers on the 'Jubilee' line.

In essence, a reproduction of the 1991 Tube map, it is identical in almost every way, apart from its unique naming of the stations. On Patterson's map, station names have been replaced with those of famous people and plotted along themed 'celebrity' lines, such as philosophers, actors, engineers and comedians. The Tube map diagram and the Great Bear constellation offered Patterson two familiar and easily accessible systems for ordering complex information. By adapting one (the Tube map) and adopting the name of the other (the Great Bear constellation), Patterson's playful arrangement of celebrity 'stars' challenges the authority and function of both systems.

In 1996, when *The Great Bear* featured in the exhibition *Mapping* at the Museum of Modern Art in New York, Patterson stated:

> There is no code to be cracked in any of my works. Meanings may not be obvious, you may not get a joke, but nothing is really cryptic – I am not interested in mystification. I like disrupting something people take as read. I am not simply pulling the rug out from under people. I'm not nihilistic. What interests me is juxtaposing different paths of knowledge to form more than the sum of their parts. [11]

It is almost impossible, however, not to look for meaning in Patterson's configuration of the stars. The football star Gary Lineker, who was famously never cautioned by a referee for foul play, has been mapped at the interchange between lines for footballers and saints, urging us to look for more happy coincidences. Because the basic Tube map still remains instantly recognisable, even after Patterson's adaptation of the station names, viewers are intuitively drawn to explore *The Great Bear* like an ordinary map, and make connections of their own.

Patterson produced 50 limited edition prints of *The Great Bear*, intended for display by galleries and art collectors, in the same anodized aluminium frames used by London Transport for their authentic Tube map.

Patterson may not have been the first person to change the names of stations on London's Tube map, but *The Great Bear* was the first example to be widely published. Neither the 1933 *Skit-Set Circuit Diagram*, designed as an in-house joke, nor Hans Unger's *Art Today*, produced as an ephemeral publicity poster, are likely to have been known to either Patterson or the public in 1992. Patterson's simple yet cerebral idea captured the public's imagination.

Over the last 20 years, it has featured in exhibitions and in books on conceptual art worldwide. Beyond the prestigious walls of the art gallery, *The Great Bear* found a broader, more mainstream audience as a mass-produced poster. Like Beck's design, Patterson's artwork captured the public imagination far beyond the expectations of the artist. Its enduring popularity is evidenced by the colossal sales figures for posters and their propensity for popping up in houses, offices, pubs and restaurants all over the world.

By the late 1990s, developments in digital media, mapping applications and the internet had made the creation and dissemination of maps much easier. More people than ever are now accessing, representing and interacting with geographical data online. In the last decade, hundreds of London Underground-related maps have appeared on the web. These range from Mathew Somerville's dynamic, live Tube map, which draws on open-source, real-time data provided by TfL, to a plague of unauthorised adaptations mimicking Patterson's *The Great Bear*. A variety of fake Tube maps have appeared online, some with their station names meticulously personalised, some anagrammatised, others translated into Latin or even obscenely profaned. Although all are a flagrant infringement of intellectual property rights, the craze does reflect one of many dimensions to the scale of interest in London's Tube map.

In his alternative Tube map, *A to Z*, Tim Fishlock pushed out the boundaries, taking the shifting connection between text and image one step further. While retaining some instantly recognisable elements, such as line, colour and station names, *A to Z* breaks down the familiar structure of the Tube map and reassembles it as the letters of the alphabet. As he explains:

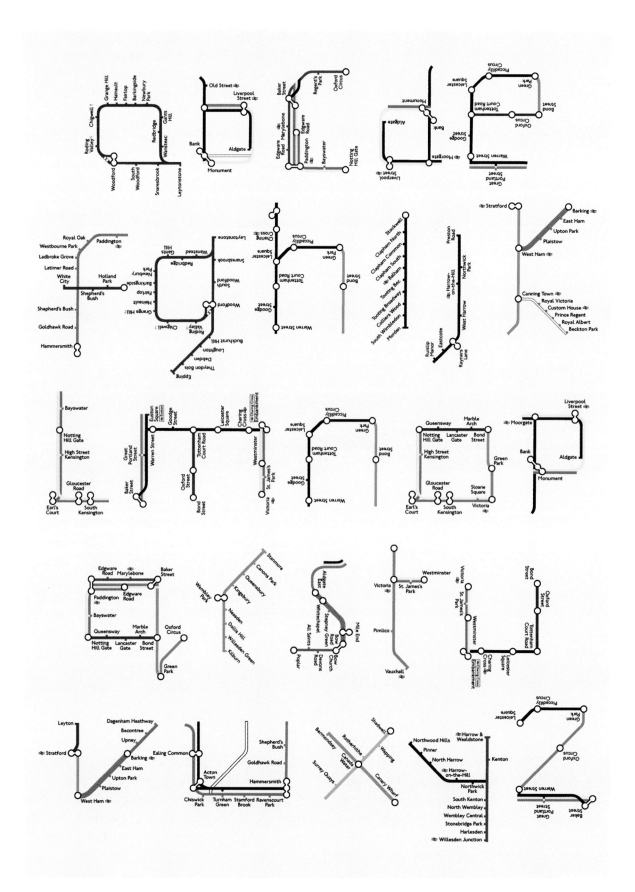

Tim Fishlock, 2011
Double royal, 1016 x 635 mm
(40 x 25 in)

A novel poster design for an alternative
Tube map – or an alternative A to Z –
in which the letters of the alphabet
have been assembled from extracted
sections of the Tube map.

17. *The Underground Film Map*
Quad royal, 1016 x 1270 mm
(40 x 50 in)
Published by TfL

An alternative Tube poster map
celebrating 70 years of film shot on
location at or near London's
Underground stations. The stations
have been named after films or TV
series shot in the vicinity, or after
film actors, directors or producers
born nearby.

A lot of my work explores symbols and the idea of pictorial shorthand ... part of my fascination with the alphabet is that most of the letters began life as pictures, icons from another era. For me, the challenge was to find these 26 icons within the London Underground map – one of the world's most recognisable and successful examples of pictorial shorthand. The Roman alphabet has journeyed far and wide over thousands of years as it's been gradually tweaked and added to. A to Z is a reference to this journey and of course to the millions of journeys the Underground map facilitates everyday.[12]

Since *The Great Bear,* TfL has commissioned an official series of alternative Tube maps. *The Underground Film Map,* produced in partnership with Film London and the British Film Institute (BFI) for the London Film Festival in 2010, celebrates 70 years of film shot on location at or near London Underground stations (pl. 17).

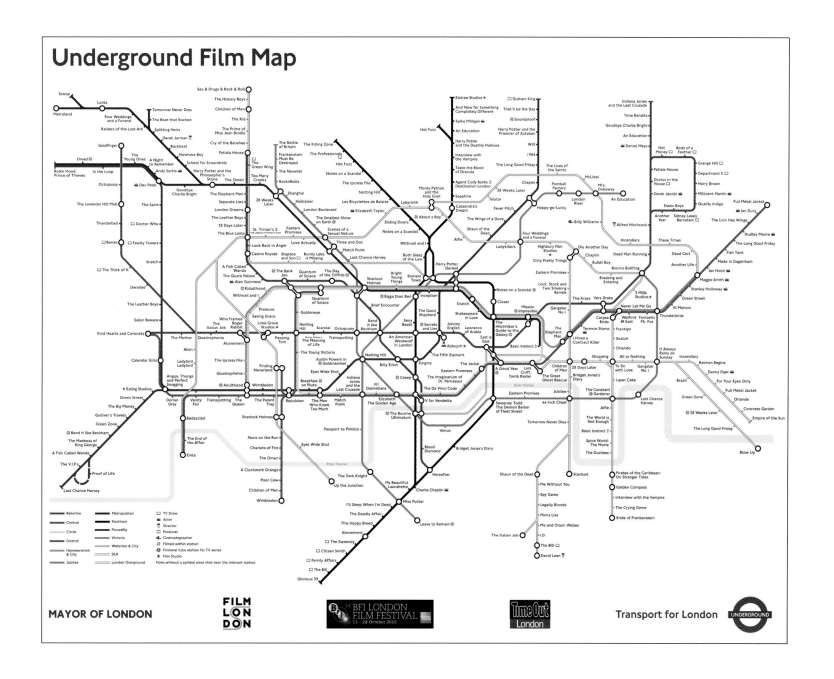

An evolving motif in advertising

The map's iconic diagrammatic form also began to feature early on as an effective, modern design motif in the Underground's own advertising. In 1935 a commercial artist named O'Keeffe designed a set of five posters promoting leisure travel to theatres, museums and shops in London (see pl. 18). In one of the set, *Design for Playgoers*, the Tube map appears in an abstracted, schematic design linked to a colour-coded key highlighting the best stations for visiting London's theatres.

A few years later in *c*.1938, Lillian Dring's poster design cast London Transport as a modern god. With the winged helmet of the swift messenger god Mercury, the roundel symbol as a heart and

18. *Design for Playgoers*
O'Keeffe, 1935
Double royal, 1016 x 635mm (40 x 25 in)
Published by London Transport
Printed by Waterlow & Sons Ltd

The first poster to employ a Beck-style map as a motif in Underground publicity.

19. *Modern God of Transport*
Lilian Dring, *c*.1938
379 x 762 mm (15 x 30 in)

An unused poster artwork presents London Transport personified, with a roundel logo as a heart and Underground lines circulating the lifeblood of the city.

Underground lines running through its veins, London Transport appears personified. Beck's diagrammatic form has played a key role in creating this powerful modern image. Unfortunately Dring's design, which was intended as a triptych, was deemed too expensive to print.

The most complex and guarded area of licensing arises when licensees request permission to change the Underground map itself, as in the case of Simon Patterson's *The Great Bear* (pl. 15). For London Transport's own publicity purposes, however, a degree of artistic licence has always

20. *The Tate Gallery by Tube*
David Booth of Fine White Line, 1987
762 x 508 mm (30 x 20 in)
Published by London Transport
Printed by Print Processes Ltd

The best-selling Underground poster of all time, designed to boost travel to London's Tate Galley. Booth's witty design, with the Underground's lines squeezed out like paint from a tube, transforms the map into a semi-abstract, sculptural artwork.

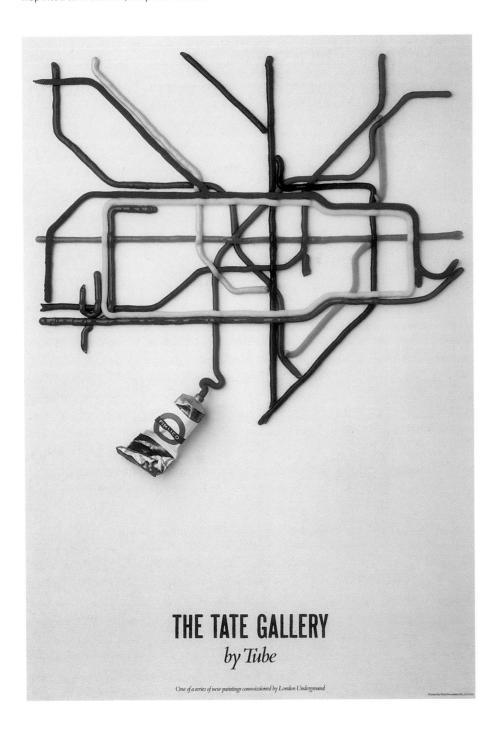

THE TATE GALLERY
by Tube

One of a series of new paintings commissioned by London Underground

been prudently permitted. One of the best examples, *The Tate Gallery by Tube*, designed by David Booth in 1986, promoted travel to London's Tate Gallery. Now iconic in its own right, its witty adaptation of the Underground map shows the network's lines being squeezed out like paint from a tube. After Booth had grappled with many mock-ups in toothpaste, the model-makers Malcolm and Nancy Fowler were commissioned to create the final artwork. Each line was individually modelled in plastic and coloured with a glossy finish to create the appearance of freshly squeezed paint. The map was then assembled and securely mounted onto a canvas. Finally, a real paint tube labelled 'Pimlico' – the right stop for the Tate – was attached to the artwork to represent the final destination.

The Tate Gallery by Tube was commissioned as part of *Art on the Underground*, a new poster-commissioning initiative launched in 1986 by London Transport's Marketing and Development Director, Dr Henry Fitzhugh. By filling unused advertising space with vibrant modern designs, the campaign aimed to improve the Underground environment and enrich passenger journeys, while also acting as a form of corporate art sponsorship. Six designs were commissioned every year, with 6,000 of each printed and posted for an average of seven to 12 months. Due to its popularity, *The Tate Gallery by Tube* was periodically reprinted and redisplayed until the early 1990s.

Like Patterson's *The Great Bear*, *The Tate Gallery by Tube* was a clever concept that proved easily accessible and profoundly popular. Booth maintains that 'Beck's map is a uniquely essential element of London's fabric and has connected with millions every day since its introduction'.[13] He credited the

21. Pocket Tube map covers
Multiple artists, 2004–11
150 x 75 mm (5.9 x 2.9 in)
Commissioned by *Platform for Art/ Art on the Underground*

Left to right: *You Are in London*, Emma Kay; *Untitled*, Gary Hume; *Map of the London Underground*, David Shrigley; *Global Underground*, Yinka Shonibare; *The Day Before (you know what they'll call it? They'll call it the Tube)*, Liam Gillick; *Portrait of John Hough*, Jeremy Deller with Paul Ryan; *Going Underground*, Mark Wallinger; *Fragment of a Magic Carpet, c.1213*, Pae White; *Troubadour Carrying a Cytiole*, Paul Noble; *Earth*, Richard Long; *Untitled*, Barbara Kruger; *Good Times*, Eva Rothschild; *All My Lines in the Palm of Your Hand*, Michael Landy; *Polka Dots Festival in London*, Yayoi Kusama.

success of his poster to the instantly recognisable properties of Beck's design, which he describes as 'a triumph of graphic problem solving … and popular because it works'.

Booth's poster, in turn, helped establish the symbolic status of London's Tube map as a powerful image, even when removed from its primary navigational function. *The Tate Gallery by Tube* has become one of the Underground's most widely recognised and best-selling posters. It also provided the signpost for a generation of advertising and art centred on Beck's distinctive design.

A new chapter for *Art on the Underground*

In 2008, the name of LT's former poster campaign, *Art on the Underground*, was adopted, by coincidence, for the Underground's art programme, originally known as Platform for Art. Since 2004 the programme has been commissioning artwork for the cover of new pocket maps. The unique

commission for a tiny piece of public art, with colossal print runs, enabling rapid dissemination throughout the capital within hours of 'display', has proved a resounding success. A phenomenal range of outstanding artists has contributed to the series (pl. 21). Head of *Art on the Underground*, Tamsin Dillon, has been careful to keep the brief broad enough for artists to bring their own celebrated styles to the piece. As a result, each artist has uniquely responded either intellectually or aesthetically to London Underground's map, history or conceptual theory. The inspired commissions reflect the dichotomous state of the Tube map, as both a design icon and a fully functioning navigational tool.

Cornelia Parker's cover artwork of 2008, *Underground Abstract* (pl.22), was inspired not by the Tube map itself but by Booth's creative adaptation of its familiar form in *The Tate Gallery by Tube*, a poster she had always admired (pl. 20). Parker painted her own version from memory, much like the

'cognitive maps' created by Scalway's passengers in *Travelling Blind* (pl. 23). She then folded her map in half to create a Rorschach blot. Abstract and ambiguous, Rorschach blots, which are usually created from a folded inkblot, provoke different reactions from different viewers. Named after the Swiss psychologist who invented them, Rorschach blots are often used as a psychological tool to reveal something about a viewer's perceptions. As everyone 'sees' something different in the blot's abstract design, an individual's unique 'take' is thought to reflect their underlying state of mind.

After several attempted blots, Parker settled on one that she believed to be suitably abstract yet simultaneously recognisable as the Tube map. Some of the earlier blots had seemed potentially too phallic in appearance for such a public artwork. Even the one she finally submitted needed a slight modification before printing. Amusingly, and actually quite fortuitously, this only added gravitas to the sentiment behind Parker's use of Rorschach blots: 'I like the idea that anyone can look at the same blot but see totally different things in it', she explained in an interview for the *Guardian*, adding:

> To me, the finished design looks like an insect, a mutant creature that has perhaps grown under ground and crawled around the tunnels in the dark ... I'm hoping commuters will make their own connections with it: I always want my work to be open to projection. Hopefully they will recognise it as the tube map – a familiar thing that has been made into an uncontrollable splodge. It's quite irrational and emotional compared to the normal tube map, which is rational and organised – but that's what I like about it. It might be the way you feel in the morning – it's like a tangle of thoughts, a map of your brain as you struggle wearily out of the Underground and into the day ahead.[14]

London Underground

Tube map

February 2008

MAYOR OF LONDON Transport for London UNDERGROUND

22. *Underground Abstract*
Cornelia Parker, 2008
150 mm x 75 mm (5.9 x 2.9 in)
Published by TfL
Commissioned by *Art on the Underground*

Cornelia Parker's semi-abstract artwork for the cover of the February 2008 Tube map was inspired by David Booth's poster *The Tate Gallery by Tube* (pl. 20).

On hearing of the inspiration his design had been to such a prestigious artist, Booth commented:

> We are lucky enough to live in a society that can indulge in and engage with art on many levels. Art on the Underground provides a totally accessible platform, (literally in some cases) for every member of the travelling public to engage with art. An opportunity that should be seized, valued and cherished. I wasn't aware that my poster had inspired another work. I like the idea of a creative lineage and continuity, but the real source of inspiration should always defer back to the original map by Beck.[15]

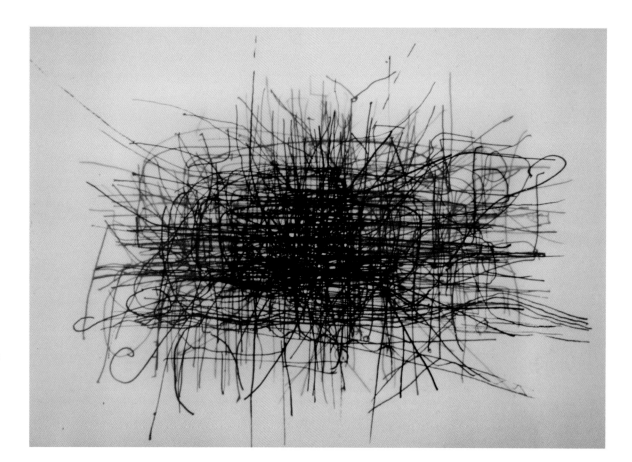

23. *Travelling Blind*
Helen Scalway, 1996

A selection of hand-drawn maps, created from memory by Underground passengers who were asked by the artist to 'draw your London Underground network'. The first image (below) reveals the personal imprint of the Tube map on individual memories. In the second image (right), passenger drawings are layered one on top of the other, then displayed through a lightbox as a dynamic fusion of individual 'cognitive maps', reflecting the common experience of travelling on the Tube.

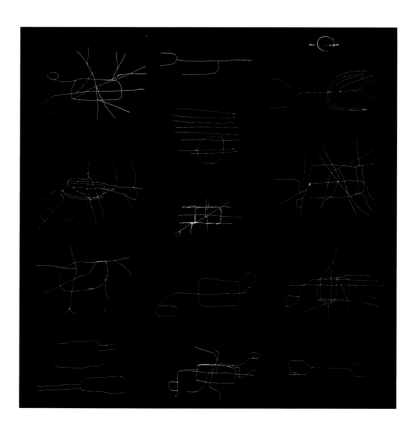

On parallel lines

Running parallel to the vibrant new artworks commissioned by LT and TfL, many contemporary artists have generated their own Tube-inspired art, reflecting the shared experience of navigating and journeying along London's Underground lines. The artist Helen Scalway, for instance, explored not so much Beck's design itself, as the impression it had made on London's travelling public. In 1996, she embarked on a journey of discovery, *Travelling Blind*, which would reveal just how ingrained the Tube map has become within the public psyche (pl. 23). To start with, she sat on platform benches and 'asked in turn anyone who unwittingly sat down beside' her: 'Please draw your London Underground network.'[16] Passengers obliged and their many drawings were later displayed in a light box, creating a single image from the mass of individual 'cognitive maps' layered one on top of another. Scalway later recalled the experience in her book of the same title, describing the experiment:

At five in the morning, no one wanted to draw. Midnight at Piccadilly, everyone did. Taken by surprise, trains due in one and two minutes, no one had time to embellish or pretend. As travellers drew 'their' Undergrounds, their hands re-enacted their different experiences of the space. There are drawings that register in the uncertain pressure of the pencil, how the mind crept uncertainly from point to point. Other hands dashed and swept confidently around. Many hands hovered tentatively above the paper, and then sketched doubt or question in the air before descending to make the mark.[16]

Travelling Blind revealed the profound yet personal impact that the Tube map has had on passengers and their grasp of urban geography. The project gave form to an observation made by Ken Garland in 1969, that Beck's design 'became the familiar image that commuting Londoners carried round in their mind's eye'.[17]

Over the last ten years there has been a resurgence of interest in cartography from fine artists. As our day-to-day dependency on paper maps lessens and navigation becomes more digitally driven, artists have embraced, commented on, and reacted against the cartographic shift from paper to screen.

Jonathan Parsons has been making art out of maps since the 1990s. *Zoned Out* presents both Tube and mainline railway lines as one fused sculpture (pl. 24). After extracting the lines from two separate maps, Parsons teased them into a third, sculptural dimension, securing the core of the structure to a hidden armature. The intricate new network created in *Zoned Out* recalls Dring's *Modern God of Transport*, in which Underground lines are represented as veins circulating lifeblood through the city (pl. 19). Parsons was careful, however, to keep the identity of the map intact:

I am fascinated by how the paper behaves as the design elements remaining from the original map become distorted by gravity and the mechanical strength of the paper curves them into beautiful trajectories. I was amused by the

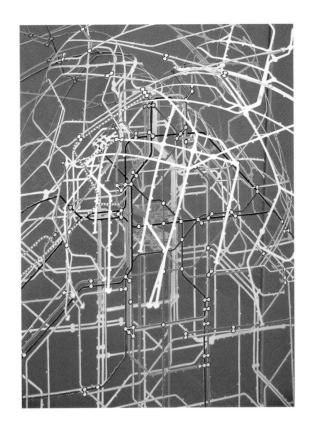

24. *Zoned Out*
Jonathan Parsons, 2004
700 x 700 x 700mm (27.5 x 27.5 x 27.5 in)

A mesmerising sculptural maze created from the fusion of overland and Underground railway lines. The lines were extracted from two different maps and then teased into a new three-dimensional form.

fact that the shape of the Circle Line resembles a drinks bottle and it put me in mind of all the studios, galleries, receptions and openings I have attended over the years. The acrylic display armature that holds the dissected maps in place follows this shape and produces the image of a bottle at the centre of London, hovering like a mirage.[18]

A quite different cartographic footprint was left by Jeremy Wood in 2000, when he began tracking his movements around London using Global Positioning Systems (GPS). He digitally captured six years of movement in the artwork *London GPS Map 2006*, followed by a further three years in *My Ghost*, 2009 (pl. 25). Every delicate line documents a unique, personal journey, giving form and permanence to data that would normally be lost after serving its real-time function.

GPS devices require a clear view of the sky to optimise the reception of satellite signals. In 2011, Wood commented on the eerie omission of London's iconic Underground lines from his maps:

25. *My Ghost*
Jeremy Wood, 2009
330 x 310 mm (13 x 12.2 in)

A beautiful map of the artist's journeys through London over a period of nine years, precisely tracked using Global Positioning Systems (GPS), and then reproduced in print on fine art paper.

26. *Stitched Subway – London*
Susan Stockwell, 2007
1000 x 550mm (39.4 x 21.6 in)

The distinctive shape of the Underground map hand-sewn in red cotton thread on to calligraphy rice paper. It was inspired during the artist's residency in Taiwan, where she was investigating Asian city subway maps.

What is missing from a map is always telling. The accuracy of the tracks tends to dither amongst the tall buildings in Canary Wharf, they dance around inside Paddington Station, and they disappear on the escalators to the Underground. It's as if the GPS struggles for air when shadowed by structures and holds its breath going through tunnels; it craves for the open sky.[19]

Taking a different, less digital tack, Stockwell makes extraordinary art out of everyday domestic and industrial materials. She has produced a series of maps from discarded computer parts, highlighting the physical waste left behind even by digital cartography, whilst other works draw on the tactile quality, aesthetic beauty and political power of maps from the pre-digital era.

Stitched Subway – London is an artwork she made in 2007 whilst working on a commission investigating Asian city subway maps in Taiwan (pl. 26). Using red cotton thread, she stitched the distinctive image of London's Tube map into calligraphy rice paper. 'I felt homesick so made a piece about the London Tube!' she confessed, adding, 'Calligraphy paper is very delicate especially to stitch into, which added a tension to the work. I liked the connections, the paper is made for learning to write on in a particularly visual language and I was using it to create a map, which I see as another form of visual language and a metaphor to communicate my ideas.'[20]

Claire Brewster, another artist who draws out the palpable qualities of print-based maps, creates beautifully intricate paper-cut artworks out of vintage maps and atlases. In *From a Time When Everything Seemed Possible* of 2011, she applied her very literal use of cartography to an Underground map (pl. 27). Brewster chose to use pocket maps from 1987 and 1888, giving them a new lease of life, in line with her own: '1987 was the year I moved to London. The start of several journeys for me. It was the first time I lived away from home, the first time I became a regular tube user and it was the start of my journey to become an artist. The tube map symbolised my new found freedom.'[21]

27. *From a Time When Everything Seemed Possible*
Claire Brewster, 2011
450 x 450 mm (17.7 x 17.7 in)

The ferns and flowers of the countryside jostle with the unmistakable urban geometry of London's Underground network in an intricate artwork created by cutting into pocket Tube maps from 1987 and 1988.

In most of Brewster's works, the original map is unrecognisable. Unlike Parsons, whose trainlines were carefully extracted, Brewster repeatedly cut straight through her Underground lines to create an entirely new and unrelated form. Remarkably, in spite of the map having been dismantled, its distinguishing features remain intact.

Underground London

The simplicity and uniformity of the diagrammatic Tube map offers an antidote to the inherent complexity of London's subterranean labyrinth.

Beck's design deliberately bore no resemblance, nor made any reference, to the actual space that the Underground's network of tunnels negotiates below the ground – the sewers, lost rivers, abandoned and secret tunnels, disused stations, burial sites, bank vaults and foundations. The river Thames is present, but with no account of how the lines apparently glide effortlessly over it. The real twists and turns of tunnels, dictated by centuries of engineering, history, architecture and geology, all conform in their graphic representation to rules of geometry. Any geospatial information that is not required by

28. *London Subterranea*
Stephen Walter, 2012
Quad royal, 1016 x 1270 mm (40 x 50 in)
Published by TAG Fine Arts

A phenomenally detailed hand-drawn map of what lies beneath the surface of the capital, from secret tunnels and burial sites to disused stations and lost rivers.

an Underground passenger has been stripped away. The Tube map offers a simple representation of London as a network of connected destinations. All that resides between those destinations is part of the route. The real space between A and B is not visible, valuable or comprehensible to the passenger. Through Beck's map, however, London's Underground has become knowable, even though the blank space surrounding his iconic, diagrammatic lines is accepted by, and acceptable to, most passengers as the 'unknown'.

It is this unknown space that Stephen Walter fills in his latest map, *London Subterranea,* commissioned for the London Transport Museum's exhibition, *Mind the Map: Inspiring Art, Design and Cartography* (2012). Fact and fiction, science and legend, feats in engineering and forgotten histories teem around the true geographical lie of the Tube lines, which would be lost in the detail if it were not for their distinctive colour lifting them into view. As Walter explains:

Beneath the ground lie many mysteries, secret burials, and hidden treasures. *London Subterranea* geographically tracks several things that exist under the surface of the city. It shines light on a clandestine world of utilitarian tunnels and passageways, and includes some folklore and legends attached to certain places ... I gathered data from books, archives, websites, contacts, and by making occasional journeys below the ground. The map is a concise compendium of what I have learnt.

I tip my hat to MacDonald Gill's highly detailed works and Harry Beck's iconic utopian tube map ... *London Subterranea* is a map that seeks to be a talisman or a fuel-base for those wishing to make further discoveries.[22]

NOTES

1 A statement submitted to the London Transport Museum by the artist, 2011.

2 For comparison with other system maps, see Ovenden, Mark, *Transit Maps of the World*, Penguin Books, New York, 2007.

3 'Green, Oliver, 'My favourite objects', the London Transport Museum collections website, www.ltmuseum.co.uk/collections

4 The evolution of the map and station design in Paris is documented in Ovenden, Mark, *Paris Metro Style*, Capital Transport, London, 2008.

5 Pick, Frank, correspondence files, TfL archives, March 1940.

6 London Transport, publicity meeting minutes, TfL archives, 4 August 1933.

7 London Transport, publicity meeting minutes, TfL archives, 7 April 1936, 9 Feb 1945.

8 London Transport, publicity meeting minutes, TfL archives, April 1947.

9 McLaren, Ian, 'Harry Beck would have been amused', *Baseline*, no.21, 1996, p.40.

10 'The New Underground Map', *T.O.T. (Train, Omnibus, Tram) Staff Magazine*, March 1933, p.77.

11 Greenberg, Sarah, 'The Word According to Simon Patterson', *Tate Magazine*, no.4, Winter 1994.

12 A statement submitted to the London Transport Museum by the artist, 2011.

13 A written interview between the artist and the London Transport Museum, 2011.

14 'On creating the Tube map cover art', the *Guardian*, 9 January 2008.

15 A written interview between the artist and the London Transport Museum, 2011.

16 Scalway, Helen, *Travelling Blind*, London, 1996.

17 Garland, Ken, 'The design of the London Underground diagram', *The Penrose Annual*, vol. 62, 1969.

18 A statement submitted to the London Transport Museum by the artist, 2011.

19 A statement submitted to the London Transport Museum by the artist, 2011.

20 A statement submitted to the London Transport Museum by the artist, 2011.

21 A statement submitted to the London Transport Museum by the artist, 2011.

22 A statement submitted to the London Transport Museum by the artist, 2011.

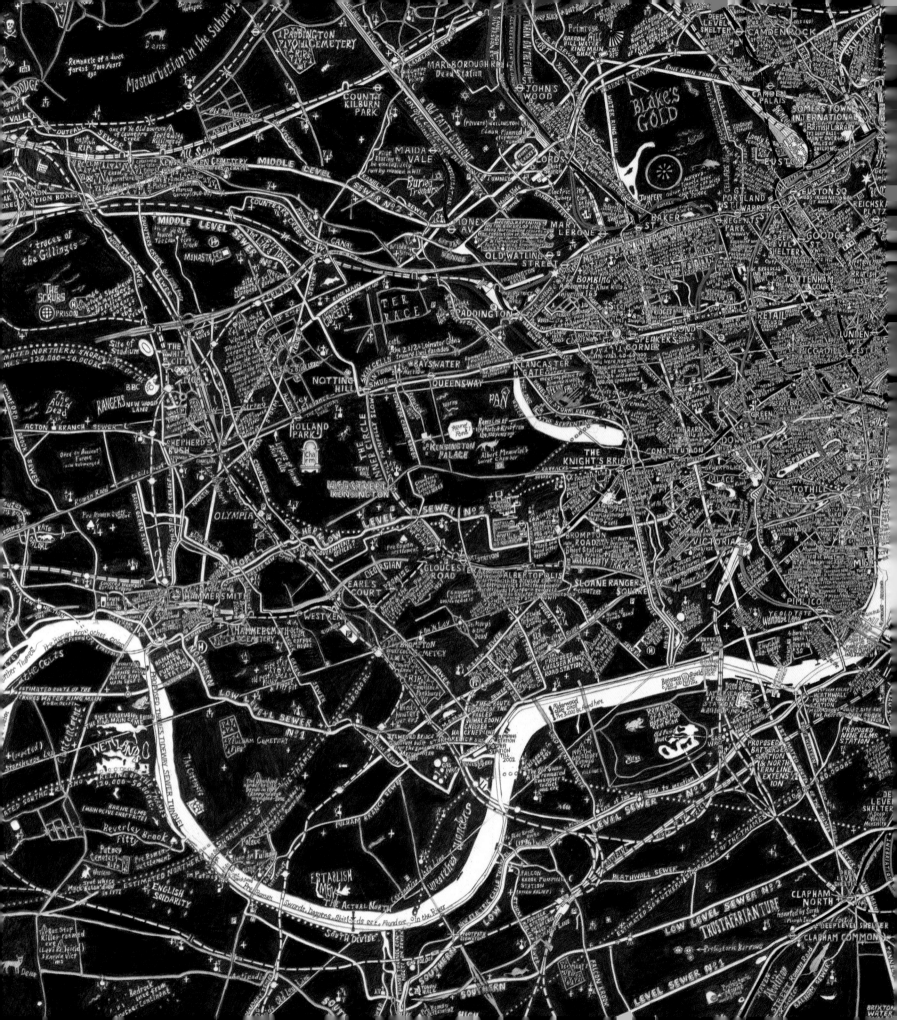

FURTHER READING

This list is not exhaustive, but a series of pointers for those wishing to investigate further the context of London Transport maps. Important archival collections relating to London Transport's map heritage are held by the archives of the London Transport Museum (LTM) and Transport for London (TfL).

See also LTM's website at www.ltmuseum.co.uk/collections for further information and collections-related resources.

BOOKS

Barber, Peter, *The Map Book*, Weidenfeld & Nicolson, London, 2005.

Barber, Peter and Harper, Tom, *Magnificent Maps, Power, Propaganda and Art*, British Library Publishing, London, 2010.

Barker, Felix and Jackson, Peter, *The History of London in Maps*, Barrie & Jenkins, London, 1990.

Bownes, David and Green, Oliver (eds), *London Transport Posters: A Century of Art and Design*, Lund Humphries, London, 2011.

Collings, R.A., *The Way Out Tube Map*, Drumhouse Ltd, Melksham, Wiltshire, 2011.

Dow, Andrew, *Telling the Passenger Where to Get Off: George Dow and the Evolution of the Railway Diagrammatic Map*, Capital Transport, Harrow, 2005.

Foxell, Simon, *Mapping London: Making Sense of the City*, Black Dog Publishing, London, 2007.

Garland, Ken, *Mr Beck's Underground Map*, Capital Transport, Harrow, 1994.

Gossop, R. P., *Advertisement Design*, London, 1927.

Heller, Steven and Fili, Louise, *British Modern Graphic Design Between the Wars*, Chronicle Books, San Francisco, California, 1998.

Lawrence, David, *A Logo for London: The London Transport Symbol*, Capital Transport, Harrow, 2000.

Leboff, David, 'The London Underground Map', unpublished dissertation, 1985.

Leboff, David and Demuth, Tim, *No Need to Ask! Early Maps of London's Underground Railways*, Capital Transport, Harrow, 1999.

Ovenden, Mark (ed. Ashworth, Mike), *Metro Maps of the World*, Capital Transport, Harrow, 2005.

Ovenden, Mark, *Paris Underground: The Maps, Stations, and Design of the Metro*, Penguin, London, 2009.

Roberts, Maxwell J., *Underground Maps After Beck: The Story of the London Underground Map in the Hands of Henry Beck's Successors*, Capital Transport, Harrow, 2005.

Roberts, Maxwell J., *Underground Maps Unravelled: Explorations in Information Design*, Colchester Institute, University of Essex, Essex, 2010.

Rose, Douglas, *The London Underground: A Diagrammatic History*, Capital Transport, Harrow, 2007.

Whitfield, Peter, *London: A life in Maps*, British Library Publishing, London, 2006.

JOURNALS AND NEWSPAPERS

Banks, Toby, 'Underground Movement: The Tube Map', *Living Marxism*, May 1990.

Burdon, Elisabeth, 'MacDonald Gill: The "Wonderground Map" of 1913 and its influence', *IMCoS Journal*, vol.116, Spring 2009.

Challis, David Milbank and Rush, Andy, 'The Railways of Britain: An Unstudied Map Corpus', *Imago Mundi*, vol.61, no.2, 2009.

Garland, Ken, 'The design of the London Underground diagram', *The Penrose Annual*, vol. 62, 1969.

Gill, MacDonald, 'Decorative Maps', *The Studio: An Illustrated Magazine of Fine and Applied Art*, vol.128, no.621, December 1944.

Greenberg, Sarah, 'The Word According to Simon Patterson', *Tate Magazine*, no.4, Winter 1994.

Hadlaw, Janin, 'The London Underground Map: Imagining Modern Time and Space', *Design Issues*, vol.19, no.1, Winter 2003, pp25–35.

'Obituary, Macdonald Gill', *The Times*, 15 January 1947.

Roberts, Maxwell J., *Underground News*, no.566, February 2009.

'The New Underground Map', *T.O.T. (Train, Omnibus, Tram) Staff Magazine*, March 1933, p.77.

Vertesi, Janet, 'Mind the Gap: The London Underground Map and Users' Representations of Urban Space', *Social Studies of Science*, vol.38, no.1, February 2008, pp7–33.

ACKNOWLEDGEMENTS

I WISH TO THANK EVERYONE who has contributed to the development and production of this book. I greatly appreciate the help of my colleagues at the London Transport Museum, in particular Anna Renton for her unflagging archival research, and Simon Murphy, Michelle Brown, Anna Creedon, Antony Forbes and Will Jones for their assistance with image delivery. A special mention is also due to Head Curator David Bownes, Research Fellow Oliver Green and Head of Trading Mike Walton, for their ongoing support and advice.

In addition, I owe great thanks to the generosity of Andrew and Angela Johnston, Caroline Walker and Mary Corell, for sharing their infinite knowledge, intimate insight and infectious enthusiasm for the life and work of MacDonald Gill. Without their unique contribution, the first chapter of this book would not have been possible. I would also like to express my gratitude to Peter Barber, Head of Map Collections at the British Library, for his kind contribution of the foreword.

I am grateful to everyone at Lund Humphries, particularly Lucy Clark, Miranda Harrison and Sarah Thorowgood, for their tireless enthusiasm and professionalism. To the designer, Nigel Soper, and editor, Belinda Wilkinson, I offer special thanks for really bringing the book to life.

Finally, I would like to thank my family and friends for their support, in particular my Mum, from whom I inherited my aptitude and passion for writing and who has been an inspirational source of guidance throughout this project.

INDEX